POWER PLACES OF
KATHMANDU

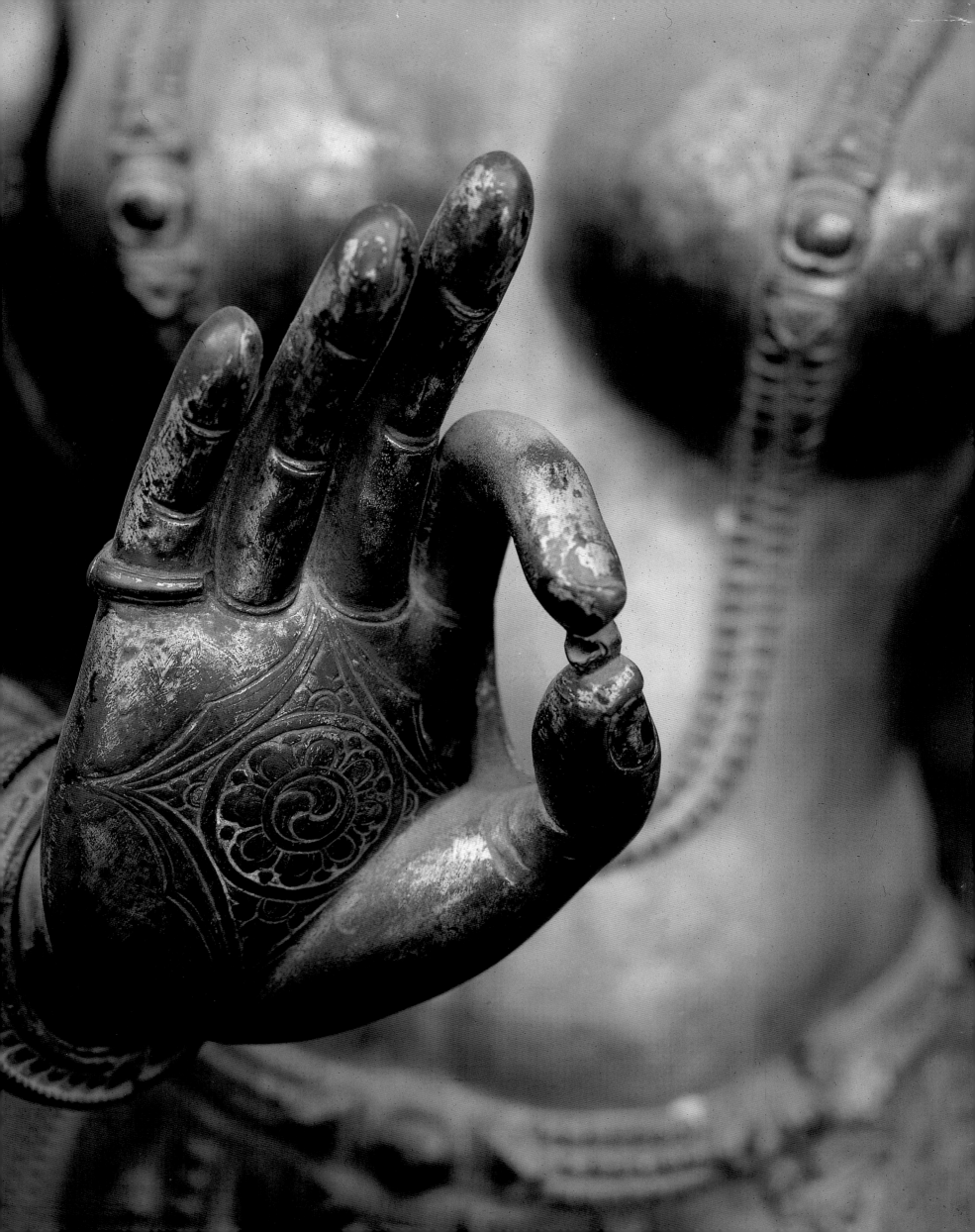

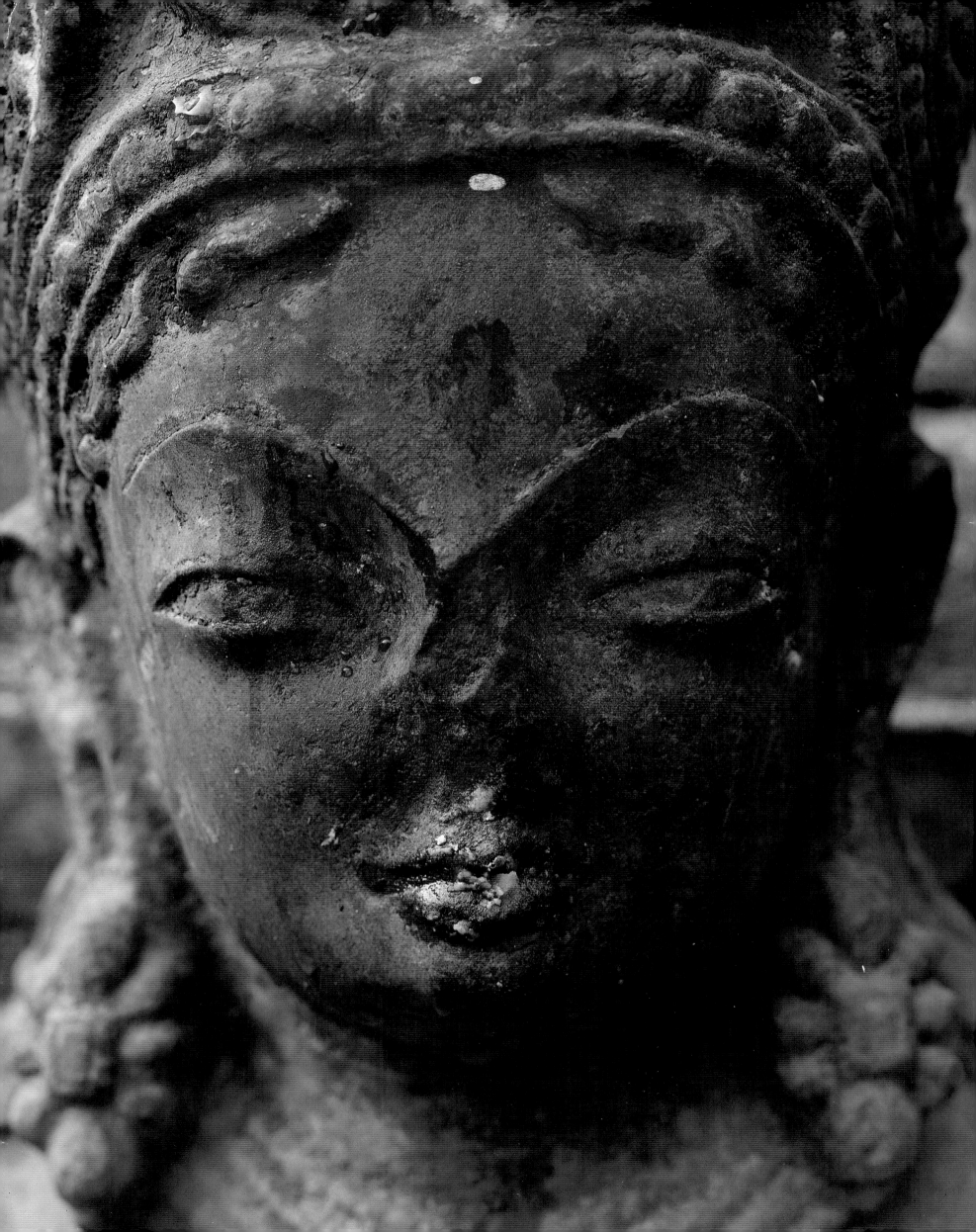

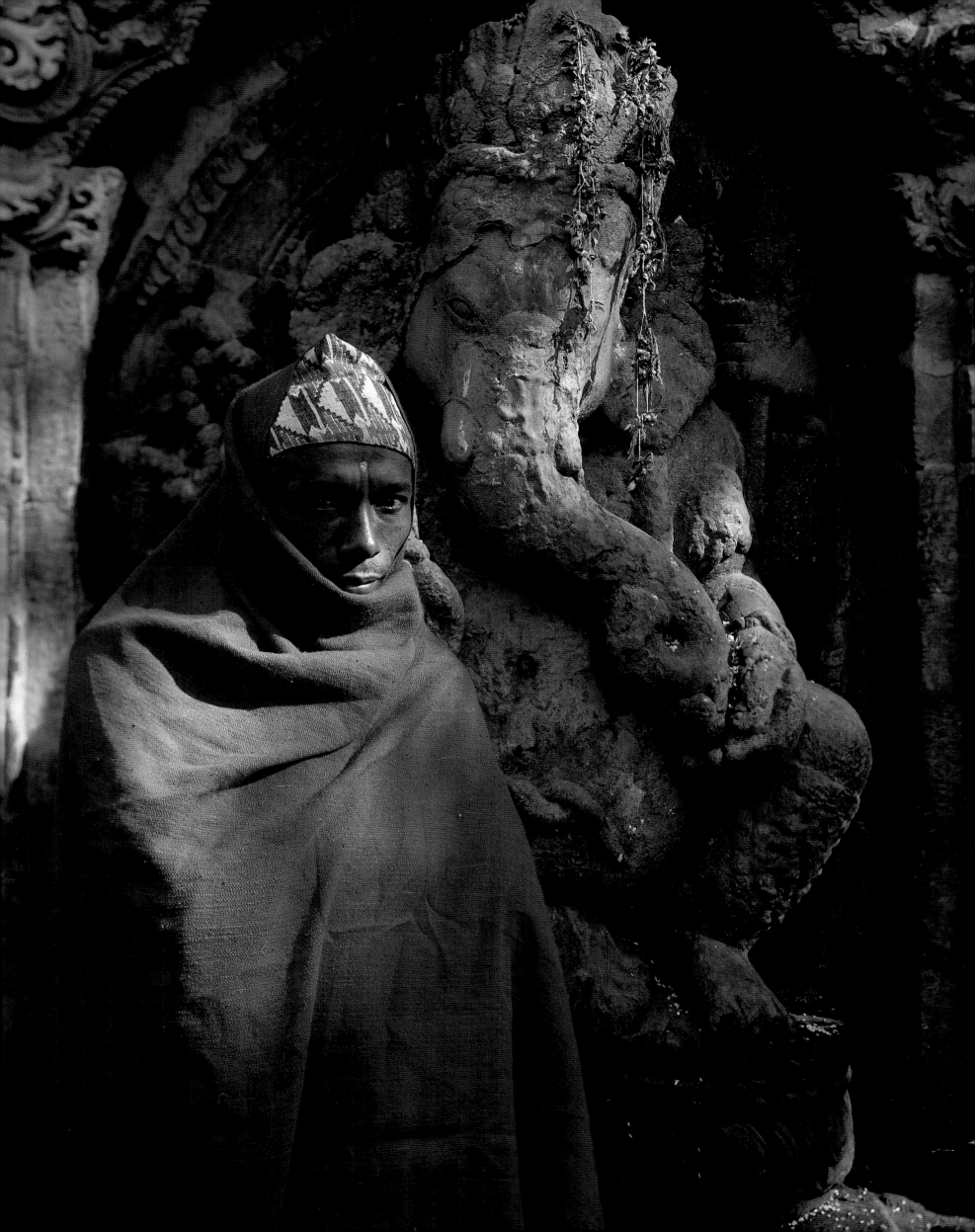

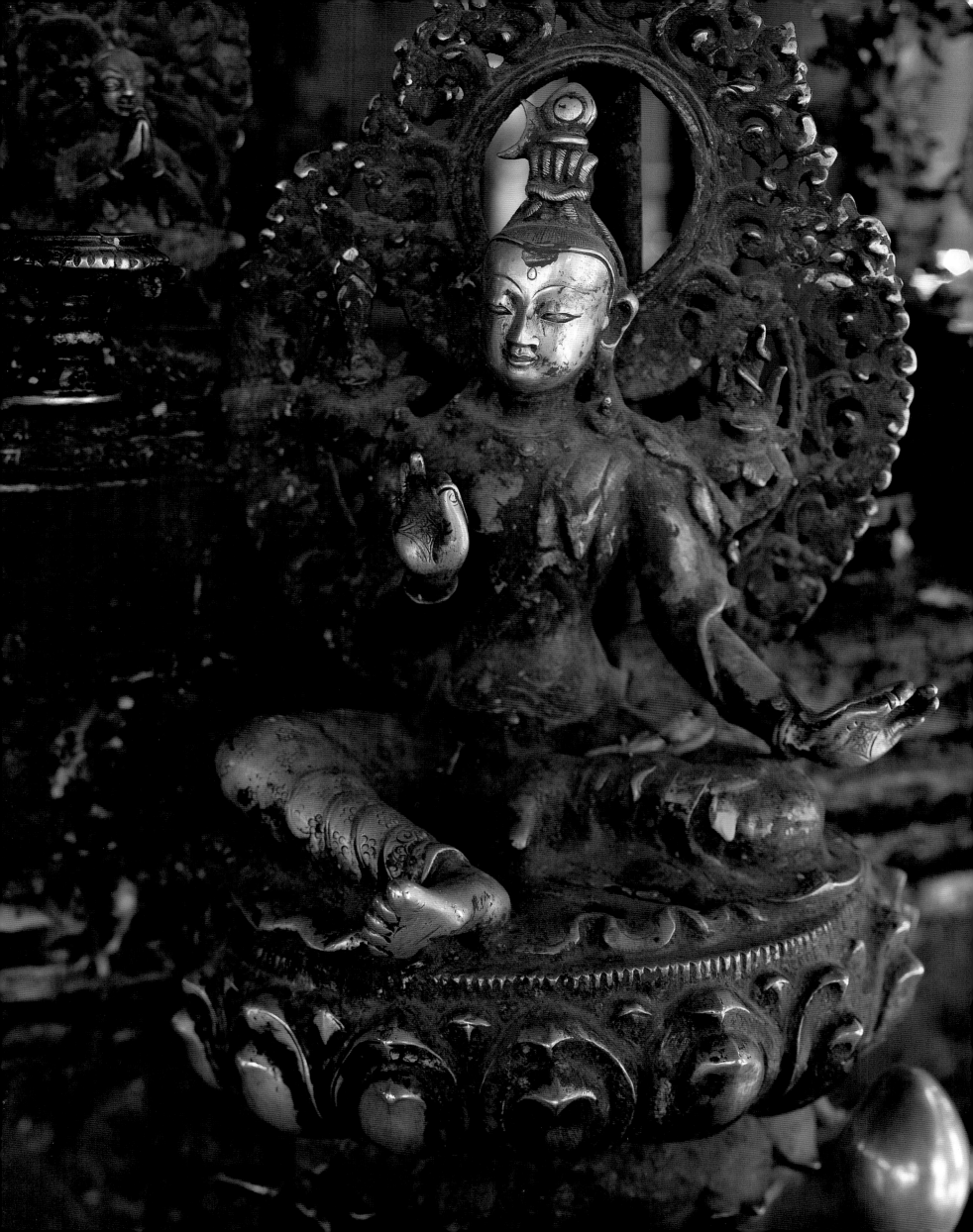

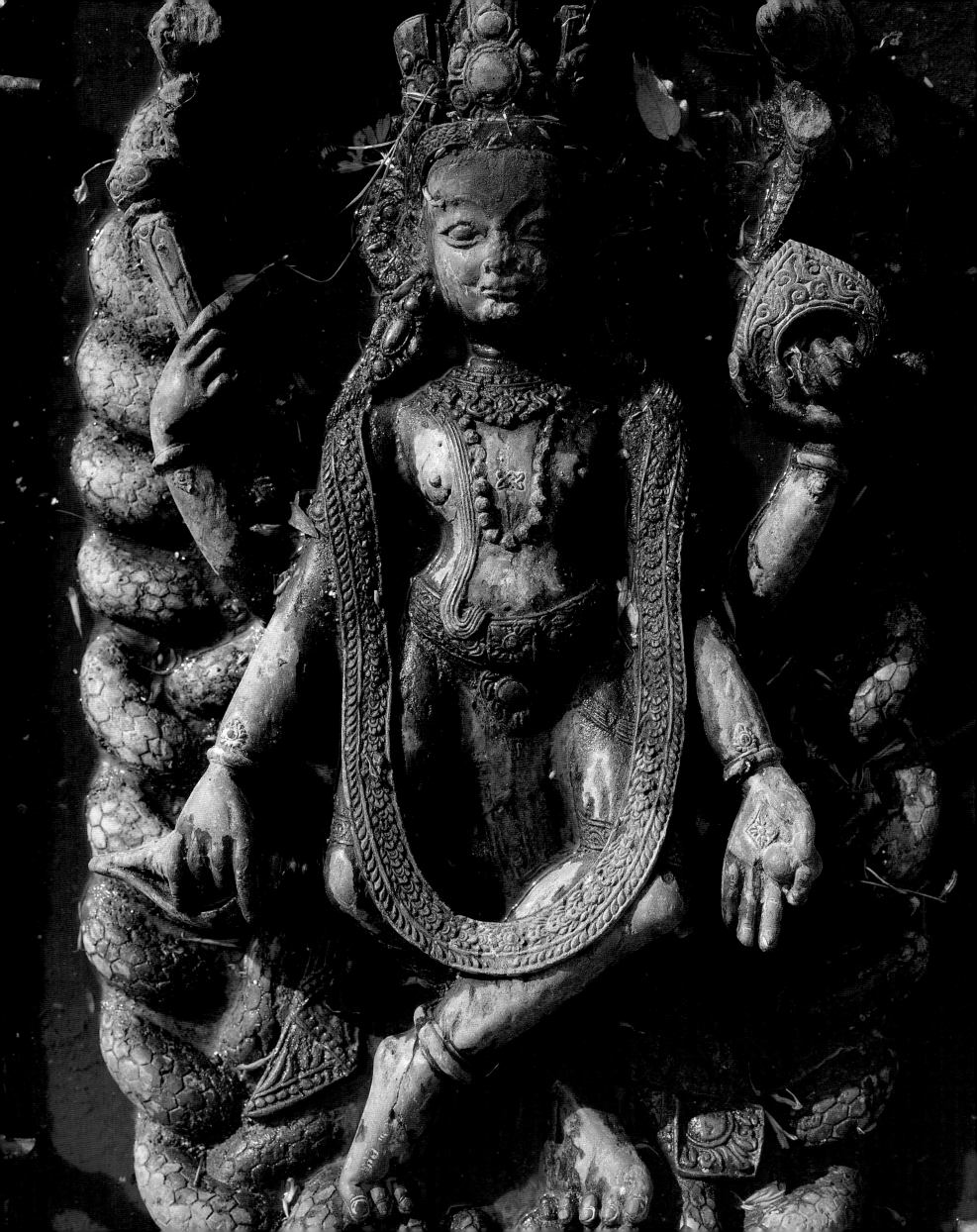

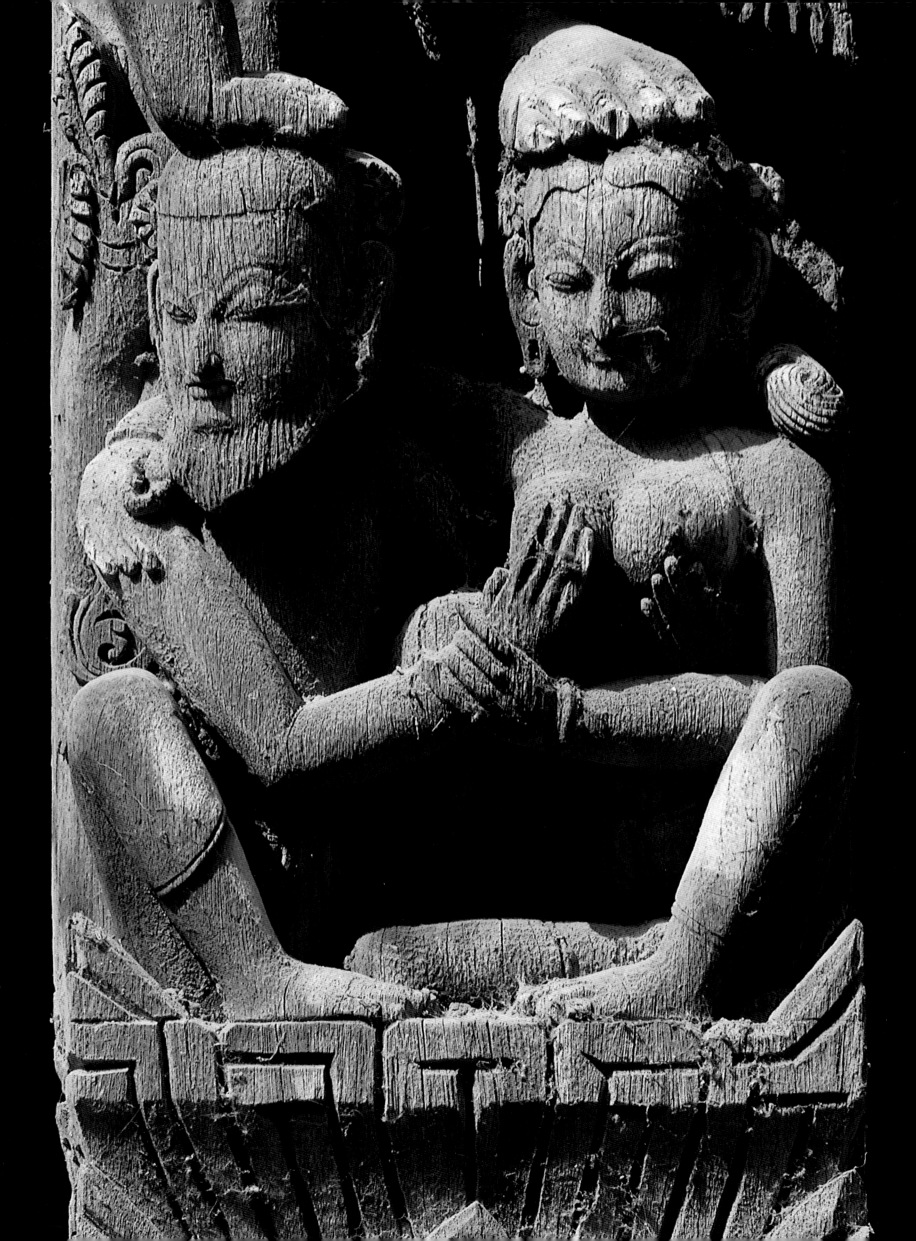

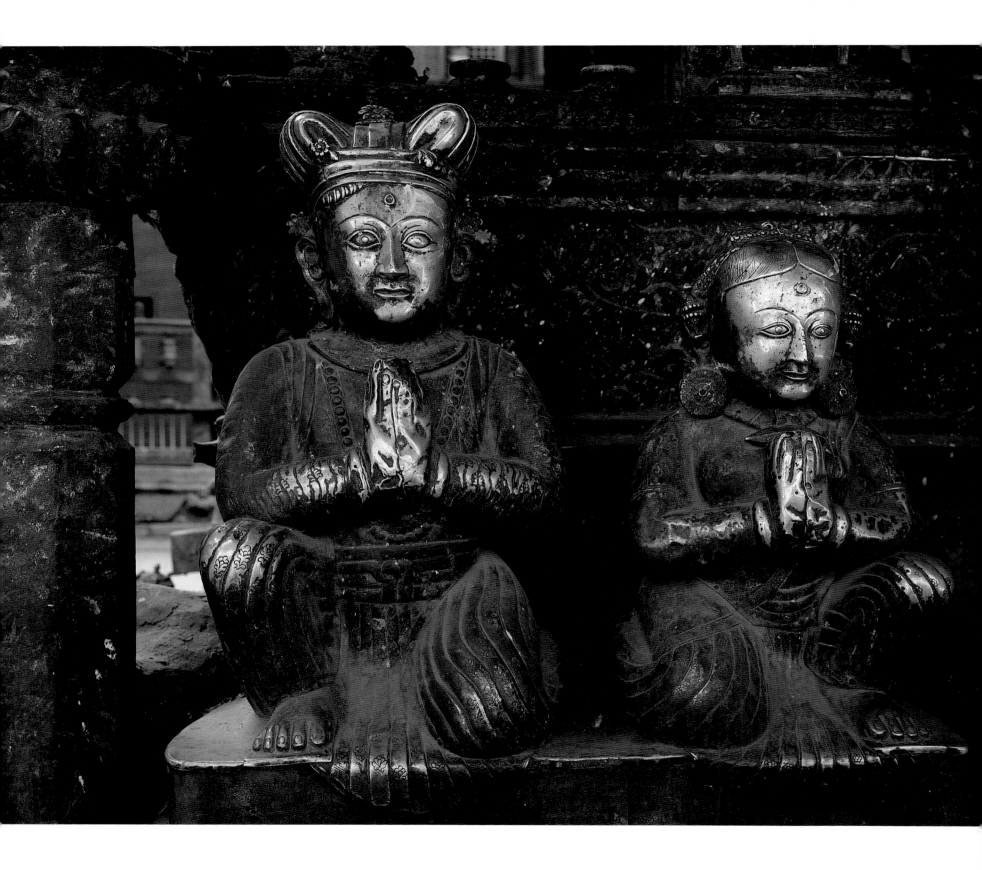

Power Places of KATHMANDU

Hindu and Buddhist Holy Sites in the
Sacred Valley of Nepal

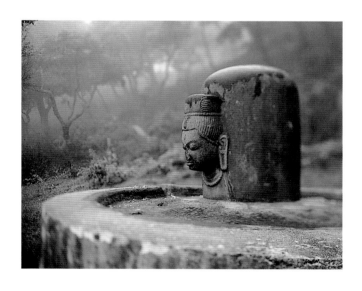

Photographs by Kevin Bubriski
Text by Keith Dowman

Inner Traditions International
Rochester, Vermont

Inner Traditions International
One Park Street
Rochester, Vermont 05767

LIBRARY OF CONGRESS CATALOGING-IN-PUBLICATION DATA
Bubriski, Kevin.
Power places of Kathmandu : Hindu and Buddhist holy sites in the sacred valley of Nepal /
Photographs by Kevin Bubriski; text by Keith Dowman.
p. cm.
ISBN 0-89281-540-X
1. Kathmandu Valley (Nepal)—Religion. 2. Hindu shrines—Nepal—Kathmandu Valley. 3. Buddhist
shrines—Nepal—Kathmandu Valley. 4. Temples—Nepal—Kathmandu Valley. I. Dowman, Keith. II. Title.
BL2034.3.K38B83 1995
294.5'35'095496—dc20 95–18667
CIP
Printed and bound in Hong Kong

10 9 8 7 6 5 4 3 2 1

Text design by Charlotte Tyler

This book was typeset in Italian Electric with OptiCuento as a display face

Distributed to the book trade in Canada by Publishers Group West (PGW), Toronto, Ontario

CONTENTS

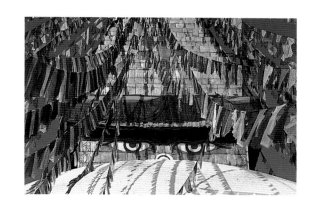

KATHMANDU

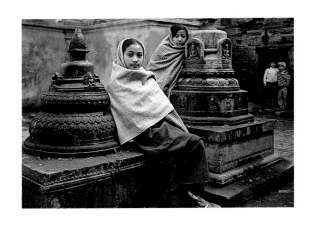

PATAN

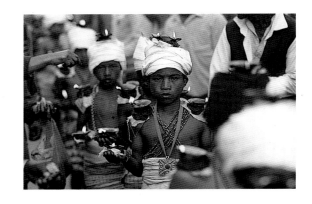

BHAKTAPUR

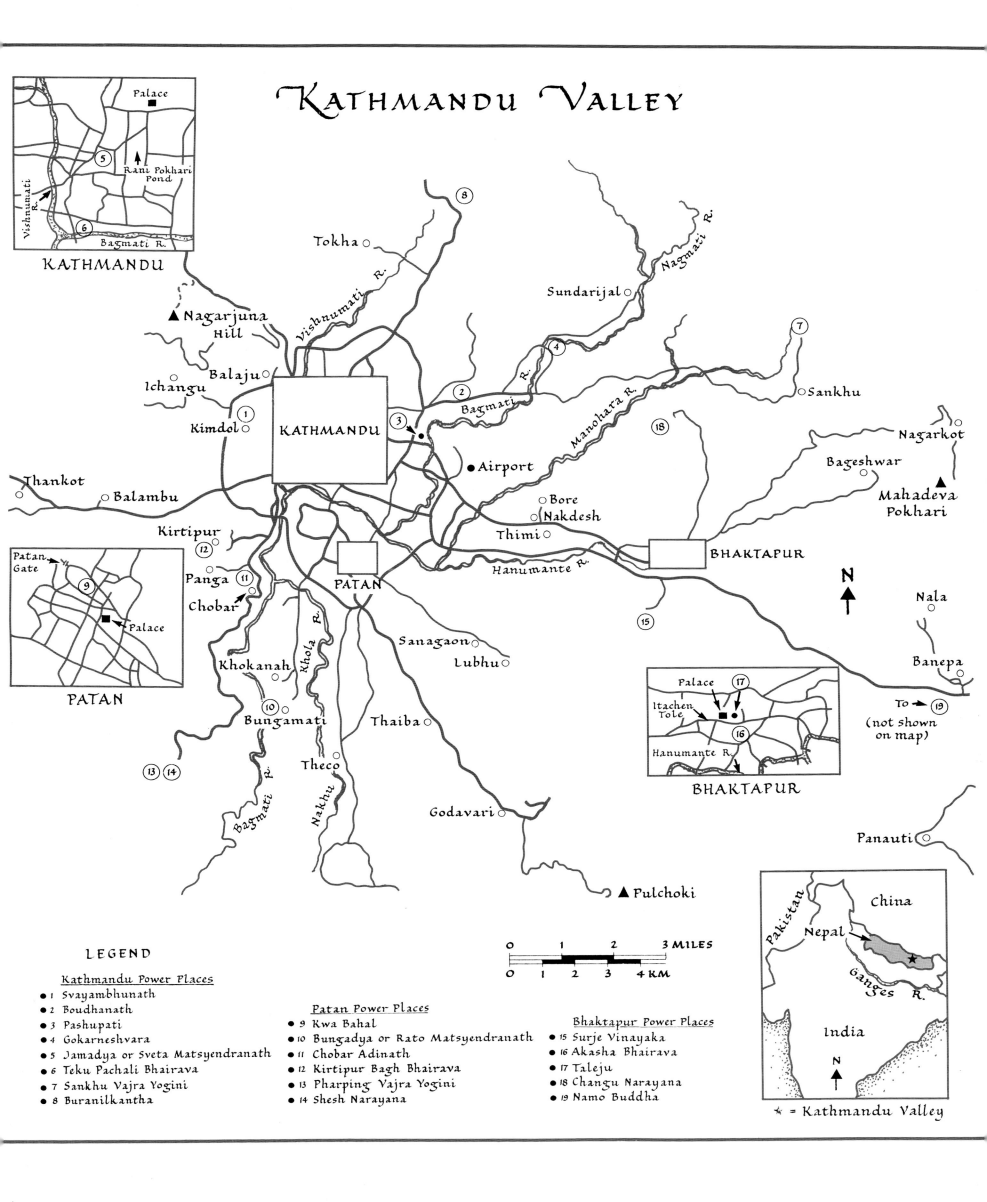

Kathmandu Valley

KATHMANDU (inset)
Palace
⑤
Rani Pokhari Pond
Vishnumati R.
⑥
Bagmati R.

PATAN (inset)
Patan Gate
⑨
Palace

BHAKTAPUR (inset)
Palace ⑰
Itachen Tole
⑯
Hanumante R.
To → ⑲ (not shown on map)

Tokha
⑧
Sundarijal
Nagmati R.
Vishnumati R.
▲ Nagarjuna Hill
Balaju
④
⑦
Ichangu
②
Sankhu
Kimdol
①
KATHMANDU
③
Bagmati
Manohara R.
⑱
Nagarkot
Airport
Bageshwar
Thankot
Balambu
Bore
Nakdesh
▲ Mahadeva Pokhari
Kirtipur
⑫
Thimi
BHAKTAPUR
Panga
⑪
PATAN
Hanumante R.
N ↑
Nala
Chobar
Khola R.
⑮
Khokanah
Sanagaon
Banepa
Lubhu
Bungamati
⑩
Bagmati R.
Nakhu R.
Thaiba
⑬ ⑭
Theco
Godavari
Panauti
▲ Pulchoki

Scale:
0 1 2 3 MILES
0 1 2 3 4 KM

(India/Nepal/China inset)
Pakistan
China
Nepal
Ganges R.
India
N ↑
★ = Kathmandu Valley

LEGEND

Kathmandu Power Places
- 1 Svayambhunath
- 2 Boudhanath
- 3 Pashupati
- 4 Gokarneshvara
- 5 Jamadya or Sveta Matsyendranath
- 6 Teku Pachali Bhairava
- 7 Sankhu Vajra Yogini
- 8 Buranilkantha

Patan Power Places
- 9 Kwa Bahal
- 10 Bungadya or Rato Matsyendranath
- 11 Chobar Adinath
- 12 Kirtipur Bagh Bhairava
- 13 Pharping Vajra Yogini
- 14 Shesh Narayana

Bhaktapur Power Places
- 15 Surje Vinayaka
- 16 Akasha Bhairava
- 17 Taleju
- 18 Changu Narayana
- 19 Namo Buddha

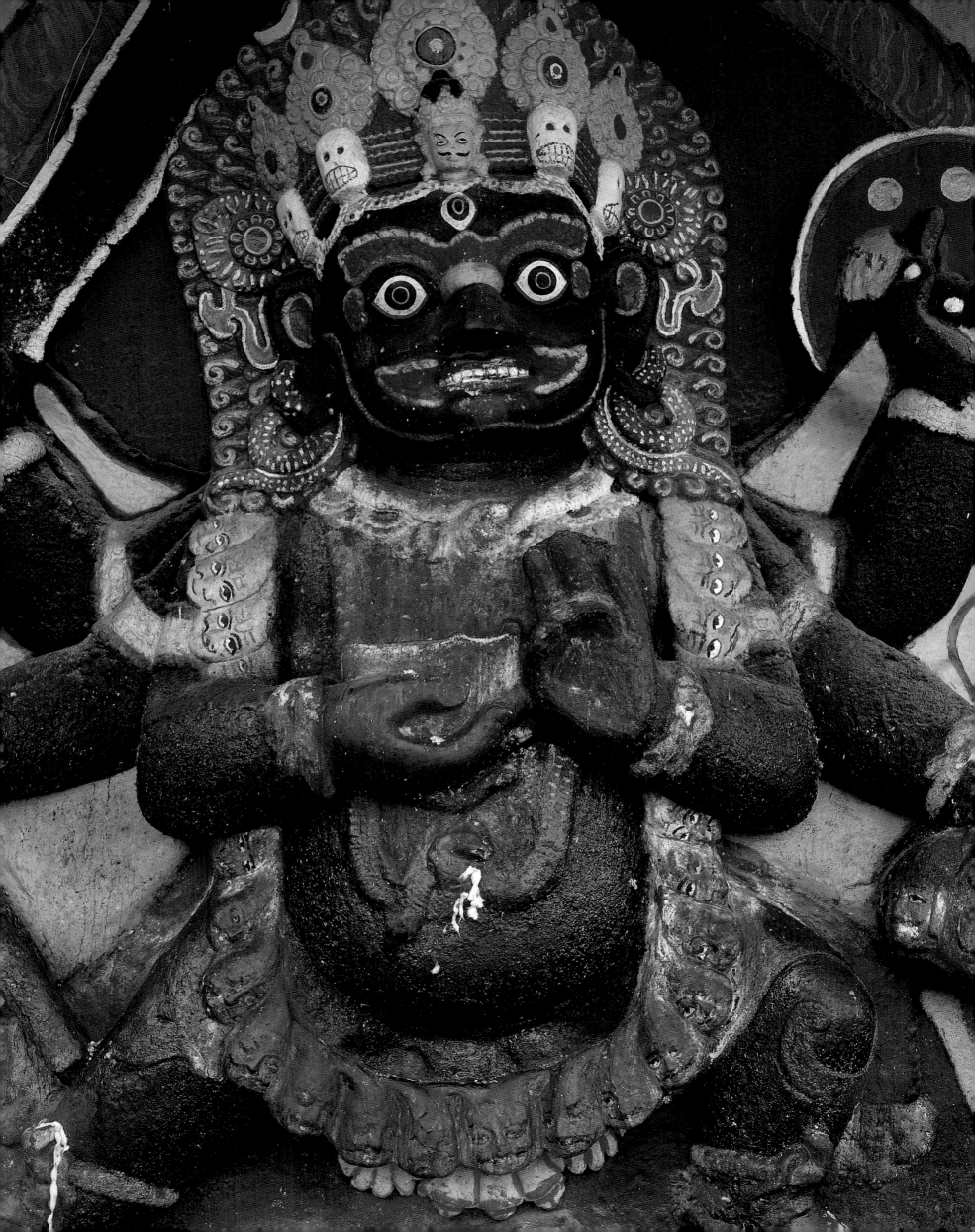

INTRODUCTION

Power places are the seats of the gods, focal points of divine energy. In the Hindu and Buddhist traditions of the Kathmandu Valley, the primary place of communication with the gods is at their residences: *pithasthan*, freely translated as "power places." The power places are windows upon the realm of the divine. They are the source of spiritual revitalization and renewed psychic energy.

In Hindu mythology the Great Himalayan Range has always been the abode of the gods. The sages and seers of the Indian subcontinent envisioned the snow peaks as the thrones of divine authority. The mountains' remoteness and inaccessibility, their majesty and magnificence, and the symbolic significance of their immutable mass all imparted a divine aura. Lying in the lap of these mountains is the Kathmandu Valley, a fertile, well-watered, undulating valley with a temperate climate, surrounded on all sides by a mountainous rim. The Kathmandu Valley is called the Playground of the Gods.

It may be the vitality of the human culture of the valley that sustains the fabled youthfulness of the gods. Proximity to the primordial state of nature produces a creative credulity and a receptivity to the realm of the gods. The inhabitants of the valley are a mixture of high-mountain Tibetan stock and people from the Indian plains. The interaction of these groups over the centuries in their once hidden homeland has produced a religious culture remarkable for its vigor and complexity. The ancient traditions of animism and shamanism coexist with the high cultures of Buddhism and Hinduism, orthodox and Tantric, as varying modes of relationship with the divine.

The vitality of this alliance between humans and the gods is revealed during the major religious festivals. During the principal annual festivals, scheduled according to lunar fortuity and astrological advantage, the gods are paraded in chariots through their city locales in an atmosphere of riotous devotion. Although quiet prayer may be the preferred mode for renunciates and contemplatives, worship for the majority is an occasion to open up to the power of the gods and to gain some knowledge of them through possession by them. Likewise, daily ritual worship takes place in an ambience of excited activity. On holy days, temples pulsate with instrumental and chanted rhythms, trance dancing is an integral part of worship, and blood still flows in sacrificial offering.

Nepal Mandala

The Kathmandu Valley is known as Nepal Mandala. "A mandala is a circle, a mystic diagram of varied form, and in ancient Indian usage signified an administrative unit or a country. From at least the sixth century A.D., in conjunction with the word Nepal, it signified to the Nepalese the Kathmandu Valley and surrounding territory."*

The elliptical valley bowl is about fifteen miles in length and twelve miles in width. It lies at an average of forty-five

* Mary Slusser, *Nepal Mandala* (Princeton, N.J.: Princeton University Press, 1982), p. vii.

1

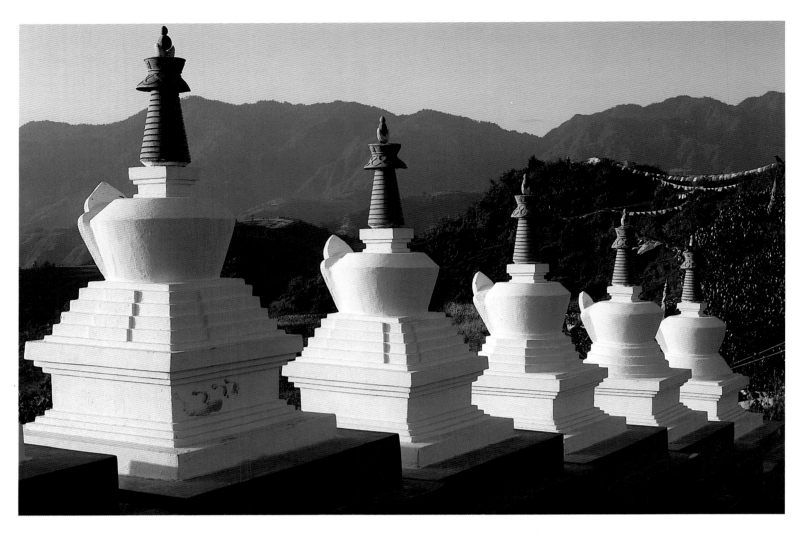

Tibetan Buddhist chortens (stupas), Namo Buddha

hundred feet above sea level and is surrounded by forested peaks up to nine thousand feet high. The rich lacustrine soils that fill the valley bottom have been eroded by its fast-flowing monsoon rivers—particularly the Bagmati and Vishnumati—to form the steep-sided hills and ridges, some still covered by trees, that border the swaths of terraced paddy fields.

Three cities dominate valley life: Kathmandu in the west, Patan in the south, and Bhaktapur in the east. Kathmandu, the capital of the Hindu kingdom of Nepal, is now the center of the valley's high-density population of about one million people. Traders and artisans still form a significant proportion of the urban inhabitants. Numerous small towns and villages are scattered between the three cities, sustaining the traditional agrarian economy of intense rice cultivation.

The city dwellers are predominantly Newar. This ethnic community, the outcome of ancient intermarriage between the Mongol and Aryan peoples, dominated the valley for most of its history. The Newars created the beauty of its traditional architecture and plastic arts, accumulated wealth through trade, and established their reputation among the Himalayan peoples as a society small in size yet immense in human spirit. The king, and many of the aristocracy and peasantry, are Gorkhali or Pahari, the people from the middle hills of Nepal who con-

quered the valley in the eighteenth century. These people—the Gurkhas—have established a worldwide reputation for fierce courage and loyalty. They are loved by their friends and feared by their enemies. Other smaller but still highly significant castes and ethnic groups inhabit the valley: brahmins from the south, who now govern a nascent democratic society; Tibetans from the north, particularly the thirty thousand economically successful refugees; and Sherpas, Manangis, Tamangs, Gurungs, and others, all immigrants from the mountain valleys.

Although the Kathmandu Valley forms an integral social and economic unity, strong rivalry exists between the inhabitants of the three regions of the valley dominated by its three cities. Each was once a separate political entity, and since time here is seemingly collapsed into an eternal present, memories of independent traditions still affect their cultural life. Each has its own religious customs and preferences, centered on its own power places.

The Historical Perspective

The Kathmandu Valley was once a lake; both Buddhist and Hindu myths assert it, and lacustrine deposits prove it. Myth also relates how the valley was drained and civilization estab-

lished by divine intervention. Legends preserved in the Newar chronicles describe archaic dynasties of pastoral kings. Archaeological evidence of urban settlements reaches back only to the Mongoloid Kirata people, who ruled the valley two thousand years ago. The Kiratas were conquered by southern Indo-Aryan invaders, called the Licchavis, in the fourth century. With the establishment of a stable Licchavi dynasty, the Kathmandu Valley entered the mainstream of classical Indian culture with a sophisticated urban society. The brahmin priests who accompanied the Licchavis accelerated the process of "Sanskritization," which brought the Mongoloid people into the Indian fold.

The Licchavi kings established the custom of inscribing royal edicts on stone tablets. Hundreds of these have survived at temple sites and provide a firm base for historical speculation. They furnish a picture of a succession of monarchs ruling a stable, prosperous, and perhaps idyllic kingdom in which the gods were effectively propitiated, temples and monasteries patronized, and the surrounding valleys civilized. King Manadeva (r. 464–505) was the preeminent Licchavi king, who was to live on in folk memory as sovereign of a golden age. The court of another great king, Amshuvarman (r. 605–621), was visited by a Chinese emissary. Chinese records describe the architectural magnificence of his palace in Harigaon. Amshuvarman, or his successor, King Narendradeva, is remembered also in Tibetan history, for he married one of his daughters to the Tibetan emperor Songtsen Gampo, the scourge of central Asia.

By the ninth century the Licchavi state had begun to disintegrate from within, and the decay of strong centralized authority led into an era known as the Transitional period. Stone inscriptions are few, and the chronicles do not give a clear picture of this period. It was the time of the Buddhist cultural swell, when Patan became a university city, and it was a period of fertile artistic creativity. So evidently there was some continued stability in urban society, and wealth certainly remained in the valley. Feudal lords and the monasteries had probably appropriated political power, and although the chronicles record a disjointed succession of so-called Thakuri kings, this may have been an ideal period of decentralized political power. In the twelfth century the valley came under repeated invasion from the powerful Khas Malla kingdoms in the west, and this undoubtedly destabilized the valley and perhaps explains the absence of Licchavi and Transitional buildings in the valley today. It also set the stage for the rise of a strong dynasty of kings—the Mallas.

Malla kings ruled the valley from the twelfth to the eighteenth century. Their rule began less as a dynasty and more as a succession of powerful princes ruling from Bhaktapur. The Bhaktapur court of this early Malla period was marked by benign influence from Mithila, a Hindu state in northern Bihar, which ended only with the succession of Sthiti Malla, one of the valley's most powerful and effectual kings (r. 1382–95), who ruled from Kathmandu. Sthiti Malla created a strong, unified state, but he is best remembered as the codifier of the Hindu

The residence of the deity Dakshina Kali

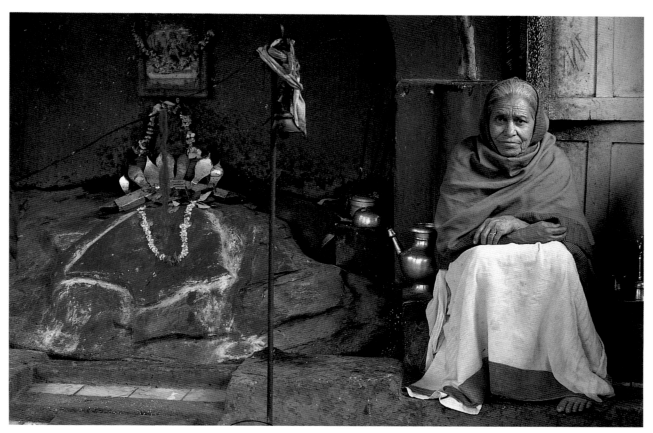

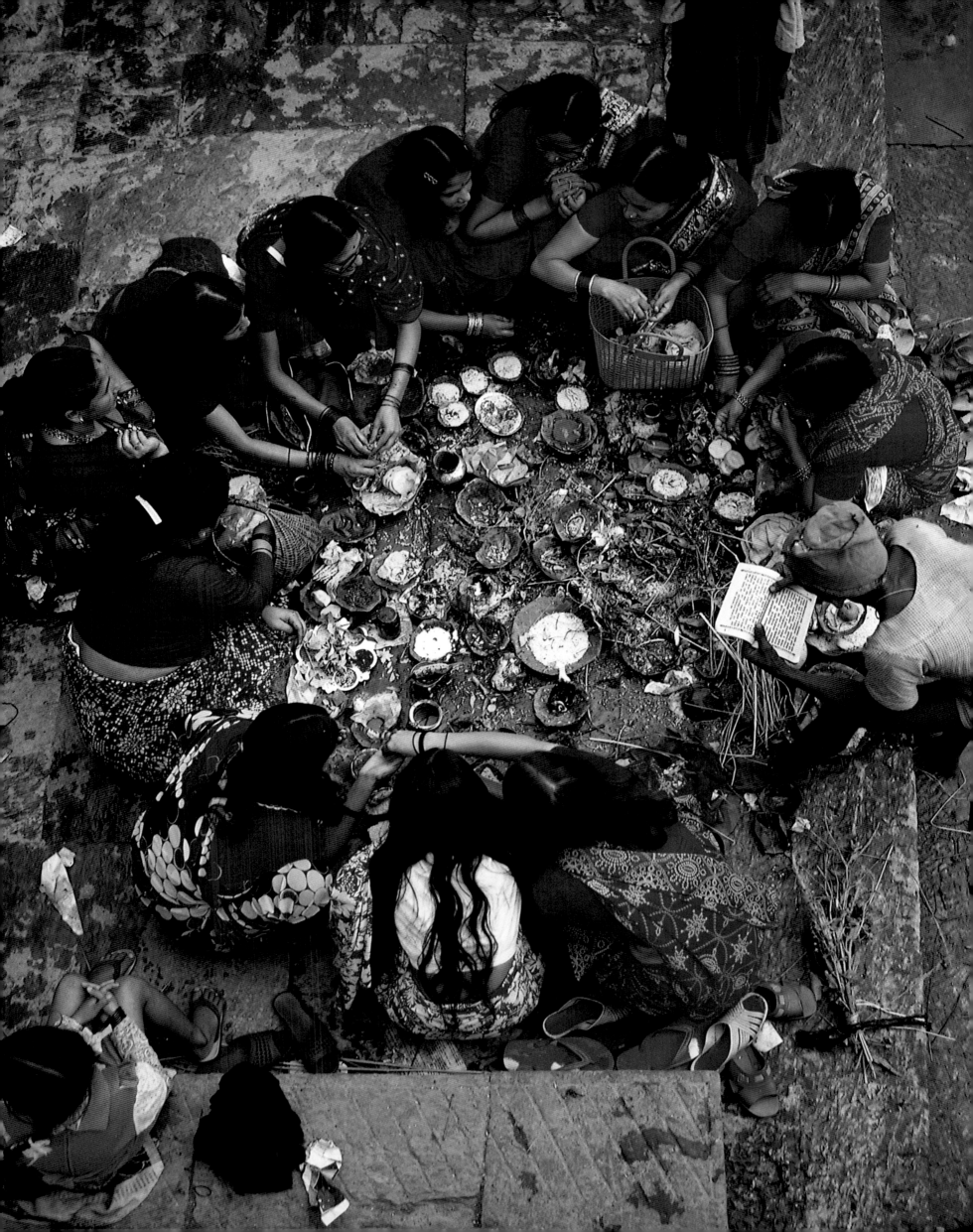

caste system. Even monks and yogis were forced into castes, bringing to an end the vigorous monasticism and dominant Buddhist culture of the Transitional period. In 1482, after the death of Sthiti Malla's grandson, Yaksha Malla, the valley was divided—some would say out of misplaced sentiment—between four of his sons, who then ruled from Kathmandu, Patan, Bhaktapur, and Banepa. After Bhaktapur and Banepa united, the political stage was set for three hundred years of dramatic political, military, and cultural rivalry between the three stable Malla kingdoms.

During the early Malla period, India was conquered by Muslim armies. Nepal Mandala was mercifully spared, except for a single devastating raid for plunder led from Muslim Mithila by Shamsuddin Ilyas in 1349. Thus Nepal Mandala, alone among Indian states, preserved medieval Hindu and Buddhist religious culture intact during the Muslim era. While influence from the south declined, Tibetan influence expanded. Trade prospered, and large Newar trading communities from

Hindu women at puja *after bathing in the Bagmati River, Pashupati*

Patan and Kathmandu were established in Lhasa. Patronage from Tibetan lamas became a significant factor in the restoration of Buddhist monuments in the valley. From the sixteenth century, however, the dominant outside influence emanated from the Hindu hill states to the west. Particularly, the kingdom of Gorkha, which tradition asserts had been established by Hindu refugees fleeing the Muslim invasion of Rajasthan, increasingly played a role in valley affairs. The military ambition of the warrior kings of Gorkha set the stage for the next act in the valley's political drama.

In 1768, while the Kathmandu Valley was in the throes of its principal religious festival, Dasain, the Gorkhali king Prithvi Narayan Shah, after years of harassment, invaded Kathmandu with a hardened army of hill men and deposed the last Malla raja. The kingdom of Patan, and then Bhaktapur, could offer no defense and were soon incorporated into the Gorkha kingdom. Prithvi Narayan Shah (1722–75) was a highly competent military commander, an astute politician, and a shrewd leader of men, and he established a dynasty that still rules the valley. He began the conquest of the Himalayan hills, which his successors continued until Kathmandu was the capital of an empire that at its largest extent stretched from the borders of Kashmir to Bhutan.

Temple roof strut, Vishvanath Madir, Patan

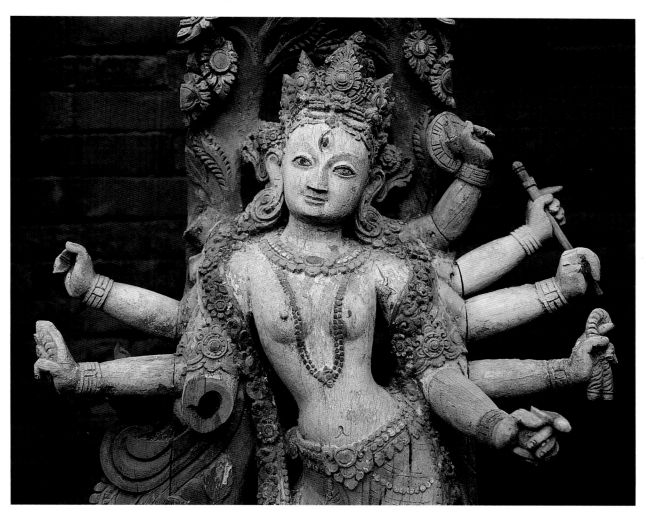

5

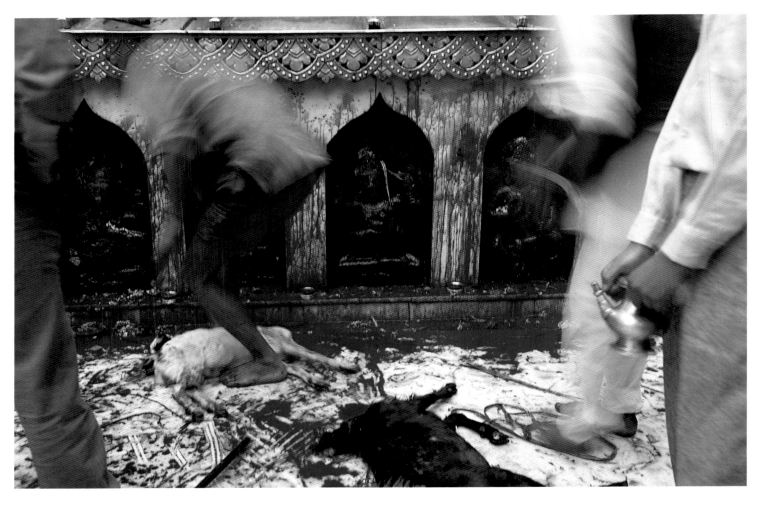

Blood sacrifice of goats, Dakshina Kali

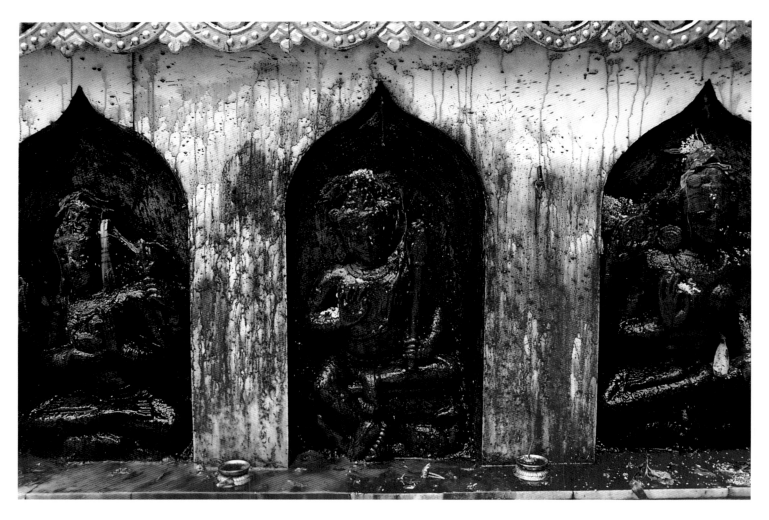

Images of the Mother Goddesses at Dakshina Kali

The Shahs were not destined to wield effective power over their empire, however, for they were dispossessed by their prime ministers, the Ranas, in the nineteenth century and became virtual prisoners in their neocolonial palaces. The Ranas' claim to the country's gratitude lies in their signal success in maintaining Nepal's independence while under threat from the expansionist British Raj. After Indian independence that threat vanished, and a revolution in 1949 led by King Tribhuvan reestablished the Shah dynasty, which eventually reshaped the Hindu kingdom in the form of a democracy.

nomena, the spirits of trees and earth spirits resident in rocks. This stratum of religious consciousness is still present today. The naga serpents rule the rivers and the rain and are held responsible for all water-borne diseases. The nagas are also protectors of the earth, the valuable minerals it holds, and the underworld beneath. The bodhi, or pipal, tree is considered sacred, and spirits and gods reside in rocks. This ancient animism forms part of folk religion—shamanism—and the shamans *(jhankris)* are healers and exorcists.

In prehistory, before the Hindu sages and Brahmins penetrated the jungles to reach the valley from the south, matriar-

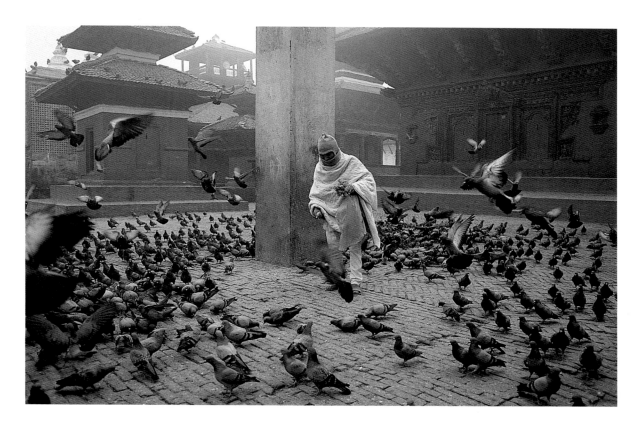

Hunaman Dhoka, Kathmandu

The Religious Tableau

The tapestry of Kathmandu Valley religion is woven from five principal strands. The first is animistic worship of the spirits. The second, the most basic and most abiding, is worship of the Mother Goddesses and Devi. The third is worship of the great god Shiva. The fourth is worship of Vishnu. The fifth is Buddhism. The plain background colors of this picture are provided by orthodox Hinduism and Buddhism; the vivid and vibrant hues that dominate belong to Tantra.

When the valley was a jungle crossed by its rivers through marsh and swamp, with clearings for agriculture on higher ground, the people worshiped the elemental spirits of water and fire, the sun and the moon. They worshiped natural phe-

chy must have dominated society. Fear of the irrational creative and destructive forces of both nature and the psyche resulted in the worship of mother goddesses—*mais* (mothers) and *ajimas* (grandmothers). Later, both Buddhism and Hinduism assimilated the indigenous mother goddesses as protectresses. Although they were given Sanskrit names and made the consorts of the brahminical gods, they retained their essential bloodthirsty nature and their covens of witches practicing black magic. The female principle in its positive aspect was identified as Devi or Durga, the all-conquering goddess and the consort of the great god Shiva. This goddess, representing the primordial collective anima of the valley, was also personified in her three sexual aspects: virginal prepubescent purity (Kumari); fecund, sexual maturity and maternal liberal-

ity (Lakshmi); and seasoned detachment of the crone (Mahakali). The Tantric *shakta* cult conceived the great goddess as the nondual matrix of the universe.

At the center of the religious vision of the Hindus who Indianized or Sanskritized religion in the Kathmandu Valley, even before the Licchavi conquerors arrived, was the great god Shiva. Shiva Mahadeva assimilated the indigenous godlings and became the predominant presiding spiritual power in the valley. His principal form was Pashupati, Lord of Animals, and he still resides in his phallic form *(lingam)* at the power place and national shrine of Pashupati. Shiva Mahadeva is Lord of Cosmic Creation and Dissolution, Savior of Mankind, and Master of the Yogis. To orthodox Hindus he is a celibate renunciate, a yogi and a sadhu; but in Tantric practice he unites with his consort Parvati, or Durga, and he is attended by his sons, Kumara, the god of war, and Ganesha, the elephant-headed god, who is the Lord of Beginnings.

The importance of Vishnu, or, as he is better known in the valley, Narayana, is his association with kingship. He is the royal god, and the kings are considered his incarnations. The Licchavis imported him into the valley and established him at his principal power place of Changu Narayana. Narayana is the Preserver and the God of Cosmic Order and the State, and as such he has little appeal to the valley people. But he is also the Cosmic Hero who emanates incarnations *(avataras)* into the world of man to save him from evil and to protect him. Narayana's incarnation, Lord Krishna, is one of the most popular gods in the valley and is a principal focus of householder devotion.

The fifth strand of valley religion is Buddhism, which can be considered the supreme flowering of Hindu religious genius. The Buddha came to the Kathmandu Valley only in legend, but his legacy is evident everywhere. Besides his essential teaching of the Four Noble Truths, Shakyamuni Buddha taught mankind how to honor the gods and avoid enslavement to them. This was a message that the Newar people took to heart in the late Licchavi period, and their response was enthusiastic and lasting. Today the city of Patan contains more than 160 monasteries *(bahals* and *bahis)*, and Kathmandu almost as many. The monasteries began as havens for celibate monks, but with the development of Tantric Buddhism they evolved into communes of married yogis and yoginis. The monastery temples enshrine Shakyamuni Buddha and a secret Tantric deity *(agamdya)*, who is the principal focus of esoteric worship. But the main popular Buddhist deity is Avalokiteshvara, known locally as Karunamaya, the Bodhisattva of Compassion, who is also a principal protector of the valley and the focus of the greatest Kathmandu and Patan chariot festivals.

The growth of Hinduism during the Malla period, first influenced by Mithila and then by the Gorkhalis, who gave government jobs only to Hindus, led to the eclipse of Newar Buddhism, so much so that it is fashionable now to say that Newar Buddhism is decadent. It is true that after Sthiti Malla forced the vajracharya priests and shakya monks into the strait-jacket of the caste system, Buddhism became a closed, exclusive order. Initiation was transmitted through patrilinear succession. It is true that contemporary Newar Buddhism is highly

Stone guardians at Indreshwar, Panauti

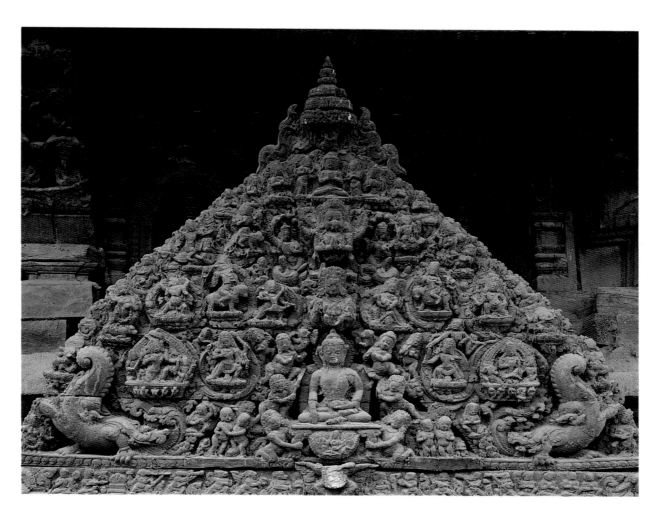

Mara's assault on the Buddha, 17th century, Itum Bahal, Kathmandu

ritualistic; that in comparison with Tibetan Buddhism, which now flourishes in the valley, it lacks creative vitality; and that the buddhas and bodhisattvas are worshiped as gods by the common people. But Buddhism still remains a powerful undercurrent of valley spirituality and an unchanged model of medieval Indian Buddhism.

In the minds of most Newars, Buddhism and Hinduism create only shades of distinction in this religious tableau. From the viewpoint of rigid brahmin orthodoxy, the Buddhists are heretics who deny the caste system, and Tibetan lamas may dwell upon the iniquity of blood sacrifice and the basic fallacy of the atman principle in Hinduism. But in actual religious practice, there is immense tolerance under the undiscriminating umbrella of Tantra. Within a single Newar family both Buddhist and Hindu gods are sometimes worshiped: the family may belong to a Buddhist caste governed by the Buddhist rites of passage, but the family deity may have a Hindu name, and members of the family may worship daily at other Hindu shrines of their personal preference. At festival time all the inhabitants of each city are united in worship of their major deities, who may have both Buddhist and Hindu identities. The Macchendranath festival, for instance, celebrates the bodhisattva Karunamaya. The same noumenal entities are worshiped by different religious communities under different names: even the most sacred Shiva lingam, Pashupatinath, is perceived by the vajracharyas, the Buddhist Tantric priests, as the Buddha himself.

The Tantric Element

Most worship in the Kathmandu Valley, Buddhist and Hindu, is Tantric ritual, and the popular Western notion of Tantra as sexual yoga is manifestly absurd to the average devotee. His Tantric reality is the yoga of ritual worship. Propitious time and auspicious place, a well-omened environment, ritual purity, the sanctity of the tangible artifacts of the ritual, and care in ritual procedure are the essential ingredients for success in this worship. Time is determined by season, phase of the moon, and astrological computation. The place must be geomantically sound—a power place. A good environment is free of negative omens and inauspicious signs. Ritual purity is achieved by bathing, wearing clean and appropriate clothes, abstaining from intoxicants, and avoiding the opposite sex or individuals with negative auras. The ritual artifacts may be, for instance, the "diamond thunderbolt" *(vajra)* and handbell *(ghanta)*, a skull bowl *(kapala)*, offering bowls, or ladles. Liturgical manuals provide details of the ritual procedure, which is also regulated by an oral tradition. Such rituals—offering rites to the gods

being the most usual—are the daily activity of Tantric priests, either Buddhist vajracharyas or Hindu brahmins and karmacharyas. In these Tantric rites the Hindus offer blood sacrifice to those gods and goddesses whose propitiation require it, and the Buddhists offer symbolic flesh and blood as in the Christian sacrament.

But for those seeking it, the temples and shrines are replete with symbols of the basic Tantric premise that the union of male and female principles is the source of cosmic manifestation and that sexual desire is the fundamental energy from which the highest spiritual achievement can be attained. The flags on either side of temple doors emblazoned with the sun and the moon herald the Tantric ethos of the temple. Erotically carved roof struts on many temples, particularly those of the mother goddesses, evoke the sexual desire that is to be sublimated in worship. The residence of Shiva is a symbolic phallus (lingam) standing in a symbolic vulva (yoni). Buddhist images and painted scrolls (paubhas) depict mother and father Buddha deities in sexual union. Like the sun and moon, the vajracharya's ritual instruments, vajra and ghanta, are symbols of male and female principles. These symbols, however, belong to the secret, esoteric stratum of Tantra, which is revealed only to the yogi-initiate practicing the meditation and ritual procedures described in the Tantras, which are the scriptures pertaining to the highest level of mystical experience. Yogis practicing the sexual yoga of the Buddhist *Chanda-maharoshana Tantra*, or the Shiva-Shakti *Kulanava Tantra*, are ostensibly few and far between at the end of the twentieth century.

Historically, Tantra was a religious movement seeking to include both sexes, all castes and tribes, and all heterodox beliefs and religious practices into an overarching scheme of Buddhist or Hindu vision. Particularly, the unorthodox rites of mother goddess worship were assimilated into the great traditions, and the mother goddess's power places became the focus of warlocks and especially witches (bakshis), practicing lower Tantric sympathetic magic to expedite their mundane and frequently grisly aims. The cremation grounds are associated with a presiding mother goddess and are the haunts of all types of Tantric practitioner, whether on the quest for the awareness that transcends both life and death, or seeking to harness mundane, manipulative powers.

The Power Places

In the greater Indian context, the entire Kathmandu Valley is a power place. Included among the twenty-four most sacred

Hindu women's Teej bath, Teku, Kathmandu

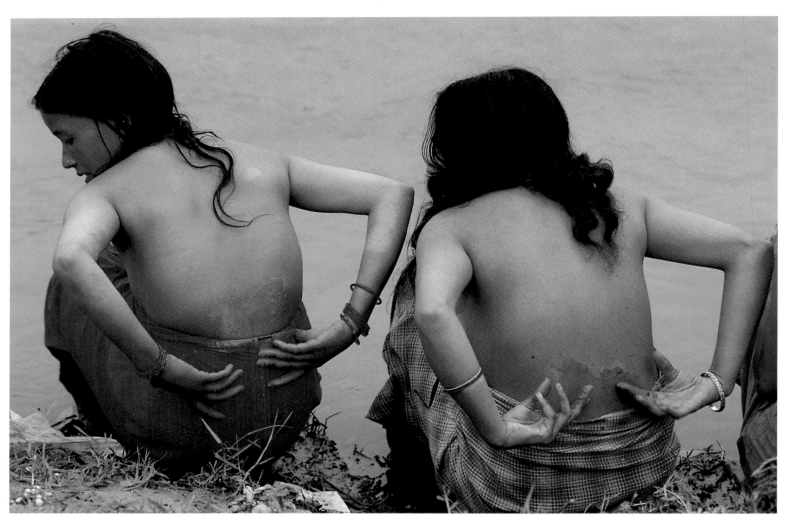

The shrine of Pulchoki Mai, Pulchoki Hill

places of pilgrimage in the subcontinent for devotees of Shiva, Devi, and Tantric Buddhism, the valley has always been a major destination of pilgrims from India, the Himalayas, and Tibet. It has the geomantic qualities of sacred geography, it is sanctified by the divine presence of the deities and myth, and it has been hallowed by the gathering of the sages and yogis of legend. Its form as a natural mandala with a circular rim is its dominating geomantic feature. Its previous inaccessibility, lying hidden under the snow peaks in a fold of the Himalayan hills, together with its spectacular beauty, adds to its geomantic significance. As a playground of the gods it is replete with myths describing their nature and relating them to specific locations in the mandala. In legend, Nepal Mandala was the hermitage of contemplative ascetics *(rishis)* such as Vyasa, the writer of the Vedas; Buddha Shakyamuni, who taught here; Padmasambhava, who took Buddhism to Tibet and achieved his enlightenment here; and the mahasiddha Gorakhnath, who meditated here for twelve years in samadhi.

Within this mandala, the mountain peaks of the rim, the isolated hills within the valley, the river confluences and gorges, and the caves on the valley sides provide the most potent geomantic sites and are the preferred abodes of the principal gods of the valley. For Newar Buddhists, the shrine on top of the wooded, pyramidal hill of Svayambhu, overlooking Kathmandu, is preeminent, while for Tibetan Buddhists, Boudhanath is supreme. For the Hindus, the residence of the great god Shiva at Pashupati, where the Bagmati River leaves

a gorge, is most exalted. Narayana's principal power place stands on the hilltop of Changu Narayana, to the east of the valley. The power places of the Mother Goddesses are most frequently located at the confluences of rivers, places made the more sacred by the cremation grounds located there. The most fearful of the valley's goddesses, the bloodthirsty Dakshina Kali, lives in a secluded spot where two streams meet in a forested gorge. Sacred groves and forests, some located on hills, are also abodes of the goddess. The naga water spirits have their major residences *(tirthas)* at river confluences.

At the major power places of the valley, geomantic significance combines with divine myth and human legend to create a powerful magnetic vibration. The minor power places, which are legion, are marked by one or more of these three elements: geomantic, mythic, and legendary. Hundreds of temples and thousands of shrines are found in the streets, squares, and alleyways of the towns and villages and in the fields, forests, and jungles, and all possess characteristics that make them the focus of worship. The Buddhist monasteries, for instance, originally located more for convenience than geomancy, are hallowed by the presence of the Buddha and impregnated by the meditative vibration of generations of monks. Some temples and stupas, located at the entrances to towns and villages, are sited according to their guardian function. Some acquired their mythic significance when originally a seer had a vision of a god or goddess at a particular spot and a boulder nearby was identified as the seat of that deity. The

11

country residences *(pithas)* and townhouses *(dyache)* of the mother goddesses are mythically empowered by the presence of the goddess who moves between them. The gods of many shrines that are the prerogatives of particular families *(kuladya)* take their power from the sense of the family lineage's unbroken connection with a god at a particular spot.

The majority of the actual abodes of the gods and goddesses are unhewn rocks *(dhunga)*. Boulders were the residences of local gods and earth spirits in ancient animistic times and became the palaces of their noumenal successors. Each god or goddess has his or her rock residence—they are not shared abodes. When the deity is in residence there is no distinction between the rock and the god. Where the stone suggests the shape of a deity—the elephant-headed Ganesha or Shiva's lingam, for example—it is sometimes called a *svayambhu,* or naturally arisen, deity. The practice of erecting an image as the residence of the god arrived in the valley with high Hindu culture. Stone was sculpted in the form of the god—symbolic or anthropomorphic—according to the canon of sacred art, and then consecrated. Thereafter, the distinction in the minds of worshipers between the image and the god's reality vanished. While some of the residences of the Mother Goddesses and Shiva, for instance, are unadorned open-air shrines, most are backed by stone arches *(toranas),* covered by open or walled shrines, or covered by temples open on at least three sides.

Most of the major power places of the valley are covered by freestanding pagoda temples *(mandirs)*. The temple is best viewed as a three-dimensional mandala. It leads the devotee through three initiatory stages, sometimes marked by three successive walls, into the *sanctum sanctorum* in the middle of the inner chamber. Particularly in Buddhist temples, the three stories of the pagoda may represent three levels of awareness. A wooden tympanum *(torana),* depicting the images of the gods of the temple mandala in wood or copper, usually surmounts the entrance of the temple. The elements of the temple architecture and the artifacts within are all charged with symbolic significance to support worship.

Only a few Buddhist shrines are covered by free-standing temples, among them the Karunamaya and Macchendranath shrines. In the monasteries, temples enshrining images of the Buddha are built into the south sides of the buildings surrounding the courtyard. The secret, Tantric shrine room *(agamche)* is usually on the second floor. But the major Buddhist power places are not monasteries; they are stupas. The stupa is a three-dimensional mandalic monument representing the Buddha. It is built to be worshiped by circumambulation at geomantically significant places, but it may also mark a spot

Svayambhu Stupa

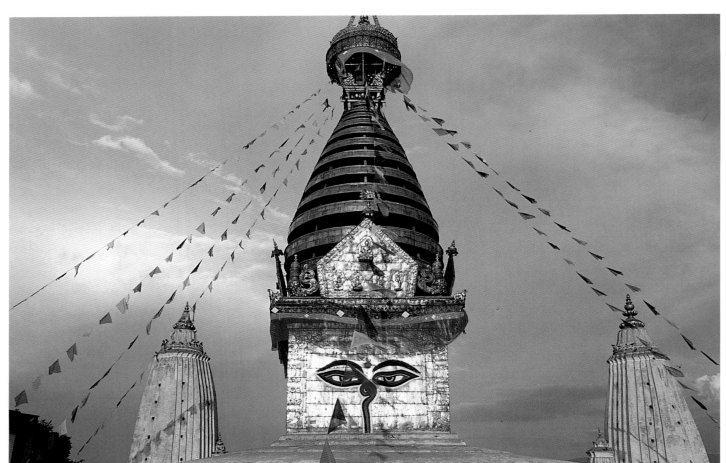

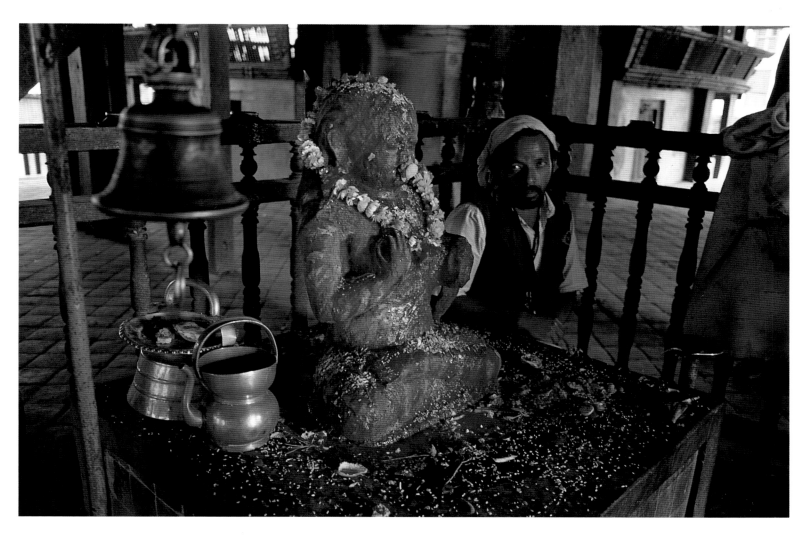

Stone image of Gorakhnath, Kasthamadapa, Kathmandu

where a mythic event occurred. The two principal Buddhist power places in the valley—Svayambhunath and Boudhanath—are of this nature, but there are also innumerable smaller stupas (called *chaityas*) located in town and village squares, in monasteries, and near temples, that are more often votary monuments to honor the dead.

All these sites, major and minor, are called power places because they give special access to the palaces of the gods and to the divine circle of which they are part. They are the gates of the mandala circle of the gods, providing an avenue to the sources of divine energy and awareness. Like holes in the enveloping fabric of material existence, they open up a space in which we may connect with our spiritual essence and with the psychic source of our collective consciousness and archetypal experience.

The Art of the Kathmandu Valley

Newar artists and artisans of the Kathmandu Valley created some of the most brilliant works of art in stone and bronze ever produced in the Indian subcontinent. Many of these masterpieces of Newar art are to be found at the valley's power places. Newar fine art, as in medieval Europe, is primarily an expression of religious consciousness, a manifestation of the divine in humankind. As such, it is itself an object of worship and thus is functional rather than decorative. Since the artist's aim is to create an object according to an ideal aesthetic canon, individual imagination is restricted to peripheral decoration, and nearly all religious art is executed anonymously.

Whereas an artist's eye is caught by an object proficiently executed, the devotee is attracted by an object's sanctity. An unhewn rock or a hastily executed work of the Shah period may therefore appear more valuable to valley devotees than a product of the high Licchavi period at its most technically proficient. This lack of appreciation has led to the loss of many of the artistic treasures of the valley. Taken from family or monastery shrines, or, more devastatingly, stolen from open-air power places, they find their way onto the international art market. Many of the Newar masterpieces in bronze, stone, and paint are now in foreign collections.

While human beings are the worst foes of the valley as a treasure house of sculpture and painting, the Mother Goddesses' wrath, made manifest as earthquake, fire, or flood, is the principal enemy of architecture. The great pagoda temples, of three or even five roofs, with their ornate wood carving, are all Malla period constructions, the earliest belonging perhaps to the

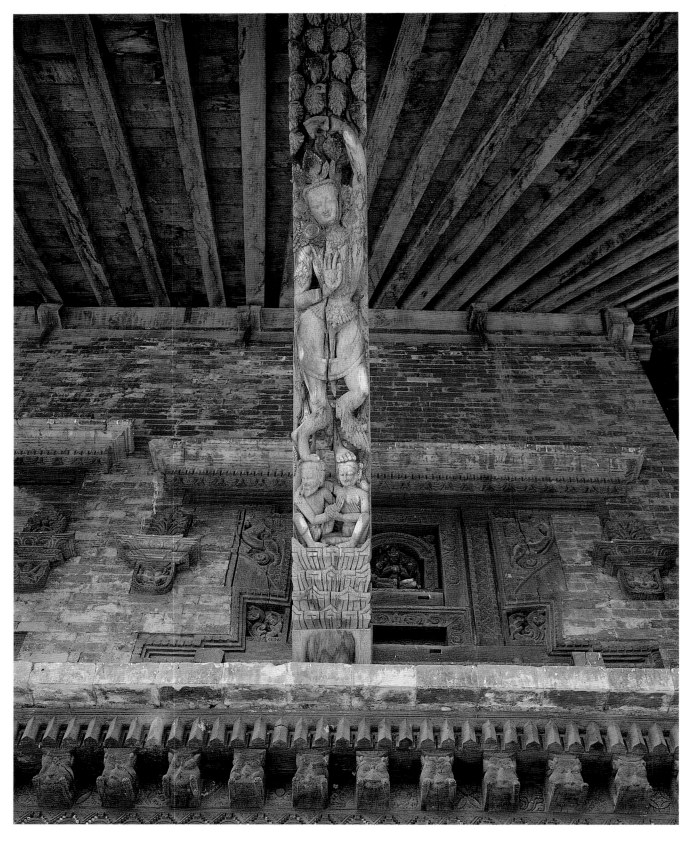

Indreshwar Mahadev, 12th century woodwork, Panauti

eleventh century. This design is said to have been taken to China in the thirteenth century. Many of the pagoda temples have been rebuilt and restored repeatedly over the centuries, after natural disasters have brought them down, but their essential form has remained unchanged. The carving of wooden roof struts provides the best evidence of the Newars' mastery of this medium, still to be seen at Oku Bahal in Patan and at

Indreshvara in Panauti. The monasteries, royal palaces, and large and small pilgrim rest houses *(mandapa, sattal,* and *pati),* all constructed during the Malla period, complete the legacy of the Newar architects in brick and wood. The plastered brick temple structures first appeared only in the late Malla period.

The valley's oldest art objects are made of stone. Images of mother goddesses were sculpted in the Indian Kushan style

14

in the second and third centuries C.E. Later Gupta influence characterizes the wonderful stone masterpieces of the Licchavi era, some still lying in the courtyard at Changu Narayana and providing a continental concept of space and a cosmic concept of divinity. The size of the Licchavi images, the ambition of their themes, and the grace and power of their execution place their work among Asia's most magnificent artistic achievements. The fertile Transitional period continued the excellence of the Newar tradition, concentrating more on Buddhist themes, but the later stone sculpture of the Malla period only rarely sustains the excellence of craftsmanship and reflects less of the divine and more

of the human sensibility of cloistered valley consciousness. The popular Uma-Maheshvara reliefs, depicting Shiva and his consort in their conjugal Kailash elysium, illustrate this essentially valley style. The Malla period was the most prolific in stone sculpture, and most of the pieces now found at the center of temple worship and around the shrines of the power places were created during this period.

Some critics consider the bronze casting done in the lostwax *(cire perdue)* method from the Licchavi period until today—particularly in Patan—to be the height of Newar artistic achievement. Bronze casting generally followed the same

Statue at Vishvanath Temple

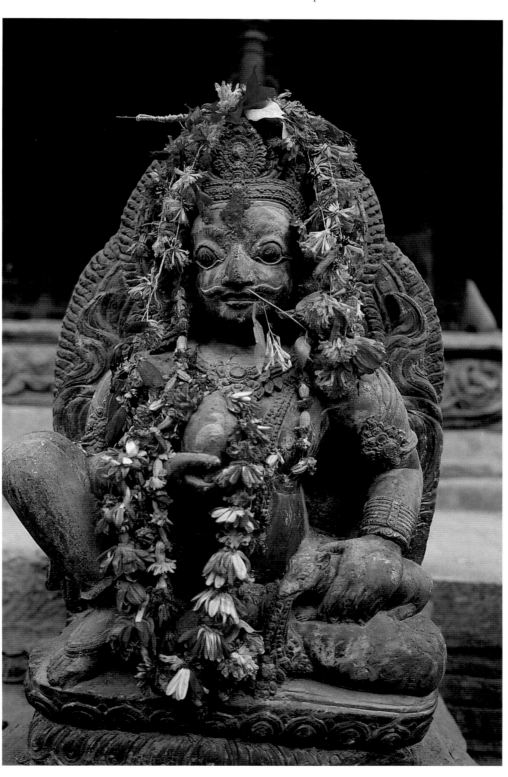

15

stylistic development as did stone sculpture: from Gupta-influenced Licchavi work to the indigenous doll-like style of the Malla period. Large early masterpieces, all Buddhist, can be seen at Sankhu Vajra Yogini and in Kwa Bahal in Patan, for example, and fine Malla Buddhas can be found peering from within the shrines of the monumental stupas. But little bronze work is evident to the contemporary pilgrim to the power places. Rather, the immensely fascinating work in gilded copper repoussé is more likely to strike the eye. Repoussé copper frequently covers the toranas surmounting the temple doors, or sheathes the wooden motifs of the door frames.

Although the Kathmandu Valley as the playground of the gods is still the potent vision of traditional devotees and pilgrims, the latter part of the twentieth century is seeing radical change. For three thousand years the culture of the valley remained in virtual isolation. To the south it was secluded by malarial jungles and hills, and to the north by the high Himalayas. Sandwiched between two cultural giants, India and Tibet, slowly it absorbed elements of both while retaining its own special individuality. In the last twenty-five years it has been catapulted out of medievalism into the international arena of tourism and development. It would be difficult to find another culture on the face of the planet that has been subjected to such a forced pace of accelerating change as that of the Kathmandu Valley.

Today the snow peaks, the abodes of the gods, are climbed and conquered rather than circumambulated and worshiped. Rapacious imported materialism and consumerism have laid a pall of smog across the valley itself. There is an increasing tendency for devotees to invest in electronics rather than offer gold to the temples and monasteries. The temples, monuments, and shrines that mark the residences of the gods and that once dominated the landscape are now squeezed into smaller confines as the demand upon land increases. To some extent this book reflects nostalgia for a vanishing culture, but it is also a plea for sensitivity to what still remains and an appreciation of what can be preserved. Primarily, however, it is a celebration of the gods of the valley, the magic of sacred places, and the unique creativity of the people.

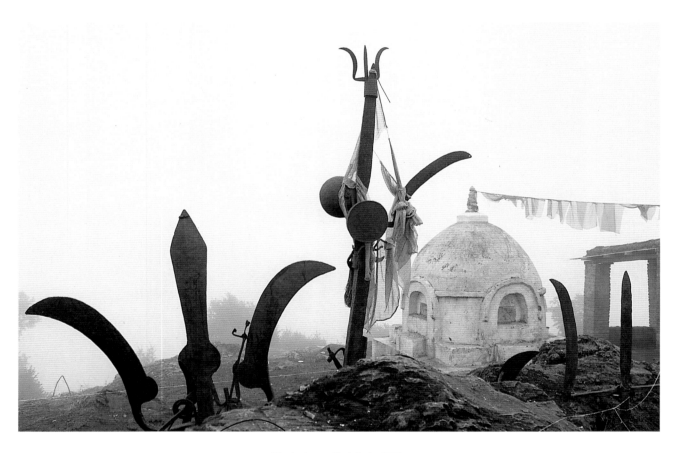

Trishuls on Pulchoki Hill

KATHMANDU

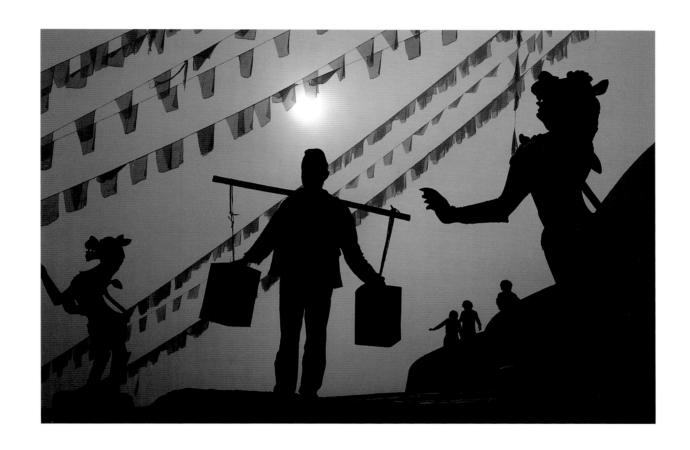

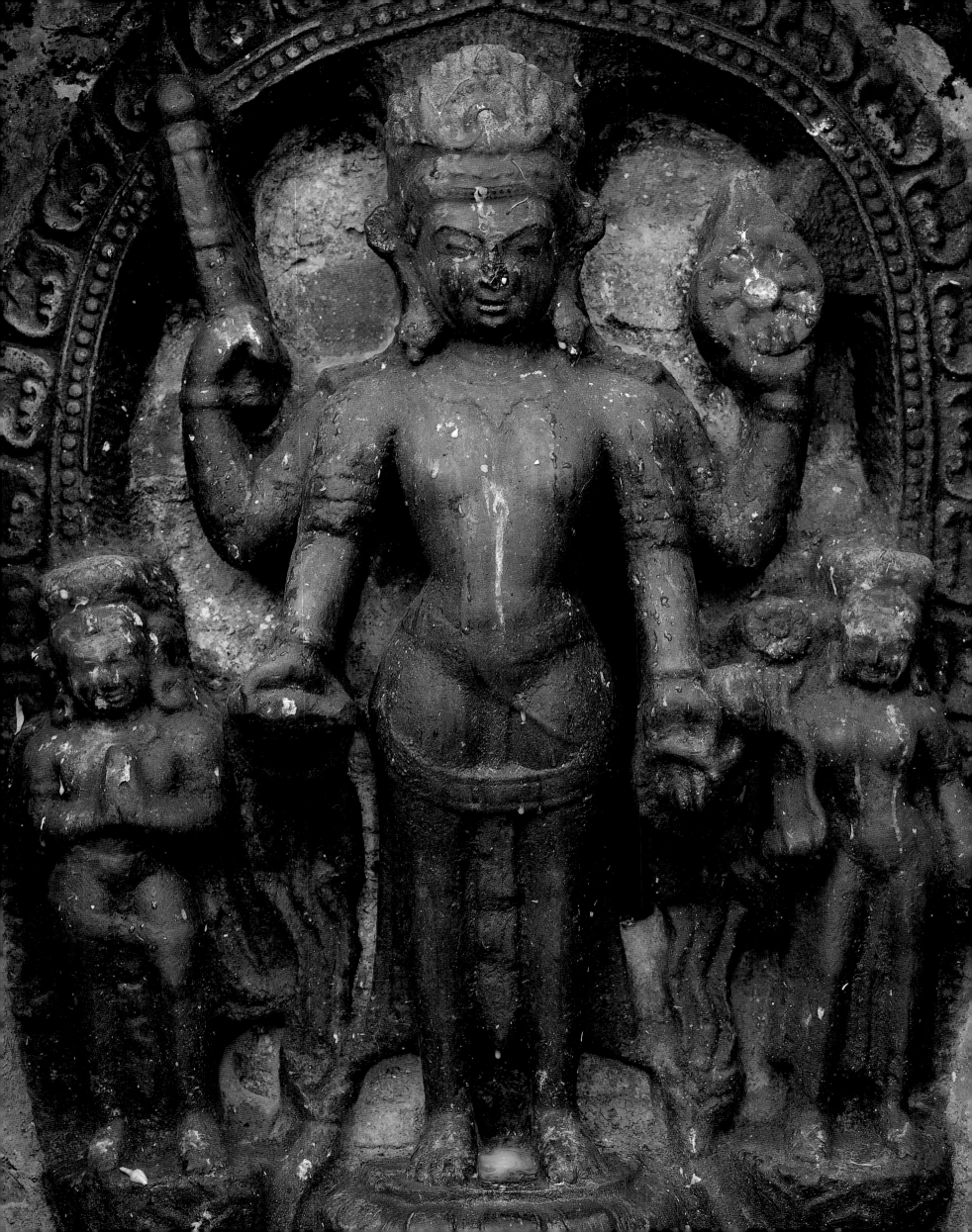

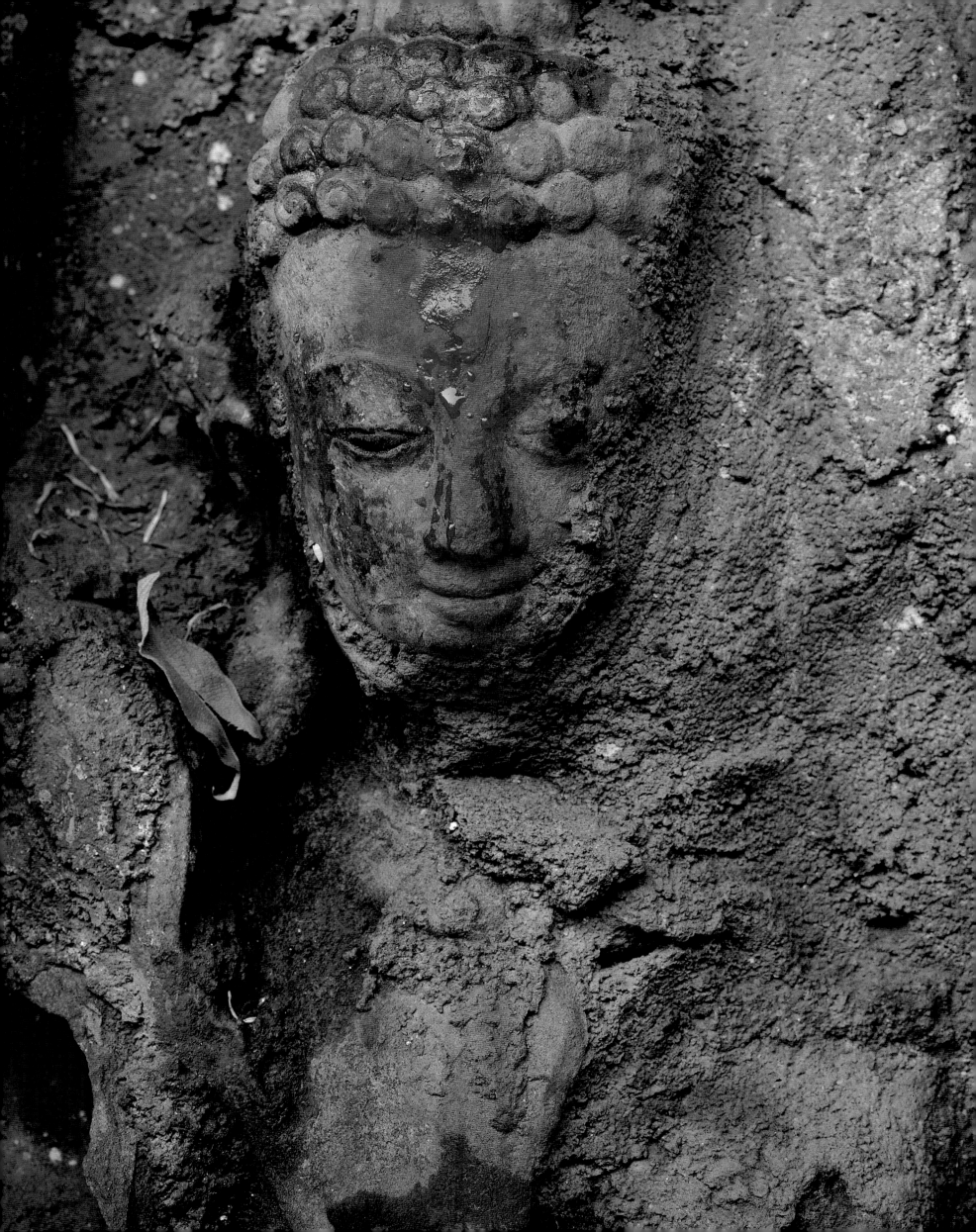

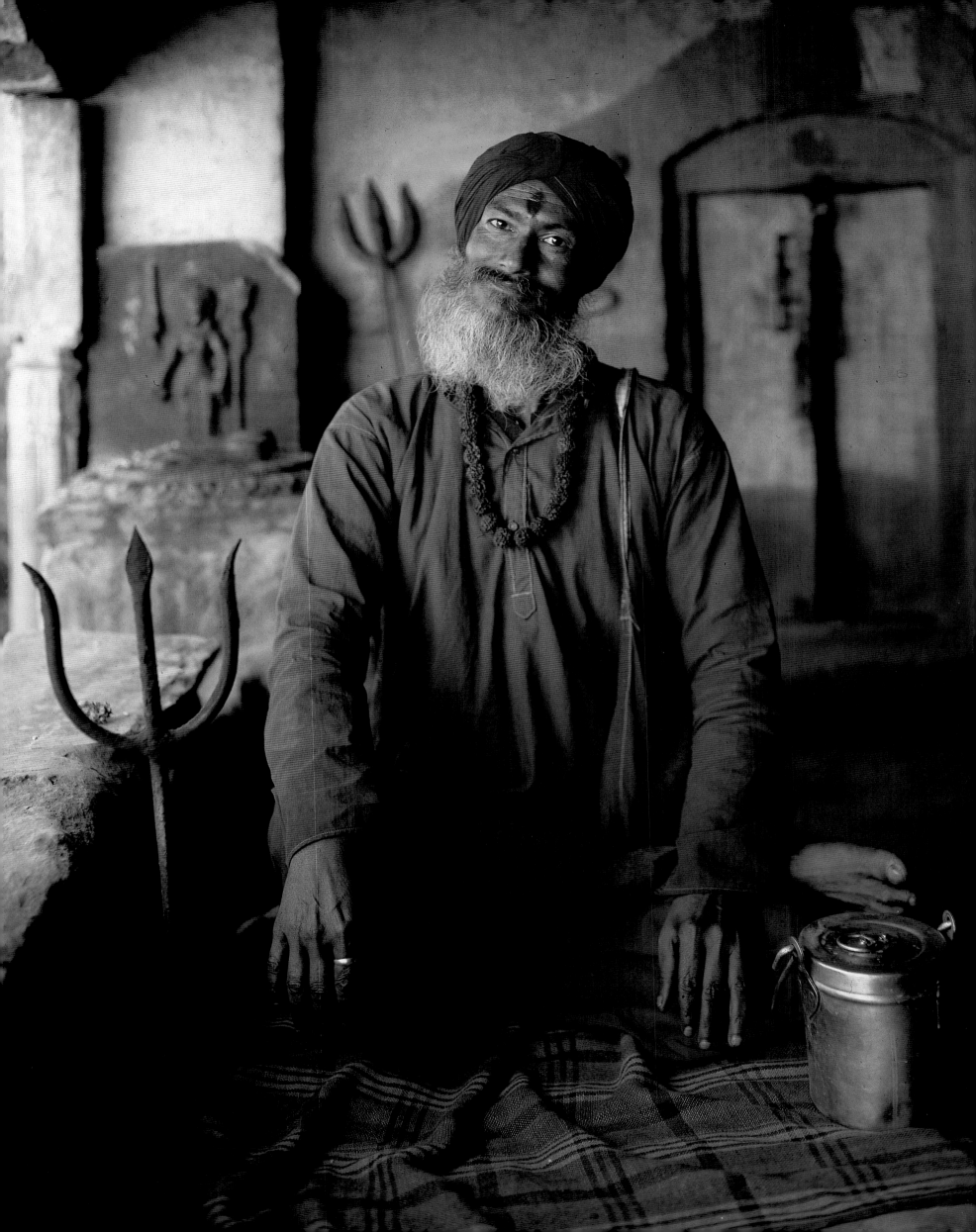

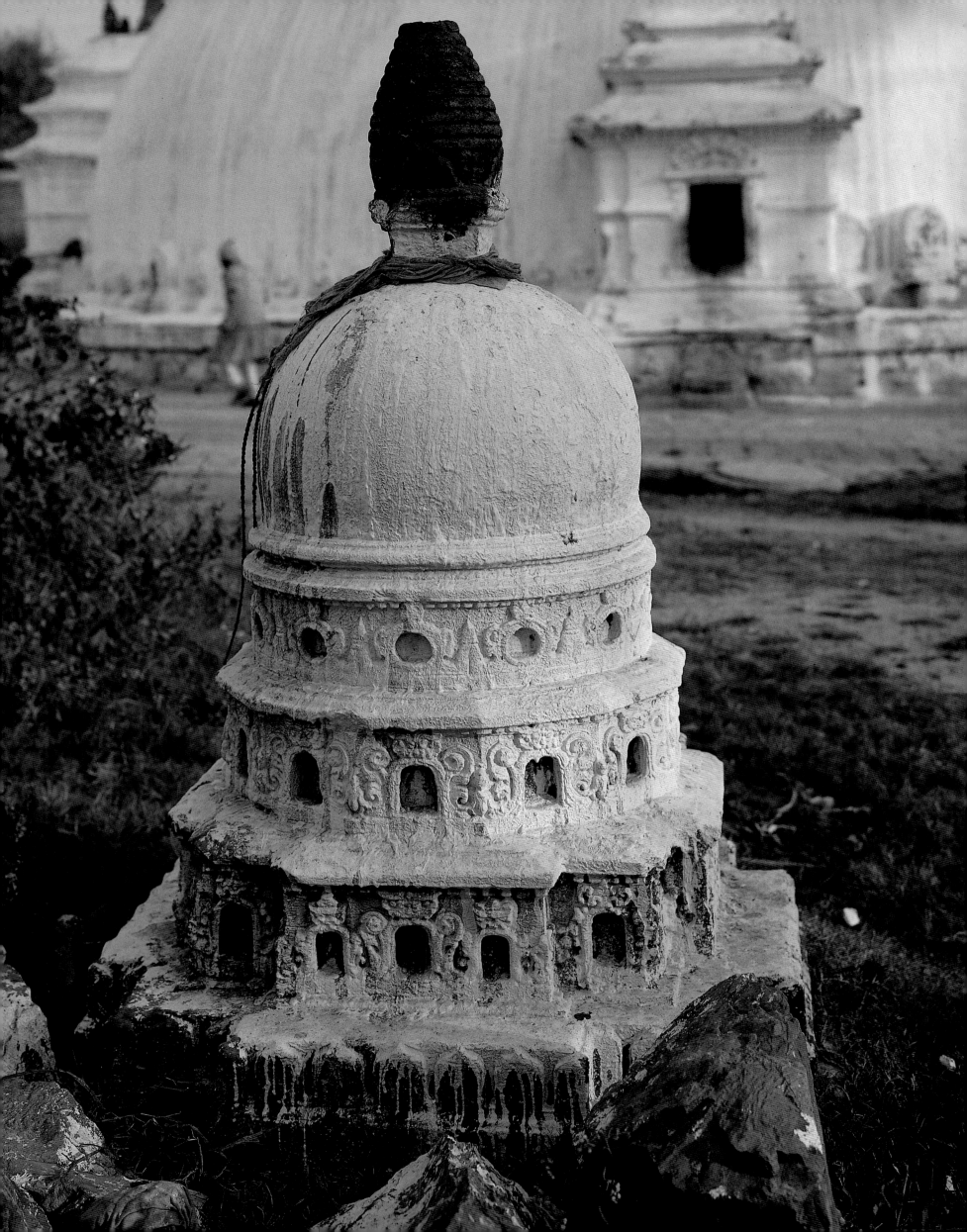

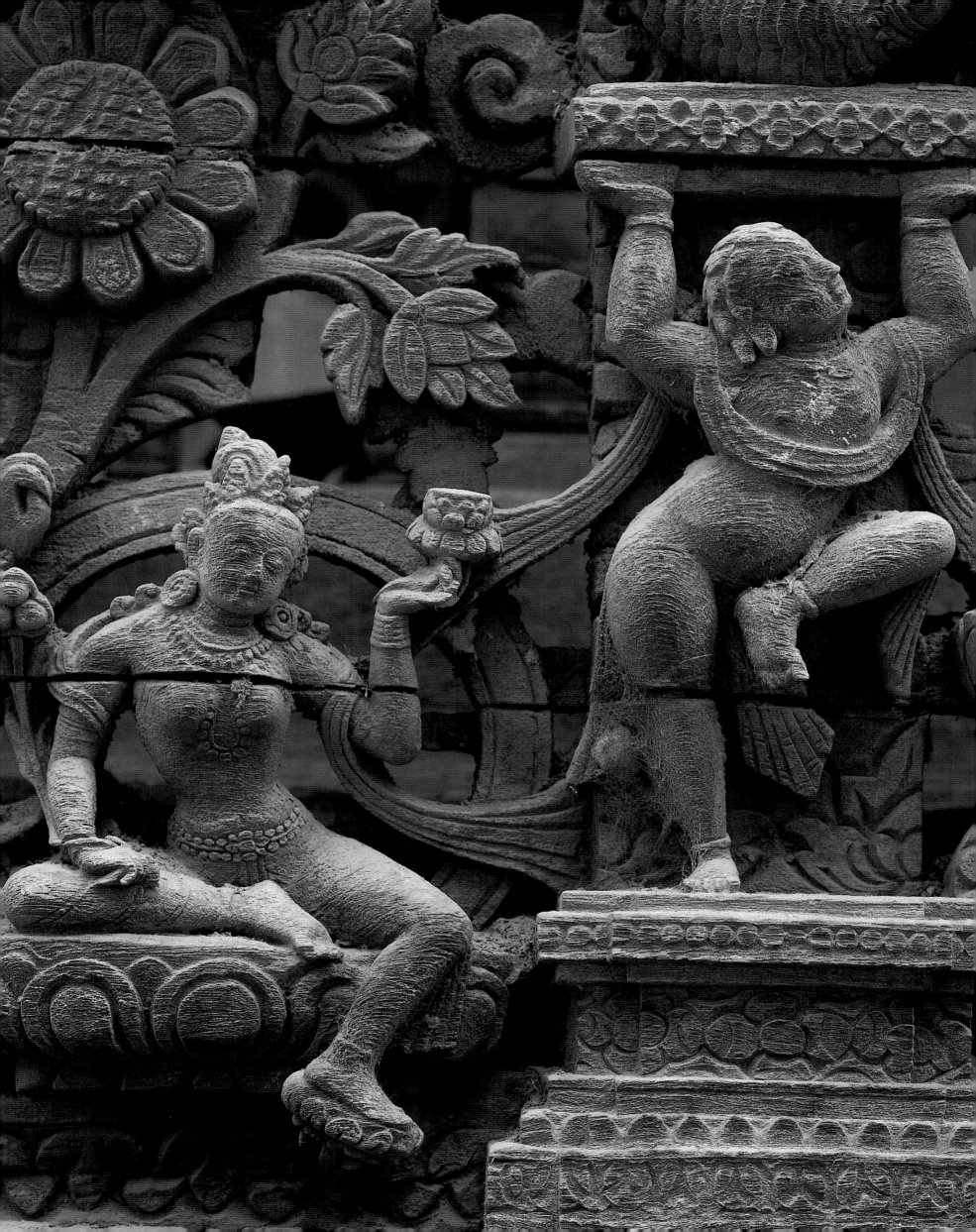

SVAYAMBHUNATH

Svayambhunath—the Great Stupa of Svayambhu—stands on a hill to the west of Kathmandu. Its name means "The Self-created, Self-existent Buddha." The myth of its origin is also the myth of the valley's origin. It tells the story of the primordial Buddha's enlightenment and of the spread of Buddhism in Nepal. This most sacred site has always been the most important power place for valley Buddhists and for pilgrims from all over the world. It is considered to be the most powerful shrine in the Himalayas.

Myth and Legend

Long before the dawn of history, the Kathmandu Valley was a vast lake. During the Eon of Truth, the Satya Yuga, eons before the Buddha Shakyamuni was born in Lumbini, his predecessor the Buddha Vipashyi came to Nepal to meditate at the hill that rose from the lake on its western shore. Wishing to give the rough mountain people an object of worship, Vipashyi threw a lotus seed into the lake. When this lotus bloomed, a light shone from the center of its thousand petals that illuminated the entire valley. This light was called the Svayambhu Dharmadhatu, the Self-sprung Infinite Field of Light, and the flame of the enlightened mind of the primal Buddha, Vajradhara, burned at its center. The light of Vajradhara also emanated in the colors of the rainbow and in each of the five colors appeared one of the Five Buddhas: Vairochana, Akshobhya, Ratnasambhava, Amitabha, and Amoghasiddhi.

In the far west of China, on Wutai Shan, the Five-Peaked Mountain, lived the great bodhisattva Manjushri, whose vow was to serve humankind through use of his deep intelligence. Manjushri in his wisdom foresaw that the Himalayan people would be greatly benefited if the Kathmandu Valley lake were drained to make the Svayambhu lotus and flame accessible to human worship, and that a great civilization would arise in the rich farmlands that would result. Then Manjushri flew through the air to Nagarkot Peak on the edge of the lake, and after having pondered in samadhi how best the lake might be drained, with his keen-edged sword of wisdom he cut a gorge through the mountain range that separated Nepal from India, and the original lake was drained. To finish the work of drainage he cut the Gokarna Gorge, the Pashupati Gorge, and the Chobar Gorge. After the lake had been drained and the valley bottom made suitable for cultivation, Manjushri founded a town, Manjupattan, and enthroned one of his devotees, Dharmankara, as king. He also taught the people the fundamentals of civics and craftsmanship and also the art of ritual, particularly the ten rites of passage.

Underlying the Kathmandu Valley is the cosmic ocean, the abode of the nagas, water spirits; in this elemental watery stratum the cosmic turtle lies motionless. In order to support the thousand-petaled lotus and its burden of flame after the lake was drained, a great timber, seven fathoms in circumference and forty-two fathoms in height, was set up on the back of the turtle. A high mound of earth and stone was then piled

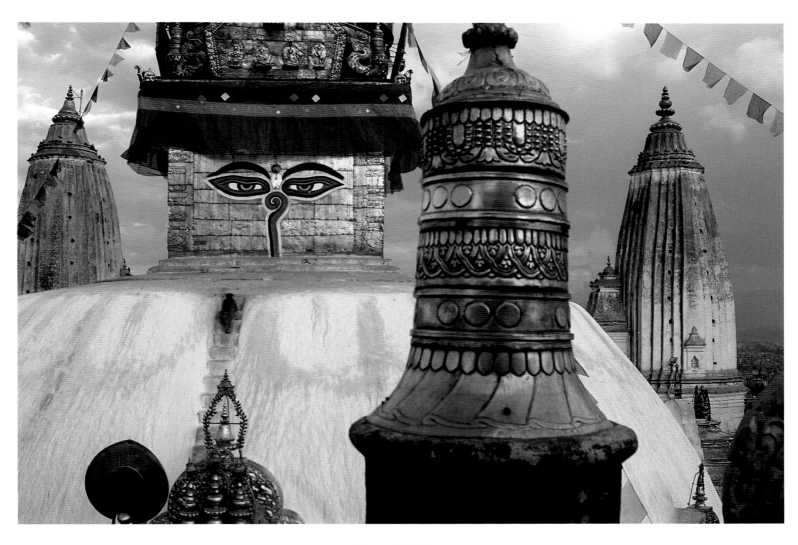

Svayambhu Stupa

around this axis by forty-two thousand arhats from Vulture Peak. Thus the primordial Svayambhu Stupa was erected.

The great timber axis of the stupa is also identified as the primordial Buddha Vajradhara himself. According to the Newar chronicles:

> On top of a jewel lotus, the blessing of the Buddha Vipashyi, the Victoriously Enlightened Vajradhara spontaneously arose from the Pureland of Akanishtha as a great sacred Tree of Life, the axis of the stupa.
>
> This self-sprung temple of wisdom confers spiritual liberation by sight of it, by touching it, by hearing of it, or by reflecting upon it. Thirteen billion times more religious merit is gained by worshiping the Svayambhu Dharmadhatu Stupa than by worship at other power places.

The History of the Stupa

Myth places the origins of Svayambhunath coeval with the beginning of valley civilization. The first mention given in the Newar chronicles avers that the father of the Licchavi dynasty, Vrisadeva, had his death rites performed on the hill in the early fifth century. This association with Vrisadeva has lived on in Newar tradition, and Svayambhunath is the principal of the four stupas said to be founded by that great king. An inscription of his great grandson, the most glorious of the Licchavi kings, Manadeva, is found there. An inscription of a later Licchavi king, Amshuvarman, makes reference to Svayambhunath. If Svayambhunath had been built in the same mold as Indian stupas of the Gupta period, it would have been a simple high dome surmounted by a stone canopy, and certainly the stupa would have been attended by monks of the Hinayana ordination.

In the reign of Amshuvarman, in the seventh century, an Indian king from Bihar renounced his throne and came on pilgrimage to Svayambhunath. He took ordination there, adopted the religious name Shantikara, and practiced Vajrayana Tantric yoga. He became renowned as Shantikara Acharya and is remembered as the first Tantric master of the valley. When Shantikara arrived at Svayambhu, the flame was hidden under a slab of stone placed there by the bodhisattva Vajrasattva to protect the jewel lotus from thieves of the dark age, the iron age, the Kali Yuga. The legend has it that Shantikara raised a stupa studded with gems and having a golden wheel attached. It is probable that Shantikara's stupa was designed with the

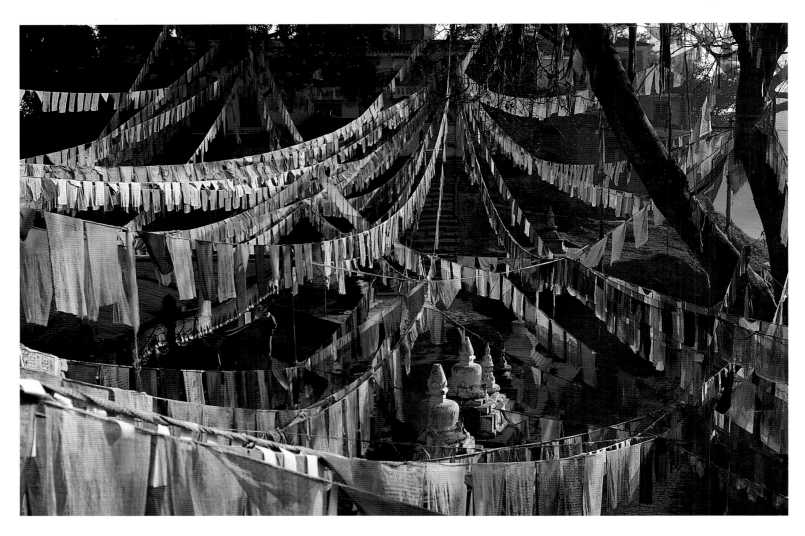

Prayer flags of Manjushri Hill

five shrines of the Five Meditation Buddhas in the four cardinal directions. Around it he built five shrines to the five elements. This story indicates the renaissance of Buddhism under Vajrayana influence, and while some say that Shantikara erected the first stupa at Svayambhu, it is more likely that the Licchavi stupa had fallen into disrepair and that Shantikara performed the first in a long succession of restorations of the stupa after damage caused by the elements or by human neglect or destructive urges.

It appears that by the eighth century Tantric Buddhism was well established at Svayambhunath. At the end of that century Padmasambhava, the great Tantric magician who was to establish the Buddha's teaching in Tibet, came to Svayambhu. During his visit the Great Guru transfixed an earth spirit with his magical dagger and established the Black Lord of Death (Yamaraja) as a protector of the place. In the eleventh century Atisha, the abbot of Vikramashila monastery in Bengal, used a pilgrimage to Svayambhunath as his excuse to leave his monastery after he had been convinced of the need of his presence in Tibet.

The eleventh century saw the beginning of a stream of Tibetan seekers arrive in the valley. The Newar chronicles tell us that one of the first, named Kangsarpa, "gathered about

him many yoginis and ascetic yogis who were residents of Svayambhu and performed rites of Tantric feasting on many occasions." Another, known as Ralo, who later achieved renown as one of the great translators, became embroiled in scholastic disputes and contests of magic at Svayambhunath with followers of the great god Shiva.

In the year 1349 Svayambhunath, as one of the principal and wealthiest shrines of the valley, suffered desecration and vandalism by the troops of the Bengali Muslim invader Shamsuddin Ilyas. This major damage was not repaired until nearly twenty-five years later, when, perhaps, the stupa was rebuilt with the harmika, spire, and pinnacle that characterize it today. The wooden central axis, replaced in this restoration, together with its attached spire and pinnacle, have required the most attention in frequent subsequent renovations. Valley Buddhists and Tibetan Buddhists alike have organized these repairs, both patronized by the kings of Kathmandu. A notable pilgrim from Tibet, the sixth Shamarpa, replaced the central axis in 1614 and also had the Meditation Buddhas' shrines covered in the gilt copper repoussé that still exists today. In 1750 lama Kathok Rikdzin Chenpo, a lama from eastern Tibet, a political emissary of the Dalai Lamas, and a highly respected scholar and priest, was responsible for replacement

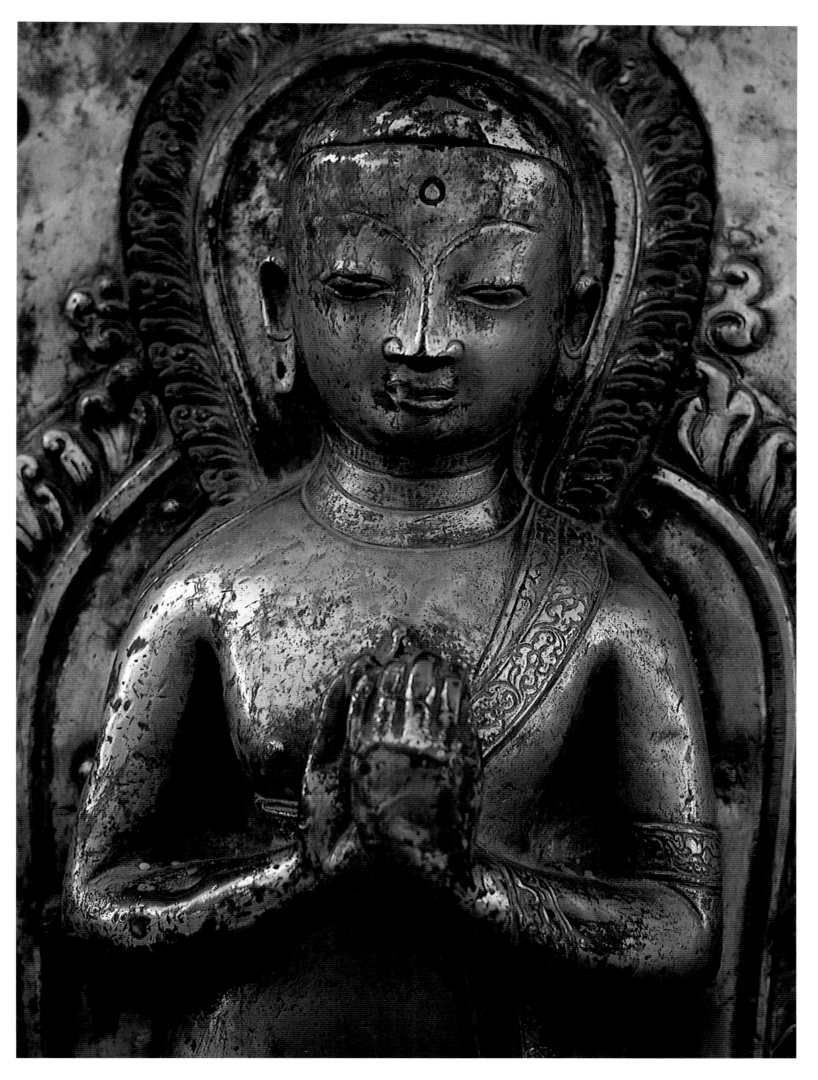

Gilt copper repoussé detail on the Svayambhu Stupa

of the central axis and other repairs, and the stupa was reconsecrated in 1758 by the seventh Pawo Rinpoche.

In 1816 a violent storm snapped the central axis, and again the stupa fell into disrepair. The replacement timber, installed in 1825, is the axis that currently supports the spire and pinnacle. Line drawings of a dilapidated stupa made by the British Resident Oldfield in the nineteenth century attest that the stupa cannot survive many decades without restoration. In the early twentieth century the stupa was again renovated. Since then a serious threat to the continued existence of the Self-sprung Temple of Wisdom has arisen with the subsidence of the southeastern corner of the hilltop. After the heavy rains of 1979, the weight of the structures and the defoliation on the hillside caused the earth-and-stone mound to begin falling away. Only by the demolition of all but one building on that side of the hill, performed in the early 1980s, has the subsidence been arrested.

Description

At the top of the eastern stairway is the great vajra, set upon a drum that has the dharmadhatu mandala inscribed on its gilt copper top. It is said that this drum covered a well that reflected images of the beloved dead with such flattery that widows and widowers would throw themselves in and drown. Another story has it that the mandala covers a pit that descends to the hells and the realms of the hungry ghosts. The drum plinth is decorated with the twelve animals of the zodiac. To the left is the Tibetan bell.

Beside the bell is the Pratapur Shikhara Temple of King Pratap Malla. When Pratap Malla thought to build this and its complement, Anantapur, as residences for Bhairava and Bhairavi, the guardian god and goddess that inhabit them, Svayambhu is said to have refused permission. Pratap Malla closed the stupa to worship for six months to coerce the authori-

Ajima Temple and Svayambhu Stupa

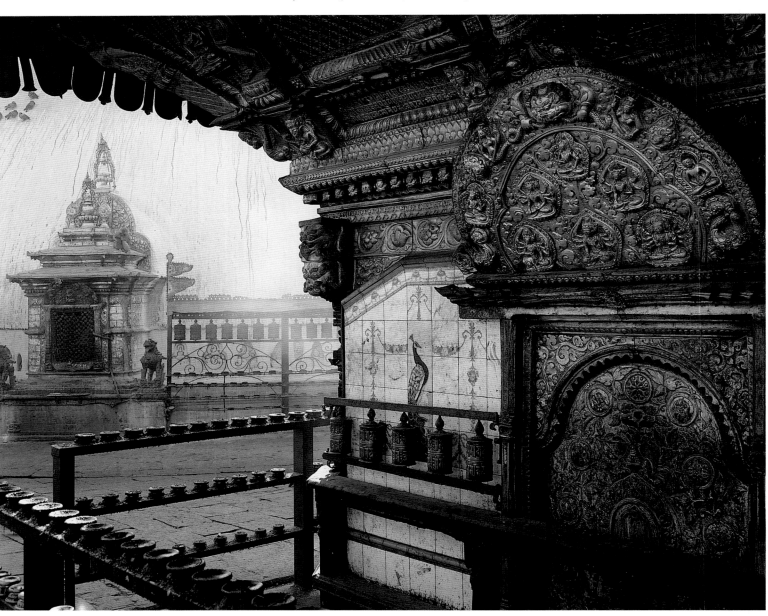

ties, which eventually acceded to his request. Today these are the only shrines on the hill ignored by devotees. Both temples have basements full of weapons. When reconstruction work was in progress in 1983, after the disastrous landslide, architects discovered that Pratapur was founded on solid rock.

Behind Pratapur is Vasupura, a shrine to Vasudhara, an earth goddess and the goddess of fertility, and she is the principal image within. The elegant temple building was constructed after the landslide of 1982. This is the first of the shrines of the five elements, the Panchatattva, consecrated by Shantikara Acharya. The five shrines are Vasupura, for the earth goddess; Vayupura, for the wind god; Agnipura, a residence for the god of fire; Shantipura or Akashapura, for the lord of space; and Nagpura, for the gods of water.

The other principal building on the south side, also rebuilt after the 1982 landslide, is the Newars' agamche, the House of the Secret God. Its sanctity is strengthened by the story that naga serpents are imprisoned on the first floor, where the secret shrine is located. The nagas' freedom would be the precursor of war and disaster.

The Bhutanese Drukpa Kagyu Gompa is located on the western side. The present Bhutanese queen mother spent some time doing devotions in the valley, and the previous king gave her this gompa, or monastery, as a boon. Several Bhutanese monks are in residence. For some years in the early 1980s this gompa was used by Tamangs. In a small room at the northeast corner of the gompa is a group of interesting stone statues, notably of the siddha Virupa pointing at the sun to stop it in its tracks.

The principal object of worship of contemporary Newar devotees is contained within the pagoda temple shrine to the northwest of the stupa. Within an exquisite temple dedicated to Mahamanjushri is an image of the mother goddess Ajima Hariti, also known as Shitala, protectress of children. The Yakshi Hariti was present at a sermon given by Shakyamuni Buddha on Gopuccha Parbat. Because she promised to serve the dharma, protect the stupa, and guard prepubescent children, her temple is sited by the Svayambhu Stupa.

On the north side of the bahal is an area full of votive stupas from various centuries. Dominating this area is a large standing Buddha made in the style of the twelfth century, although its date of carving remains obscure.

The path descends to join the top of the steps ascending from Pulan Svayambhu, and on the left is the temple of Shantipur. This temple is the abode of Shamvara, a secret Newar ishtadevata, and the most mysterious of the powerful shrines on Svayambhu Hill. The great southern door is flanked by lion- and tiger-headed dakinis and a standing Buddha to the right. The wooden door itself and its frame are ancient, done in excellent wood carving. A wooden torana surmounts the door, with the Adibuddha Vajradhara at the top and the Five Buddhas underneath. Inside the vestibule the murals illustrate the history of the stupa according to the *Svayambhu Purana*. Within the secret chamber is the mandala of the Sixty Buddhas of the Shamvara mandala.

In the northeast corner is the Tibetan Karma Kagyu Gompa, Karmaraja Mahavihara. This was built by the venerable Tibetan lama Sabchu Rinpoche in the 1960s; during the minority of his reincarnation it is the seat of his regent, Shamarpa Rinpoche.

At the center of the hill is the Self-created Stupa, the Svayambhu Vagishvara Dharmadhatu Stupa itself. The great Svayambhu Stupa consists of a simple dome built on a drum plinth, with the Five Buddha shrines and the shrines of the Four Taras, their consorts, attached to it. The dome is surmounted by a square harmika upon which the eyes are painted, with four toranas on the four sides, and above it is a stepped spire with a canopy above the wheel and a lotus-and-jewel ornament as finial. The entire stupa is ringed with prayer wheels. The shrines of four of the Five Buddhas—Akshobhya (east), Ratnasambhava (south), Amitabha (west), and Amoghasiddhi (north)—are found in the cardinal directions, with the shrines of the Four Taras in the intermediate directions. The fifth Buddha, Mahavairochana, who belongs to the center of the mandala, is found in the east beside Akshobhya's shrine. The shrines of the Buddhas are elaborately decorated with gilt copper repoussé, their roofs graduated to the jewel ornament on top. On each side of the iron-grilled shrines are arhat devotees; below them in stone are the animal vehicles of the Buddhas. Repeated stone reliefs of the garlanded stupa are inset at the base of the dome.

BOUDHANATH

To the east of Kathmandu, on the old road to Tibet, in a depression above the Bagmati Valley, lies Boudhanath, one of the largest stupas in the world. It towers above a small Tamang and Newar village, Boudha, which since the arrival of Tibetan refugees has become the center of a thriving ethnic Tibetan town of monasteries, carpet factories, and businesses. Like Svayambhunath, Boudhanath has its roots in Newar history, but in the past few centuries it has increasingly become associated with Tibetan Buddhists. Today it is their main center of worship in the valley and a major destination of Tantric Buddhist pilgrims from the Himalayas, Tibet, and southeastern and eastern Asia. Apart from its ancient Newar history, Tibetan Buddhist myth and legend color it, define it, and endow it with human significance.

Its common name is Boudha or Boudhanath, Lord of Wisdom, or perhaps Lord Buddha. The Newars call it Khasa or Khasti Chaitya. The Tibetans know it simply as Chorten, the Stupa, or Chorten Chembo, the Great Stupa. In their legends it is called Chorten Jarung Khashor, "Permission Given for Proper Action."

Myth and Legend

The Tibetan tradition of the foundation of Boudhanath is related in the text called *The Legend of the Great Stupa*. A long time ago a poultry keeper and devotee named Jadzimo aspired to make a great offering to the Buddha, using her hard-earned savings. She approached the local king for permission to build a magnificent monument to the Buddha; permission was granted, and construction began. But this lowly woman's aspiration wounded the pride of the wealthy and powerful. Jealous lords petitioned the king to have the stupa demolished, but the king replied, "Since permission to build has been given, it shall not be rescinded"—which is the meaning of the stupa's Tibetan name, Jarung Khashor. Another version of the legend adds that the king had granted her the extent of land that could be covered by a buffalo skin and that the woman cut the skin into thin strips and claimed the land enclosed by the strips laid end to end. When Jadzimo died, the stupa's construction was finished by her four sons, who had been begotten by four different fathers.

This story is related in Samye, the original great monastic center of central Tibet, by Padmasambhava, who was asked by King Trisong Detsen to describe the fruit of the karma of building the Great Stupa. The Great Guru then relates how Jadzimo's sons were reborn as the principal actors in the drama of transmission of the Buddhist doctrine to Tibet. They included Tibet's most venerated king, Trisong Detsen himself, the saint who ordained Tibet's first monks, Shantarakshita, and also Padmasambhava himself, who subjugated the Tibetan demons.

The *Legend* avers that the relics of the Buddha of a previous eon, Kashyapa, were installed within it, that when the

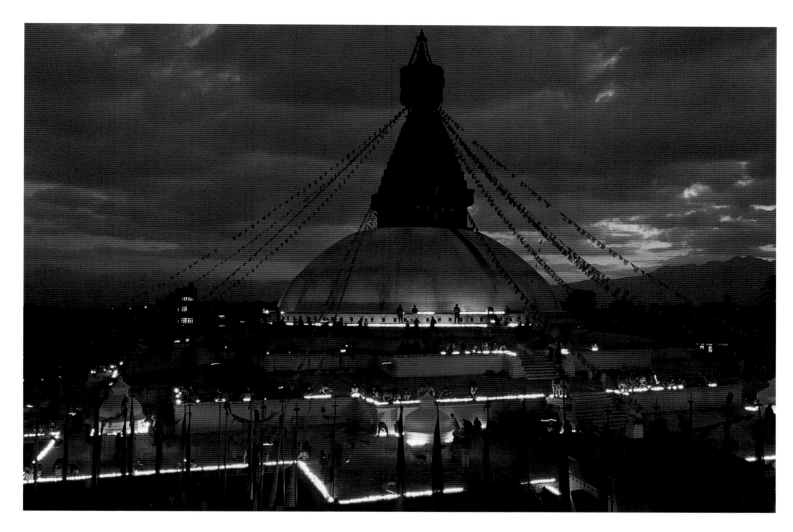

Boudha Stupa

stupa was consecrated a hundred million Buddhas dissolved into it, and that it has the glory of being filled with their sacred relics. "Whatever prayer is offered to it is fulfilled, and if the yogi meditates upon his personal deity here, at the time of his death he will be reborn in Sukhavati, the Pure Land of Bliss."

The Newar Buddhists tell a very different story. During the reign of King Vrisadeva, a fountain called the Narayana Hiti, which lay opposite the old gate of the Shah palace, ran dry, and a drought struck the land. The king consulted his brahmin astrologers to discover the means of breaking the drought. He was informed that the gods required the death of the most virtuous man in the kingdom and that only such a sacrifice could bring rain. The king searched throughout his kingdom and concluded that only he and his son qualified as victims. The old king decided that he himself must die. He instructed his son to decapitate with one stroke the shrouded form that he would find lying beside the Narayana Hiti on a certain moonless night. The son, Manadeva, obeyed his father's command and was horrified to see the head of his own father fly up from the corpse and away to the east. It landed at the temple of Khadga Yogini in Sankhu, and the dakini of the place told him that the only way to expiate his sin of patricide was to let fly a

cock and build a reliquary stupa for his father's remains wherever the bird might land. The cock alighted at Boudha, and the great king Manadeva built a magnificent stupa there.

Lhundrub Tsekpa: A Great Cremation Ground

Boudhanath is identified as the stupa associated with Lhundrub Tsekpa, the Spontaneously Amassed, one of the eight great cremation grounds of the Buddhist world. According to the Tibetan chronicles:

> It is written that Jarung Khashor is one of the eight stupas built at the eight great cremation grounds of the Eight Mother Goddesses (Mamo) of Kala Bhairava's retinue when long ago Bhairava was vanquished by Chakrashamvara. . . . In the Spontaneously Amassed cremation ground in Nepal dwells the blood-sucking serpent-witch Kasmali. Surrounding the stupa are funereal birds, sepulchral creatures, a cremation ground, ghouls brandishing skeletons, and creatures of the tombs. A flashing cloud of airy regions lifts heaps of men, fire, skins, and pulverized organs; a Yaksha vomits tigers, wolves, and other

wild beasts. Here Padmasambhava subdues the eight classes of demons, reduces the three worlds, subjugates the three domains, and turns the wheel of dharma for five years. Here the Great Guru is known as Senge Tratrok, He Who Teaches With a Lion's Roar.

Kasmali, or Pukashi, is identified above as the protectress of the cremation ground. Kasmali is confounded with the image in the small temple-shrine on the north side of the stupa, where she squats with a corpse on her knees, sucking up its entrails and devouring them. Tamangs initiated into the mandala of the Eight Mamos now attend her.

History

The Newar legend of the stupa's origin, which attributes it to King Manadeva as atonement for his unwitting patricide, places its original construction in the fifth century. Manadeva was the great Licchavi king, military conqueror, and patron of the arts whose deeds are recorded on the Changu Narayana pillar, and who died in 505 C.E. The chronicles also include it as one of the four stupas founded by King Vrisadeva, Manadeva's father, and they associate King Shivadeva (r. 590–604) with it, perhaps as a restorer. Although there is no major Licchavi sculpture in the vicinity of Boudha, in the eastern enclave there are three undatable mani stones (ancient stones inscribed with mantras), and in the south two chaityas in the Licchavi style, which could perhaps be dated as late as the thirteenth century. There is no epigraphic or archaeological evidence of its Licchavi origins, however. Indeed, the early history of the stupa is based entirely on legend.

The earliest Tibetan sources of reference to the stupa are Nyingmapa "revealed texts" (terma). It is significant that the earliest of these, a twelfth-century biography of Padmasambhava, fails to name Boudha as a pilgrimage destination of the Great Guru, and in recounting the legend of Jarung Khashor's foundation, it places the stupa in Magadha in India. A century later, however, another biography of the Great Guru locates Jarung Khashor in the Kathmandu Valley. It is evident, then, that the Tibetan connection with the stupa was established by the thirteenth century.

Clues to the stupa's origin and history may be derived from the etymology of the Newar name of the stupa, Khasa or Khasti Chaitya. Some believe that the name derives from Kashyapa, the manushi Buddha of the preceding eon, whose relics are said to be enshrined within. Some believe it is derived from the Newar word for dew, for the chronicles mention that when the stupa was under construction, a drought struck, and the workmen were forced to lay out cloth to collect the morning dew, which was wrung out for the day's work. Some

believe that Khasa was the name of a Tibetan lama whose relics were interred there, although no other reference to such a lama has come to light. Again, a connection has been established between the stupa and the Khas Mallas, a Buddhist dynasty that dominated western Nepal and raided the valley several times around the time of the stupa's entry into historical records. Finally, Tibetans have interpreted the Newari word to be a corruption of khata, which means "excavated" and refers to the stupa that Shakya Zangpo dug out of the mound he found at Boudha in the sixteenth century.

Shakya Zangpo was a Nyingmapa Tantric master from Kham in eastern Tibet who lived in the last half of the fifteenth and the first part of the sixteenth century. At Samye Chokhor in central Tibet, while circumambulating its uppermost temple, he received a divine command to travel to the Kathmandu Valley to excavate and restore the Boudha Stupa. After some difficulty in determining the exact mound containing the original structure, he began his digging and discovered in the axis the relics of the great king Amshuvarman, which were distributed to the people as blessings. He also unearthed a spring. He then constructed a stupa that was probably in a form close to that existing today.

Shakya Zangpo was recognized as a tulku (incarnation) of Padmasambhava, Guru Rinpoche, and he established a line of tulkus associated with Yolmo (Helambu), the Tamang and Sherpa district to the north of the valley. He was henceforth known as Yolmopa Shakya Zangpo.

Contemporary history of the stupa has revolved around the enigmatic personality of the Chini Lama. The Chini Lama's Chinese father accompanied the Chinese delegation to the peace talks following the Nepali-Chinese war of 1852 and was given the abbotship of Boudha as adjunct to the settlement. Boudha retained some extraterritorial privileges from the period of this first Chini Lama, to the lifetime of his grandson, Punya Vajra, who died in 1982.

Description

The perfectly proportioned dominating unity of Boudhanath is approached under an archway on the south side of the stupa. A lane leads to a broad paved circus surrounded by old Tamang and Newar cottages. The stupa in the center is surrounded by a high angular wall, its symmetry broken only by an enclave on the east side. All around the wall are shelves for copper prayer wheels with the Five Buddhas painted behind them. In the four intermediate directions are shrines housing images of the Four Guardian Kings. Small stupas surmount the wall. The principal entrance is on the north side, where two doorways lead into a small courtyard. Between these, a small temple breaks into the wall.

Hariti shrine with offerings, Boudhanath

This single-chamber temple, with latticed screen in the front and silver repoussé door jambs and torana richly ornamenting the doorway, houses a single image of a female deity. Her silver form is clothed, but her iconography is identical to that depicted on the torana shading her and also on the torana above the outer door. She crouches with a human corpse on her knees, sucking on its disembowled intestines. She is known by different names by the various communities. By the Newars she is known by the generic name Ajima (grandmother). Probably her best-known personal name is Hariti, a demoness who inflicted smallpox upon children until converted by Shakyamuni preaching the significance of Svayambhu on Gopuccha Parbat. Thereafter she fulfilled her vow to remain within her shrines located close to the Buddha's temples, and

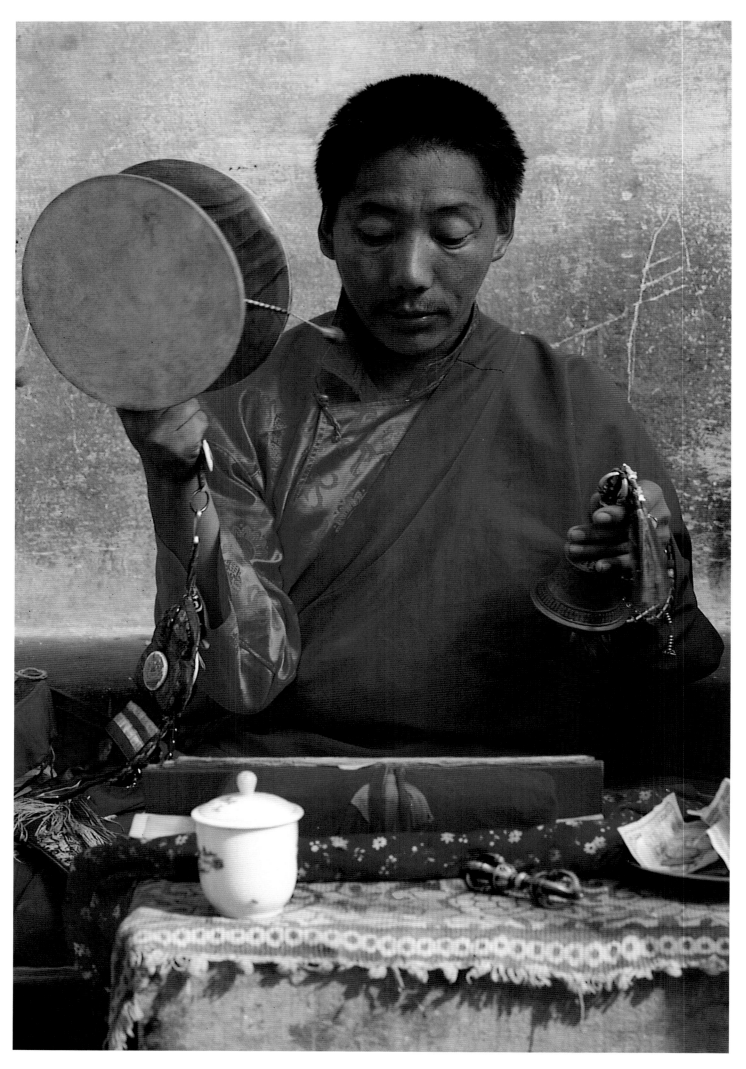

Tibetan Buddhist monk worshiping at Boudhanath

so long as she was propitiated she would refrain from inflicting disease. In Svayambhu, and likewise in Kathishimbhu, she appears in her usual form of a benign mother with children on her knees. The Hindus call her Shitala. She is also Pukashi, the protectress of the cremation ground. Whatever her name, this goddess is a force to propitiate rather than coerce. In recent years the Tibetans have come to call her Jadzimo after the female devotee who built the stupa.

The Boudha Stupa is unique in the dimensions of its three terraced plinths, upon which the drum and dome are built. The height of the first is approximately seven feet, while the two upper plinths are lower by about a foot. All three are "twenty-corner" plinths *(vimshatikona)*, "gated" plinths indicating the doorways to the three levels of initiation into the stupa mandala. Steps lead from one to the next on all sides—there were no steps from ground level to the first plinth in the original design, which was stark in its simplicity.

In the intermediate directions of the first plinth are four small auxiliary stupas remarkable for their spare lines and lack of spire; on the north side are two more of the same design. Also on the north side is a recently built *sang-khang*, an altar for burning juniper incense to propitiate the protecting deities, and an image of Vasuki Nagaraja, a principal valley water spirit. On the south side are two stone images, one of the Guardian King and Protector Vaishravana facing outward and another of an unidentifiable god, perhaps of Hindu provenance, looking inward. The stairway onto the second plinth in the north is guarded by two elephants and riders, a Mongol warrior brandishing sword and shield on the right and a Mongol queen in skirt and elaborate coif holding a shell on the left. Beside this stairway are two standing Buddhas and a bodhisattva.

The drum, three and a half feet high, upon which stands the dome, is unadorned except for an added terrace with its remarkable 108 niches filled with sculpted stone deities of the Nyingma school's pantheon. They replace the usual Five Buddha shrines in defining the content of the stupa mandala; however, they elaborate rather than depose the mandala of the Five Buddhas. These images almost certainly were commissioned together by Shakya Zangpo in the sixteenth century, when the present stupa was built, or soon thereafter. In the conventional Tibetan manner, clockwise, these images depict buddhas, siddhas, lamas, yidams, dakinis, and protectors. These are the buddhas and deities of the stupa mandala. The one Buddha that does not form part of this 108-fold mandala is the Akshobhya Buddha, standing above the terrace of images on the north side. Candle wax and incense offerings have disfigured the sometimes exceptional execution of these sculptures.

The splendid dome of the Boudha Stupa is approximately 120 feet in diameter. It is unadorned by shrines, and only the steps built into it on the north side, seemingly the ladder that took Shakyamuni to the Tushita heaven, break its uniformity. A thick layer of whitewash coats the dome, and the form of a double lotus depicted in saffron water colors it.

The harmika box and the thirteen steps of the spire are covered by gilt copper sheets. A textile apron hangs around the top of the harmika, fringing the powerful eyes of the stupa. Toranas over the harmika are remarkable by their absence. A large gilded lotus surmounts the spire, and the gilt copper canopy that sits on top of the protruding wooden axis is supported by a wooden scaffold of which the lotus is the base. A jewel pinnacle caps the entire structure.

PASHUPATI

Pashupati is the principal residence in Nepal of the great god Shiva. Pashupatinath, a name of the great god, is the protector of the kingdom and the royal deity. Moreover, as Svayambhu and Boudha link the valley through myth and history to the entire Buddhist world, so Pashupati is a major destination for pilgrims from all over the Hindu world. Located to the east of Kathmandu, in the small town of Deopatan, to the south of a gorge carved out by the Bagmati River, Pashupatinath resides by the river above sacred bathing ghats.

Myth and Legend

In olden days, in Vedic times when the gods were young, the Kathmandu Valley was a wild jungle. In Mrigasthali, above the banks of the Bagmati, the sky god Prajapati was intent upon copulation with his daughter Ushas, goddess of the dawn. In his wild and dangerous form of Rudra, the hunter, Mahadeva interrupted Prajapati's incestuous activity by shooting arrows at him. A lingam representing Shiva as Pashupatinath, Lord of Beasts, arose on that spot.

A later legend tells of a time when Shiva Mahadeva as Vishvanath Baba was overwhelmed by the adulation of his devotees in Kashi, Banaras. Fleeing from Banaras, Mahadeva transformed himself into a gazelle and lived in peace on the Mrigasthali hill. Vishnu, Brahma, and the other gods, unable to tolerate Mahadeva's absence from Banaras, came to fetch him back. They caught the gazelle by the horn, but as they

did so the horn broke. Shiva thereupon declared himself Pashupati, Lord of Beasts. Vishnu erected the broken horn as the original Pashupati lingam, and all the gods worshiped it.

Much later, the first human being to walk the forests of the valley was called Ne, the progenitor of the Nepali people. A cowherd, he tended his herd in the pastures of Mrigasthali. On occasion, a milking cow would not give him milk but would wander away by herself in the forest. Following her, Ne discovered that she would water a certain spot with her warm milk. Ne dug at that spot and uncovered the original lingam of horn; setting it up, he worshiped it as Pashupati, Lord of Beasts.

Another legend establishes Shiva as Mahadeva, the great god, and also first lord of gods. When Shiva, Vishnu, and Brahma were rivals for the title of lord of gods, Shiva transformed himself into a pillar of fire, or a lingam of light (*jyoti lingam*), challenging his rivals to climb to its top to establish their primacy. Vishnu was soon left behind in the climb by Brahma, who on his way down assured Vishnu that he had reached the top. Descending, Brahma showed Shiva a flower that he said he had brought from the top of the lingam, and Shiva called him a liar, since his lingam had no end. Brahma thus proved himself unworthy of worship, and Shiva became the undisputed lord of gods. His lingam of fire was capped by the original four-faced lingam and became worshiped as Pashupati, Lord of Beasts.

The Bagmati River at Pashupati is as sacred as the Ganges itself. To bathe at Pashupati on particular phases of the moon

is to ensure translation to Shiva's paradise, Kailash. To be burned at Pashupati on the banks of the river is to be granted certain release from rebirth. The gorge here, which cuts through a ridge that would have contained a lake spreading east to Sankhu, was cut by the bodhisattva Manjushri.

The Names of the Deity

The general names of the god are Shiva, the "Peaceful One," Mahadeva, the "Great God," and Maheshvara, the "Lord of Great Power." The god's manifestation in Nepal is Pashupati, "Lord of Beasts," or Pashupatinath, "Lord of Pashupati." *Pashu,* however, also means "fetters," so esoterically Pashupati is also the "Remover of Fetters," the "Saviour."

History

The myth of the gazelle points to Pashupati's origins as an indigenous pastoral god. With the advent of Shiva worship in the valley, brought perhaps by ascetics and sadhus from the south, the indigenous deity was identified as Shiva. This identification may have been made centuries before the birth of Shakyamuni Buddha, in prehistory, before the era of the Kirata dynasty. In the Mahabharata epic, Shiva assumes the guise of a Kirata, to give Arjuna a weapon called Pashupata. By Licchavi times, when according to inscriptions Pashupati received the lion's share of royal patronage, Pashupati was the preeminent form of Shiva in the valley and probably the most revered of the valley's deities. The legendary Licchavi king Amshuvarman began the custom of Nepali kings to style themselves "Favored by the Feet of Pashupati" and "Laden with the dust of Lord Pashupati's Lotus Feet."

Pashupati's significance was enhanced during the Tantric period by its inclusion among the twenty-four preeminent power places of the subcontinent. The essential mark of these places was their association with both Shiva and Shakti, the father and mother principles of Tantric metaphysical reality. The legend that established these locations is popular wherever Shiva is worshiped. Dasharatha, Shiva's father-in-law, gave a once-in-a-lifetime Ten Horse Sacrifice *(dashashvamedh)* but spurned his ascetic son-in-law by not inviting him. Shamed to the point of death, Shiva's consort, Sati, Dasharatha's daughter, immolated herself on a pyre. Shiva took her corpse and in mad despair flew with her in his arms all over the world. Parts

Hindu bathers at the Bagmati River, Pashupati

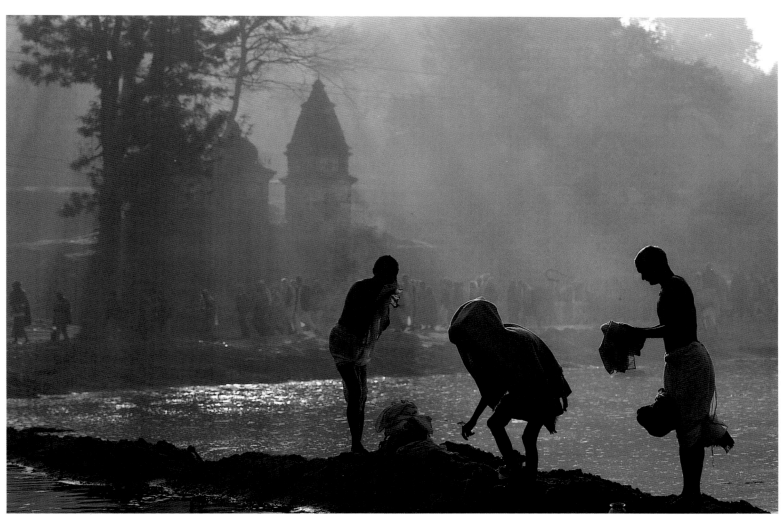

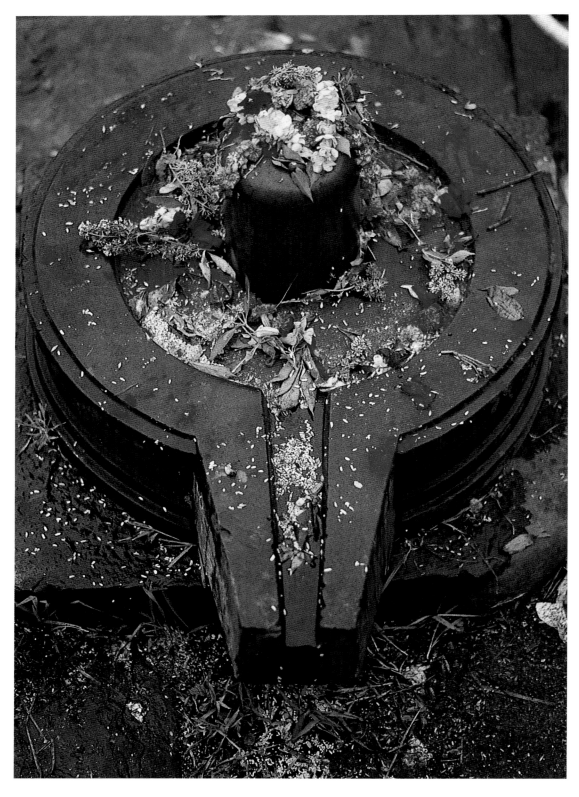

Shiva lingam with pilgrims' offerings

of Sati's decomposing body began to fall off, and each part where it landed became a *shaktipitha:* a place of power and devotion for all Tantric initiates. The place where her vulva (some say her anus) fell was Guhyeshvari, at the northern end of the Bagmati gorge.

Although Mahadeva has always been worshiped by lay people, he is primarily the deity of ascetic yogis and itinerant sadhus. The ten schools of Shaiva monks established by Shankaracharya in the eighth century are his principal devotees.

During the early part of the Tantric era, perhaps in the sixth century, Pashupati became the ideal of the Pashupatha sect of yogis following the left-hand ascetic path and living well outside the pale of Hindu society. The popular Nath school of yogis, founded by the Buddhist Siddha Gorakhnath and established in the valley in early Malla times, has had a high-profile presence at Pashupati. Today, sadhus of the Ten Schools, the Naths, and various *aghori* sadhus—Tantric practitioners of the left-hand way—maintain the ascetic Shaiva tradition at Pashupati.

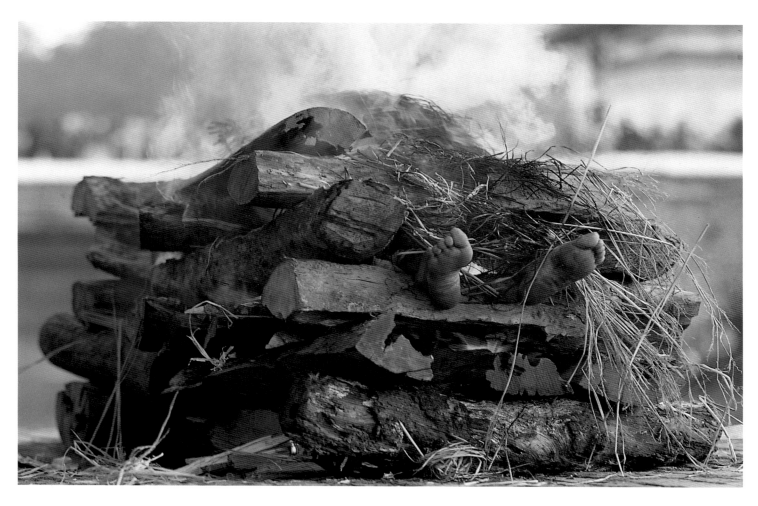

Cremation pyre

Buddhadharma at Pashupati

For Newar Buddhists, Pashupati is the bodhisattva Avalokiteshvara. Both Avalokiteshvara and Shiva are known as Lokeshvara, Lord of the World, and this identity in Tantric consciousness is easy to sustain. But Newar Buddhists believe that the original form of Pashupati is a Buddhist deity. While this belief may relate to an atemporal metaphysical reality, it may also have historical roots. Buddhist priests had rights at Pashupati into the sixteenth century, and still, once a year, Buddhists place a Bodhisattva crown upon the Pashupati lingam and worship it as Avalokiteshvara, or as the Five Buddhas.

In recent centuries, since Pashupatinath became the Rajguru of the Gorkhali dynasty, Tibetan pilgrims have found no easy access to the inner shrine of Pashupati. However, it has been a major destination in their guides ever since they began pilgrimage to Nepal. They know Pashupati well, from their Tantric texts on sacred geography, as an Upachandoha power place, counted among the twenty-four pithasthanas of the principal mandala of sacred Tantric sites of the subcontinent. The primordial symbols of father and mother principles of Tantric metaphysics are recognized as Shamvara and Nairatmya and also as other Tantric deities and their yogini consorts.

However, the lingam of Pashupatinath is also recognized as a representation of Mahadeva Ishvara, and Pashupatinath is known as the power place of Lhachen Wongchuk. Mahadeva is an important protector of the buddhadharma in the Red Hat school's mandala. As one of the four major protectors of the Sakya school, he is frequently painted on the rear walls of Sakya gompas, and as a Nyingma protector he is depicted standing naked with his consort Uma, or Parvati, his phallus erect as in Yogeshvara, Lord of Yoga.

The Tibetans recall the legend of the siddha Jalandharipa (Gorakhnath's guru), who with his psychic energy burst the Pashupati lingam apart. It is said that long ago the siddha's curse destroyed it and the fragments were enshrined in a wooden Buddhist stupa to preserve it.

Deopatan

Pashupati's shrine is located in the small town of Deopatan, now a suburb of Kathmandu, said to have been built by the Indian Maurya emperor Ashoka's son-in-law. This place has its roots in the second century B.C.E. and is certainly one of the oldest settlements in the valley. Deopatan formerly included the village of Chabahil, which is the residence of Chandra Vinayaka, a form of Ganesha, who is one of the gatekeepers of Pashupati. Offering there will assure the devotee's satisfac-

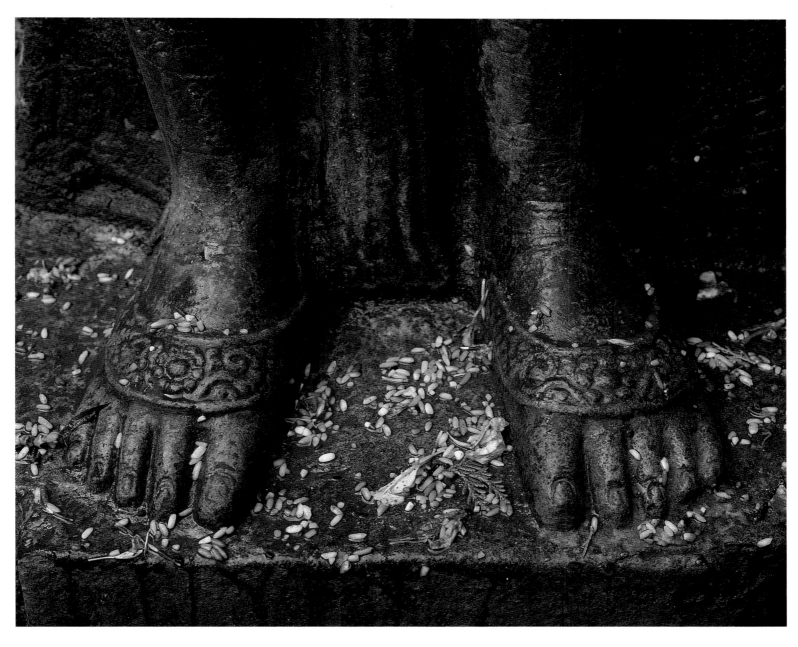

The feet of Parvati, 8th century, Arje Ghat, Pashupati

tion at the shrine of the great god. Another keeper of Pashupati is Bhandareshvara, on Siphal Hill. He is the treasurer of Pashupati and is also visited en route to the main shrine.

Pashupati Temple Compound

The temple compound of Pashupatinath is reserved for Hindus and Buddhists of certain castes. This exclusivity was established by the Ranas only a century ago. Pashupatinath himself is neither sectarian nor discriminating. The term *non-Hindus* is caste-based and a racial, not a religious, appellation. The custodians and pujaris of the shrine are Bhatt brahmins whose lineal roots are in south India.

Roof strut on the Vatsaleshvari temple, Arje Ghat, Pashupati

The temple itself is of a square two-roofed Newar design and was last renovated in the eighteenth century. Its wealth is evident in the rich silver decorations. Doors in the four directions open to reveal the four faces of the lingam. The large four-faced lingam *(chaturmukha lingam)* is covered by a silver sheath surmounted by a crown of Bhairava. As proof of the tolerance in Newar religion, the four faces of the chaturmukha lingam of Pashupatinath are generally believed to represent Shiva, Surya, Vishnu, and Buddha. Orthodox Brahmins, however, believe that the four faces represent the four Vedas. The original Licchavi lingam was broken by the Muslims in the raid of 1349, but its replacement, erected some years later, was probably a fair replica, since the present image has faces similar to those on dated Licchavi lingams.

The courtyard and its adjuncts are full of shrines, sacred symbols, votive offerings, and inscriptions. The giant gilt

monolithic sculpture of Nandi, Shiva's mount, is visible from the western gate. Through the ages it has been sufficiently impressive to have gained the legend of a nonhuman origin. The gilt trident *(trishula)* that stands on the north side, about twenty-five feet high, like the Nandi is said to be a gift of early Licchavi kings.

Arje Ghat

Arje (Arya) Ghat, immediately below the Pashupati shrine, is the ghat upon which the kings of Nepal, Pashupatinath's most prestigious votaries, and the twice-born are cremated. In one of the small temples on Arje Ghat is an exquisite image of the "Three-Eyed Shiva" called Virupaksha. This Licchavi image of highly polished black stone is sinking into its earthen foundation, and it is said that the Kali Yuga will end when the image has disappeared.

Surje Ghat

Tilopa and Naropa's caves are found a hundred yards up river from Arje Ghat. By paddling across the river or by taking a tortuous path down from Kailash, one arrives at Surje (Surya)

Ghat. Above this ghat are several caves carved from the living rock. This place of solitude has been the home of yogis down through the centuries, and some of the caves are still inhabited by contemporary yogis. Legend names two of these caves after the great Buddhist mahasiddhas Tilopa and Naropa, sadhu yogis of the tenth century and progenitors of a lineage of Buddhist Tantra that became the Tibetan Kagyu school of the Karmapas.

Rajarajeshvara Ghat

Walking downriver from the lower of the two bridges, passing the small eighteenth- or nineteenth-century Jalashayana Vishnu on the left, one reaches the all-caste burning ghats. A dark, cavernous sadhu's *kuti* on the right, where a succession of yogis of the left-hand Tantric way have had their seats *(asan),* is presently occupied by Pagalananda, of Aghori lineage. One hundred yards beyond the ghats is a seductive, slight but elegant standing Buddha of eleventh-century execution, evidence of a less sectarian Pashupati. Just beyond the Buddha is Anahavrateshvara, a giant lingam on a walled pier jutting into the river. It is a fifth-century, highly polished but exfoliating hard black stone with a flat top, sitting in its giant single-

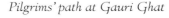

Pilgrims' path at Gauri Ghat

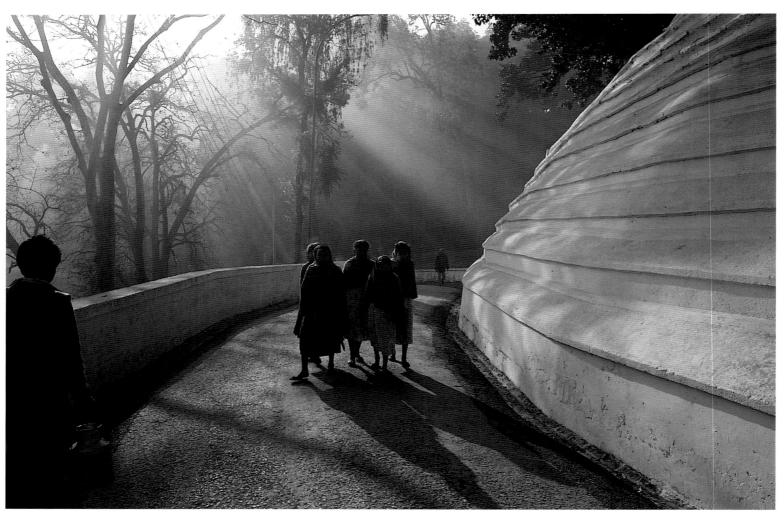

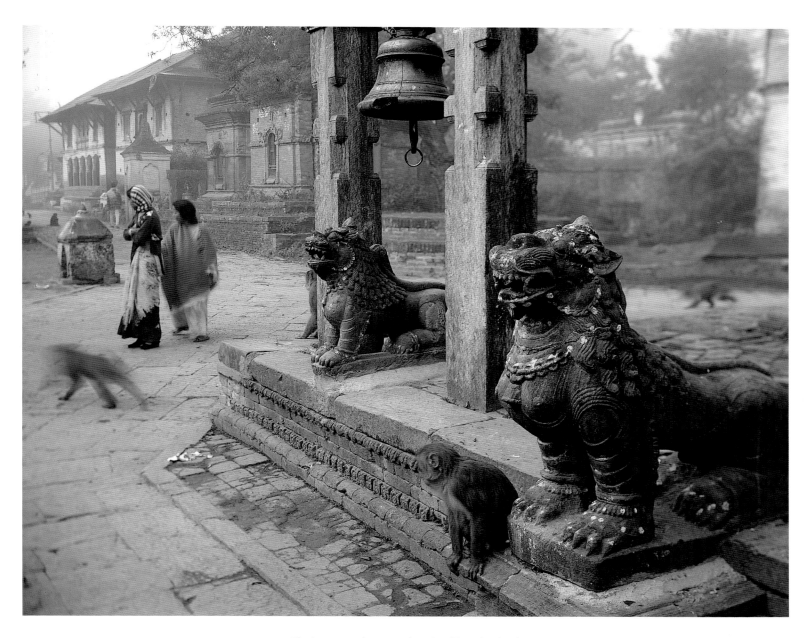

The lion guardians at the Gorakhnath Temple

piece jalahari base, and is evidence of the larger spatial concepts of that early age. Nearby is an empty Licchavi shrine with a simple flat stone roof on four pillars, probably a shrine cover for a lingam.

Mrigasthali

East of the Bagmati River is a forested hill covered with medicinal trees. Here Shiva lived as a gazelle, and here the father of the Newar race grazed his cows. On the riverbank are ghats. Opposite Arje Ghat, above the level of the temple itself, is a tourist deck and promenade. At the northern end of this area the magnificent fifth-century one-faced *(ekamukha)* lingam is located. The statue is sadly neglected, and its nose has recently been vandalized. In the row of statues at the back of the deck is a remarkable Uma-Maheshvara from the ninth century.

Opposite the burning ghat, above the ghats on the east side of the river, is the Ram Mandir compound. The Ram Mandir itself is a Rana-era domed temple covering a divine-sized image of Para Vishnu flanked by small images, identified as Vishnu's avatar Ramachandra and his sons. This image is said to be a seventh-century Licchavi masterpiece portraying King Vishnugupta, the patron of the sculpture, and his sons. The black, heavily oiled image is painted in folk style and is covered by chintzy cloth and rough copper repoussé ornamentation, so that the stone is all but invisible. Large statues of Garuda, Ganesha, and Hanuman on a pillar stand outside the shrine.

Kailashpuri, Shivapuri

On the hill at the top of a flight of monumental steps is a collection of temples and dharamsalas. The principal temple of these, marked by a gilt trident, is the Gorakhnath Temple, which enshrines the mahasiddha's footprints in stone. The *nathmath*, or monastery, is to the west of it.

Hanuman at Gauri Ghat

Gauri Ghat

At the top end of the gorge, where the Bagmati plunges into its chasm, a stone formation washed by the river and guarded by river nagas honors Gauri, Shiva's prospective consort. Shiva was a brahmachari yogi and was loath to marry, but in obedience to his parent's wishes he was betrothed to Gauri and promised to marry her consequent to her purification. For twelve years Gauri practiced purification yoga *(tapasya)* on this stone. Then, in a state of beatitude, she was married to Shiva on Kailash, his holy mountain paradise.

Bhubhaneshvara

In the center of Deopatan, at the first crossing, is the Bhubaneshvara Temple compound. This temple of Shiva's consort Durga, or Bhagvati, is a large, rectangular, two-roofed pagoda temple, recently restored. The wooden torana shows Mahesha-suramardini, Durga, destroying the buffalo demon. In front of the temple is the open shrine of Bhubaneshvara Mahadeva represented as a four-faced chaturmukha lingam, finely carved and probably of the Transitional period.

Bankali

The principal home residence of Bankali, the dreadful and terrific Kali of the Forest, blood-drinker and flesh-eater, lies south of Deopatan and east of Gokarna, in the remnants of the forest that was once thick and jungly on this side of Pashupati. These words are put into the mouth of this Kali: "I shall eat the asuras . . . and eat them up; then my teeth, hair, body, and weapons will all become red with their blood, and for that reason they will call me in the world as Rakta-Chamunda." Once in an open pitha shrine, the simple image of this dreadful mother goddess depicts an eight-armed form dancing on a human corpse. Time and a surfeit of blood and other offerings have taken their toll on this stone image, which probably dates from Licchavi times. King Shivadeva I (r. 590-604) caused the image of Bankali to be dug up after she had been buried "in the reign of Raja Dharmadatta, when she ate up an army and concealed herself in a wood, the flesh of the human army still sticking to her teeth." King Mahendra Shah renovated the site and built the present enclosure. The torana shows Ganesha, a four-armed Mother Goddess, and Kumara.

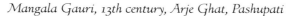

Mangala Gauri, 13th century, Arje Ghat, Pashupati

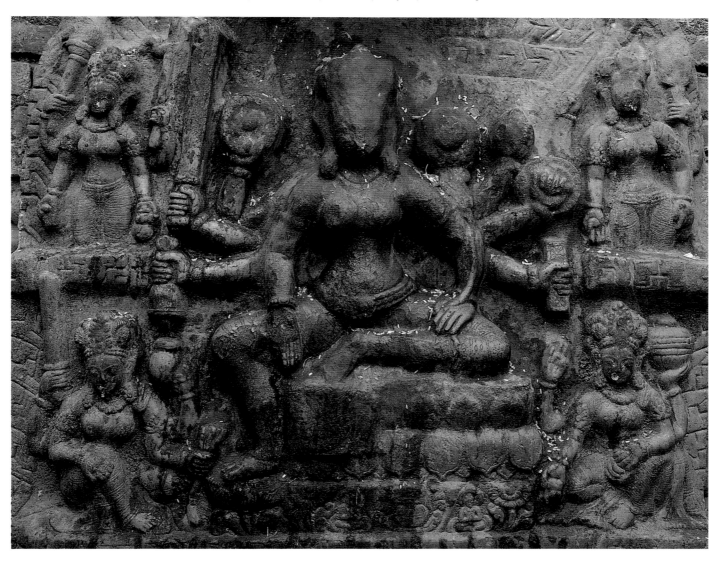

GOKARNESHVARA

The power place of Mahadeva at Gokarna may be considered, after Pashupati, the most significant shrine of the great god Shiva in the valley. On the road to Sundarijal, it is located just outside the wall of the Gokarna Park at its northwestern extremity. Here the Bagmati River, still a clean and pristine stream, breaks through a ridge, forming a deep rock chasm fifty feet deep and ten feet wide. The Gokarna Gorge is the fourth gorge to have been cut by the bodhisattva Manjushri to drain the valley of its lakes and allow full use of the rich lacustrine soils for cultivation. The Gokarna Temple lies by the river at the northern end of the gorge, just below the Baghmati's confluence with the Chandramati stream. This confluence marks the Punya Tirtha. Bathing ghats lead down to the river's edge.

Myth and Legend

Long ago the eternal yogi-ascetic Shiva, performing his ascesis at the Gokarna power place, begged for rice at a nearby cottage. A child named Goma answered that her parents were away and that she had been ordered to conserve the best rice for Satya Narayana. Refusing her offer of the second-best variety, the angry Shiva threatened her with the curse of marriage at age seven to a sixty-year-old man. Goma still refused to disobey her parents, and Shiva left empty-handed. When the child was seven years old, Shiva returned in the guise of an elderly brahmin, married her, and fathered a son, Navaraja. In his old age the brahmin fell from a tree while picking flowers for offering at the Gokarna shrine. Navaraja found his bones under the tree, which was close to the river, and here he cremated his father and performed his father's death rites (shraddha). This was the origin of the annual father's day ritual at Gokarna.

Gokarna is related to the origin of Shiva worship in the valley by the myth of the great god's original visit here. When Shiva fled his principal seat at Kashi (Banaras) to take the form of a gazelle and enjoy the solitary peace of Mrigasthali at Pashupati, Brahma and Narayana came to take him back. They seized the gazelle by the horn, but the horn broke off. One third of it flew into the sky and one third fell to the ground. The final third, destined for human worship, was taken to Gokarna, where it remains as the most potent relic in the temple.

The Punya Tirtha at Gokarna is the residence of Takshaka Nagaraja. Originally the naga sought relief from leprosy by doing penance here.

Description

The Gokarna Temple, one of the largest and most aesthetically pleasing in the valley, dates from the early Malla period. Three pagoda roofs cover the large, square, two-floored sanctum. The wood carvings that decorate the ground floor walls are the glory of the temple. The door frames are exquisitely conceived and finely executed; above the doors are evocatively

Gokarna Temple

carved historical scenes. Below these friezes are carvings of the Mother Goddesses, of devis in the shoulder brackets, and of Bhairavas in the foot brackets. Near the corners of the building are window shrines. The carving of the roof struts is very good.

The copper torana surmounting the main door, facing east, depicts Uma and Maheshvara in Kailash in the center, flanked by their sons, Ganesha and Kumara. The door frame is covered by fine gilt copper repoussé work.

The inner sanctum is approached through a gilt metal doorway with lingams decorating the doors. The Gokarneshvara lingam itself is a gnarled natural stone lingam about fifteen inches high and fifteen inches in diameter. A silver milk-filled pot drips its contents upon the lingam, and its jalahari is decorated with silver repoussé. Beside the principal lingam is a chaturmukha sheath *(kosha)* without a top, in copper repoussé, covering a polished lingam. Saligram offerings surround these lingams.

Stone images surround the temple. Directly in front, going from left to right, are Narayana, then Yogeshvara, Dhanan Nari, and Surya on the same plinth, and Chandra, Narad, and Agni on another plinth, then another Narayana with a Vishnu Garudasan above it. On the south side, Indra, Naradya, and an anthropomorphic Gokarneshvara are of most interest. Behind the temple are Brahma, Nandi, and an unusual anthropomorphic Vayu, the wind god. On the north side are Mother Goddesses, Ganga, and a small standing two-armed Kali. Stone images also line the stairway down from the road, most notably the cow Karmadhuti; a four-armed Bhairava wielding sword, shield, and trident and holding a severed head; and an image of the Buddha, the only Buddhist icon in the compound. On the west side of the road are, among others, Mahamanjushri as an eight-armed Vishvakarma and a Kubera. Some of these statues are from the late Malla period, but most appear to be of more recent provenance. They describe a broadly based, nonsectarian Hindu pantheon.

Of the buildings that surround the temple—the priest's houses; a bhajan pati; a dharamsala; a small shrine to the goddess known locally as Sarasvati; and the deteriorated votive lingam shrines further to the north, including a fine bodhi tree shrine—the hall called the Vishnu Paduka is of most interest. This open pillared hall, about twenty by thirty feet, with a Narayana shrine within, is used for ritual devotions, particularly the rites after death (shraddha). It is built on a triple plinth

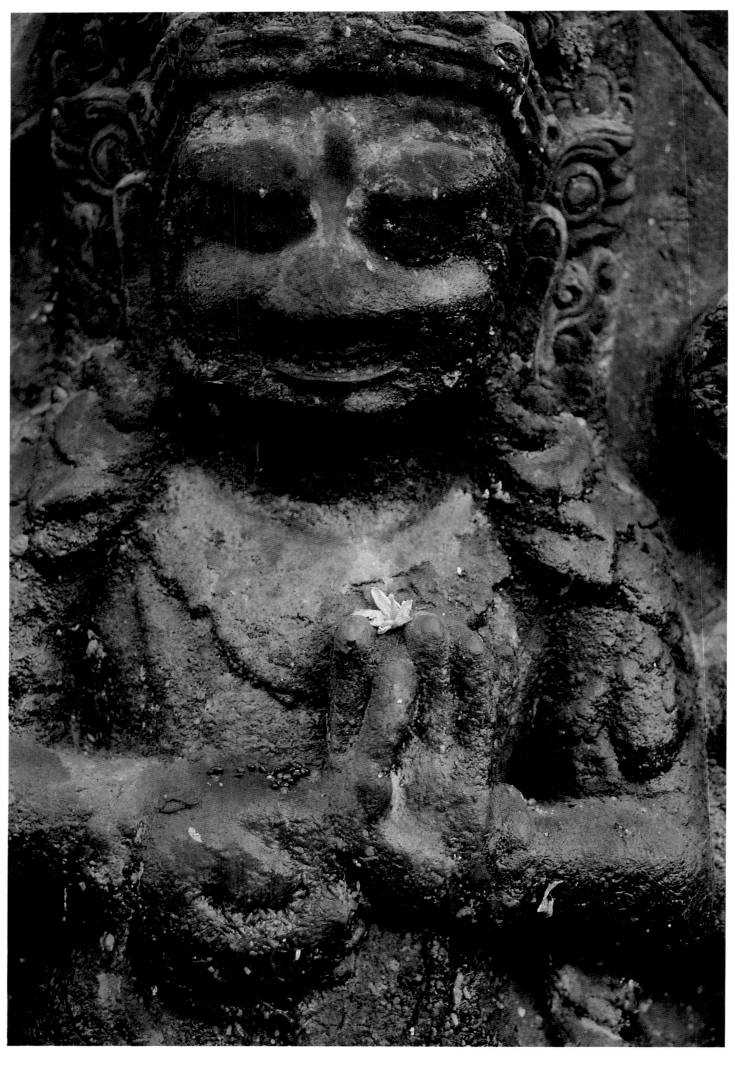

Statue at Gokarna

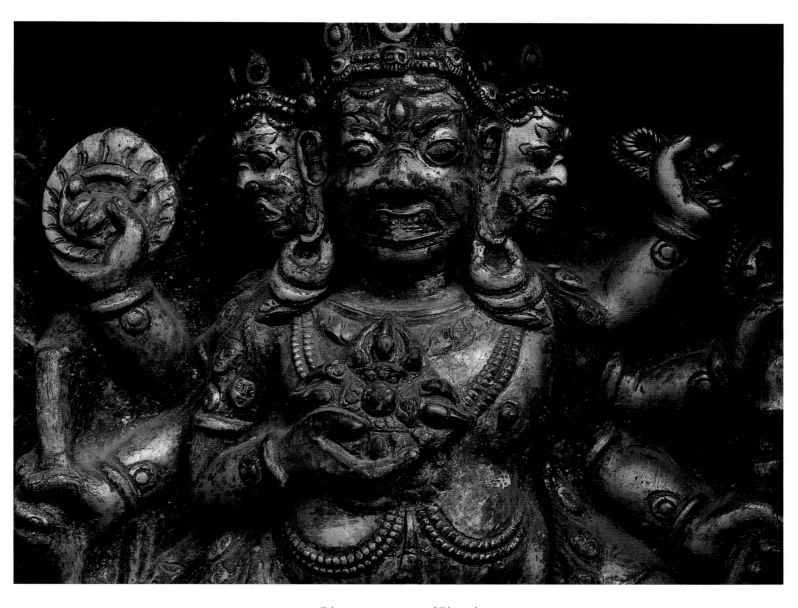

Gilt copper repoussé of Bhairab

that is washed by the monsoon river at its height. The roof struts, some with erotic carving, are new.

The Vishnu Paduka and the Gokarneshvara Temple have recently undergone restoration and conservation. The Vishnu Paduka was rebuilt from its foundations after they had been shifted by the flooding river. Some timbers were replaced, a new roof was erected, and the building was then reconsecrated. The contents of an original copper pot—the five jewels (*pancharatna*) and coins—were placed in a new pot with more coins and gold and silver. The foundation keystone was washed with milk and water from the seven seas (or rivers), blessed with oil, anointed with honey and sindhura powder, and placed ten feet down at the bottom of the foundation pit.

Most of the work on the temple consisted in cleaning the wood carvings, some of which had been anointed with old motor oil in the annual application of votive oil. The accretion of oil was removed by clay poultice. One roof strut was replaced, and when the tiled roofs were cleaned, weed killer was mixed with the roofing clay.

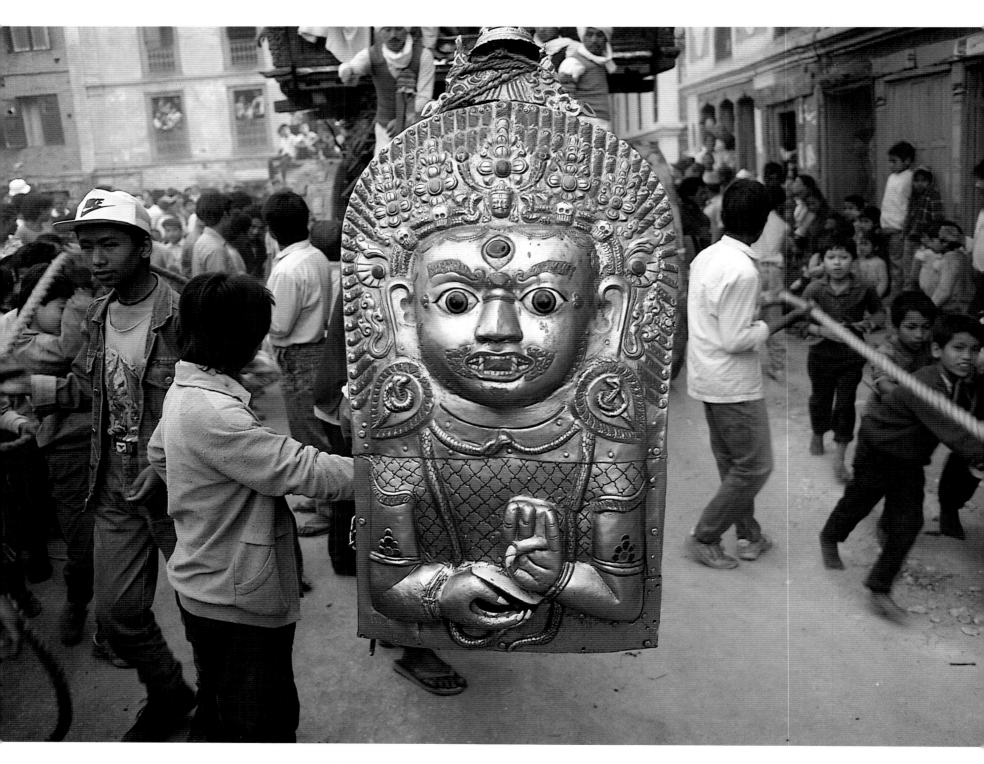

Bhairab image on the tongue of the chariot of Sveta Matsyendranath

JAMADYA
OR
SVETA MATSYENDRANATH

Jamal Bahal, the residence of Jamadya, is located in Khel Tol, between Indra Chowk and Asan Tol. Jamadya may be considered the principal deity of Kathmandu honored by the entire town in Kathmandu's greatest chariot festival. To the Newars he is originally Karunamaya Lokeshvara, the bodhisattva of compassion. To all the valley people he is Sveta Matsyendranath, the patron saint of the valley. He is also known as Sano Matsyendranath, the Lesser Matsyendranath, because he is the younger brother of Bungadya Rato Matsyendranath. *Sveta* (or *seto*) means "white"; the Bungadya is *rato*, "red." He is called Jamadya or Jamaleshvara because he was discovered in Jamal, an area to the north of Jamal Bahal.

The Tibetans know him also as Jowo Dzamling Karmo, the White Lord of the World, or as Jowo Jamal Karpo, the White Lord Jamali. He is renowned as one of the Four Exalted Brothers, and the divine essence of these brother divinities is Avalokiteshvara. He is a talking bodhisattva, for this image of Avalokiteshvara arose from the buddha fields blessed with the power of speech.

Legend and History

The ancient name of Jamal Bahal is Kanaka Chaitya Mahavihara, one of the eighteen principal viharas of the city. Al-though there is no record of this bahal before 1400 C.E., the Kanaka Chaitya itself is probably of Licchavi provenance and the bahal a Licchavi foundation. With the coming of Jamadya the fortunes of the bahal soared. This bodhisattva deity became the principal patron and protector of Yambu, the northern part of Kathmandu.

The origins of Jamadya are obscure. A late Newar chronicle associates King Gunakamadeva, the legendary Licchavi founder of Kathmandu, with the establishment of Jamadya. This accords with the Tibetan legend that as one of the Four Exalted Brothers he was born, though magically, in the seventh century. A Licchavi king, Gunakamadeva, ruled at the same time as the Tibetan emperor Songtsen Gampo, mentioned as a principal player in the Tibetan legend.

The chronicles aver that later the image was stolen by Tibetan invaders from western Nepal, apparently in the Transitional period. The invaders from western Nepal were most likely Khas Mallas, whose kingdom prospered from the seventh to the thirteenth century. It may not be coincidental that Kojarnath, mentioned by the Tibetans as the location of one of the Four Exalted Brothers, was within the borders of the western Malla kingdom. According to the legend, the image was abandoned in the Gandaki River by the retreating invaders. The thieving king and his progeny were thereafter afflicted with an incurable skin

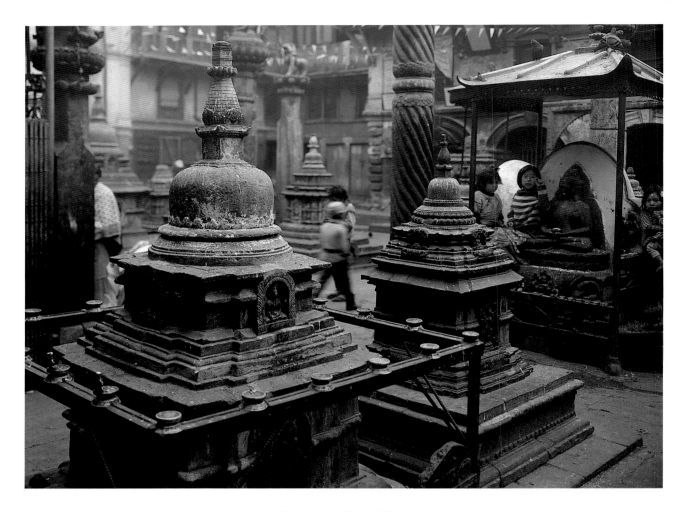

Courtyard of Jamal Bahal

disease and other maladies unto the sixth generation, when it was divined that the ill treatment of Jamadya was the cause of this plague on the house. The image was then recovered from the river, secretly returned to Kathmandu, and buried.

In the reign of Yaksha Malla (1428–82), the image was unearthed by potters digging for clay—or, as some say, it was found in a well. The king had the image enshrined where it was discovered, in the Licchavi village of Jamal, the area to the west of today's Durbar Marg. But soon after, perhaps even during Yaksha Malla's reign, it was moved to Jamal Bahal, in the heart of Yambu, northern Kathmandu. There it took the name of Jamaleshvara, Lord of Jamal, and the people of Jamal still play a major role in the deity's rites, particularly during the chariot festival, which begins in Jamal.

Regarding the antiquity of the image of Jamadya, innumerable coats of paint make it impossible to verify whether the image within is actually of sandalwood, the original material of all the Four Exalted Brothers. Determination that the image discovered in Jamal is not of wood would indicate that it was not that taken hostage by the western Malla king.

Jamadya was installed in a two-roofed pagoda temple in the center of Jamal Bahal and became the principal object of worship. The kwapadya, Akshobhya, became virtually ignored, and the doorway of the bahal was changed from west to east. The chariot festival of Jamadya, a major annual event

certainly by the seventeenth century, became the principal chariot festival in Kathmandu.

In 1917 a disastrous fire at Jamal Bahal destroyed the entire south side, including the shrine room of the kwapadya. The stone image was replaced by one of brass. The old wooden buildings were replaced by stucco-faced structures, which accounts for the disunity of style within the courtyard.

Description

Jamal Bahal is located in Khel Tol on the diagonal arterial route bisecting northern Kathmandu. Outside the entrance is a pillar surmounted by back-to-back images of Akshobhya and Amitabha. Over the entrance is a recent torana depicting Akshobhya flanked by Prajnaparamitama and Sadakshari Lokeshvara representing Buddha, Dharma, and Sangha, respectively. Entering the bahal, the pilgrim is confronted with a plethora of votive chaityas, images, and pillars standing in front of a large, freestanding, two-roofed pagoda temple. The entire courtyard is surrounded by houses that are no longer the residences of the bahal sangha but belong to merchants and traders. The bahal evinces a busy atmosphere of trade and secular community activity.

At the right upon entering is the unremarkable shrine room of the kwapadya, Akshobhya, its latticed front surmounted by a recent brass repoussé torana depicting Buddha, Dharma, and

Sangha. A fine wooden torana high above the tunnel-like entrance shows Mahakarunika, the thousand-armed, thirteen-headed Avalokiteshvara, in the center. Immediately in front of the entrance is a four-foot-high bronze Victorian Britannia or Victory, lightly clad, and modified to hold an incense burner over her head. Four pillars facing the temple support Sadakshari Lokeshvara, Simhasana Lokeshvara, Manjushri, Prajnaparamitama, and Green Tara. Another pillar supports a lion with an upraised paw holding a standard. Several Eight-Bodhisattva shikharakuta chaityas are to be found in front of the temple. This chaitya design, popular in the late Malla and early Shah periods, is an unusual feature of the bahal. To the right is a relief image of ten-armed Namasamgiti Manjushri. To the left is a large, old abraded image of Amitabha on a more recent plinth.

Directly in front of the temple is the Kanaka Chaitya that first gave its name to the bahal. Its original form, probably a Licchavi chaitya, is obscured by centuries of votive replastering and whitewashing that have given it the shape of a yoni. The tip of a stone axis protrudes from the top. It is surrounded by a grill and covered by a repoussé mandala canopy. Two pillars raise two Green Taras to face the compound entrance. To the right of the Kanaka Chaitya is a relief of Buddha, Dharma, and Sangha, a small Mahamanjushri, a Mahamanjushri with consort similar in design to the Uma-Maheshvara reliefs, and a small four-faced chaitya showing four standing Buddhas. This last is reminiscent of the rather larger chaitya at Svayambu sometimes dated to early Licchavi times.

In the middle of the courtyard is the temple of Jamadya, a large, freestanding, squat, two-roofed pagoda structure with elaborate decoration. The roof struts are carved with different multiarmed forms of Lokeshvara and from the roofs hang halampo banners. Under the eaves are gilt copper repoussé flags showing the mahasiddhas—eleven in the front and three on each of the other three sides. The ground floor has been caged in to

prevent theft, particularly of the fine cast images that adorn the toranas, but to little avail. Under the lower roof hang glass-framed paintings of Lokeshvara's 108 forms according to a simplified Newar iconography. The front is entirely covered with gilt copper repoussé decoration. The three doors of the front entrance are surrmounted by three remarkable toranas covered by a plethora of floral work in which various Buddha images nestle. The central torana shows Sahasrabhuja Lokeshvara flanked by Green and White Taras; the left-hand torana once showed an Amoghapasha Lokeshvara, now missing, flanked by consorts; the right-hand torana shows a six-armed Amoghapasha also flanked by consorts. Repoussé Mahakalas stand at the base to the right and left of the doors. Within the doors on the left side are two stone images of Padmapani, and on the right side an image of Mahamanjushri.

Within the inner walled sanctum, Jamadya is Padmapani Lokeshvara, who shows the gesture of boon-giving with his right hand and holds a lotus with his left. About four feet high, he is seemingly formed of plaster, painted white. His hair is piled on his head as a jata with his parent buddha, Amitabha, painted in the center. Adorned with bodhisattva ornaments and crown, he is covered with garments and ornamentation and wears the sacred fivefold thread. When the image is being washed it can be seen that his body has a golden tika on his forehead, an endless knot (shri vatsa) in the center of his chest, and a swastika at his navel. A blue dhoti is painted on his body. The image is flanked by White and Green Taras.

Doors give entrance from all sides. The door on the left shows repoussé protective Mahakalas, and the torana shows a cast Amoghapasha, flanked by one new Green Tara. The torana over the rear doors shows three new cast figures: a four-armed Amoghapasha, flanked by Green Taras. The torana over the doors on the right show the same three cast images. The gilt repoussé work on the doors shows the eight Newar siddhas.

Worship of Sveta Matsyendranath during his chariot festival

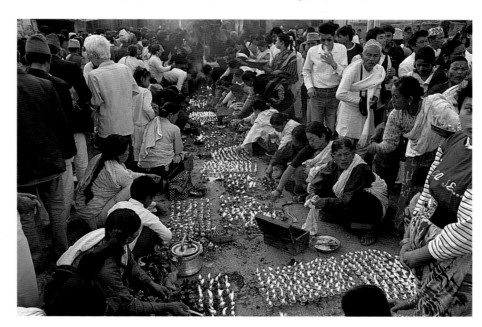

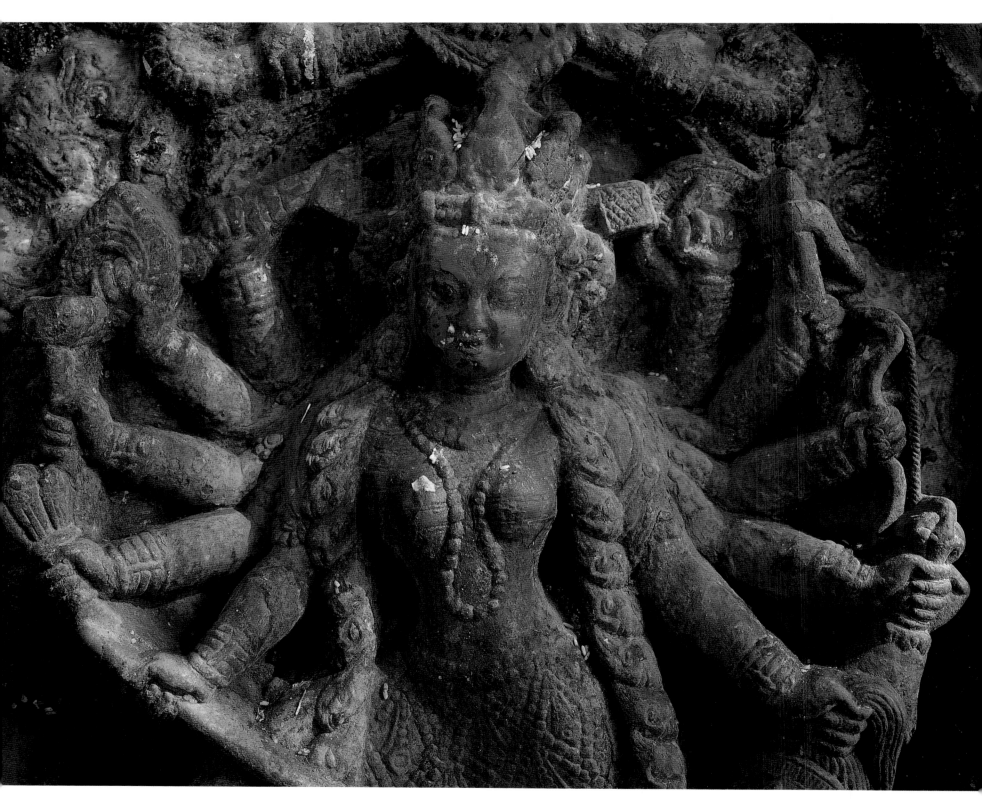

Statue of Durga Maheshasuramardini

TEKU PACHALI BHAIRAVA

Close to the Bagmati River and not far from Teku Dobhan is the stone residence of the terrible Pachali Bhairava, protector of southern Kathmandu and one of the four great Bhairava protectors of the valley. The great age of the shrine is shown by its site in a pit under a giant bodhi tree, the roots of the tree forming a cave behind it.

While the origin legend of Pachali Bhairava nicely conveys the terror-inspiring quality of the deity, a ludicrous twist at the end deflects the fury of the god evoked by the story. According to the legend, Bhairava incarnated as the king of Pharping in order to woo a butcher's daughter, a kasaini girl. Infatuated with this girl, he imprudently told her of his divine origin and finally succumbed to her importunate wish that she see his divine nature with her own eyes. On the night of his revelation the king gave her strict instructions that she should scatter rice over him after he had shown her his true form, in order to return him to his human shape. But seeing the god's fury disclosed, she was terror-stricken, threw down the rice at her feet, and fled, Bhairava in hot pursuit. He chased her until dawn, but when the cock crowed he dived into a roll of matting, leaving his buttocks protruding. In this undignified stance he was discovered by the people. His stone residence at the pitha, represents his buttocks, "the emblem of Bhairava," which King Pratap Malla later enshrined.

The name Pachali Bhairava is commonly understood to mean Panchalinga (Five Lingam) Bhairava. But perhaps he took his name from the Panchali district of Licchavi times. Pachali Bhairava is a well-known treaty witness, guaranteeing that retribution will fall with bloody vengeance upon the breaker of any compact witnessed by him.

The pitha compound is enclosed by patis, shelters for pilgrims. The actual pitha is enclosed by railings holding oil lamps, and its entrances are guarded by large stone lions. The stone residence itself is covered by the torana erected by Pratap Malla. The gods Ganesha, Kumara, Ajima, Durpatti, and Varahi attend him. In front of the stone residence is the eight-armed brass image of Bhairava, twelve inches high, which receives devotees' offerings. A copper mandala-inscribed canopy hangs above, while swords, tridents, and other symbols have been erected beside the standing stones around it. In front of the image, on the west side, is a gilt copper repoussé image of a supine vetala—a corpse, six feet long, where blood offering is made. A pit for *yajnya* fire puja is beyond this. On the north side of the bodhi tree is a fine bell with a Bhairava mask. Nearby is a fine stone sculpture of Durga Maheshasuramardini, probably from the mid-Malla period.

The god's principal residence is in the rock under the bodhi tree, but he also resides in the four-armed image in front of the rock and in a pot *(kalasha)* of alcohol, which is rotated annually among the jyapus, the Newar farming caste of southern Kathmandu, who are his principal devotees. On the fifth day of Dasain *(panchami)* this kalasha is brought in a delirious

procession to the pitha and exposed for worship, and then with the same fanatic excitement is carried to Hanuman Dhoka, where Bhairava is given a sacrificial buffalo in the name of the king before returning to a jyapu's house. The major twelve-year mela includes dance celebrations.

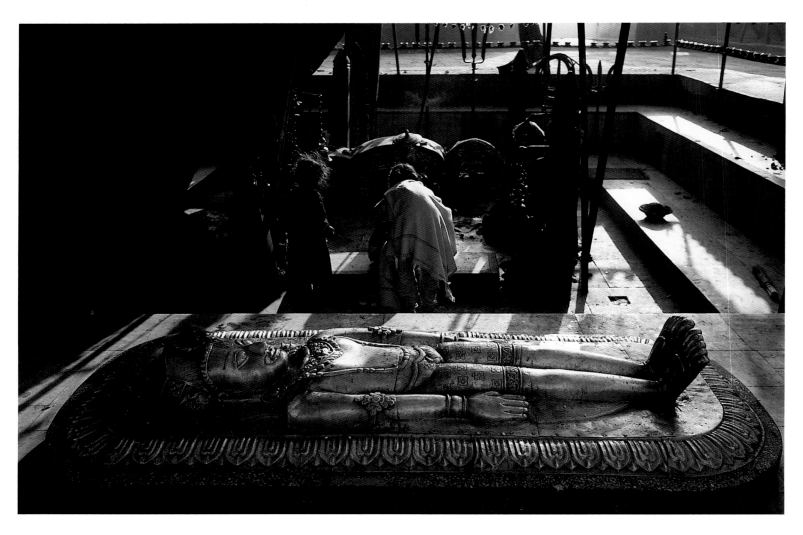

The residence of Pachali Bhairava, Teku

SANKHU VAJRA YOGINI

The large and unspoiled Newar village of Sankhu lies in the northeast corner of the valley on the old road to Helambu and Tibet. The villagers' principal shrine is the Vajra Yogini Temple above the village on the pine-forested flank of Manichura Dhara to the north. Although the highly popular, omnipotent Vajra Yogini in her freestanding temple is the principal object of devotion here, another temple enshrines an important svayambhu chaitya. The entire site belongs to Gum Bahal, the oldest certified vihara in the valley, and another building houses some of the most excellent cast images ever to be produced there. Access to these shrines is limited, however, to initiates and those with special good fortune.

Legend and History

The earliest reference to Gum Bahal is made in the legend of the great Licchavi king Manadeva described earlier in the chapter on Boudha. It was to Gum Bahal in Sankhu that the head of Manadeva's father flew after he had unwittingly severed it. The Buddha's head in the bahal shrine room is called the head of Vrisadeva. Manadeva resided here in retreat to perform penance for his patricide, and the svayambhu chaitya is said to have arisen spontaneously in response to the great king's atonement. The legend asserts that Manadeva was directed by Vajra Yogini to let fly a cock, let it land, and build there a reliquary stupa for his father's remains. It is unlikely, however, that Vajra Yogini was resident here in the fifth century.

At this time we can visualize Gum Bahal as a forest vihara of strict Hinayana monks relying for support on the town of Sankhu on the Tibetan trade route.

The importance of Gum Bahal in the seventh century is indicated by an inscription in Harigaon recording the donations given to various valley bahals by King Amshuvarman (c. 605–21). Gum Bahal was mentioned first on the list. It was probably during late Licchavi times that Gum Bahal was transformed from a Hinayana to a Mahayana monastery. At about this same time, Sankhu or Gum Bahal itself may have developed one of the subcontinent's greatest bronze-casting workshops. Some of its putative products are still extant in the bahal.

The earliest Tibetan mention of Sankhu occurs in a fourteenth-century revealed biography of Padmasambhava. At the end of the eighth century, Tibet's Great Guru was on pilgrimage to the valley and stayed at Sankhu. Here he encountered a young girl, whom he took as his mystic consort. Her mother had died in childbirth and she had been left alone in the cremation ground to be taken and reared by monkeys. Guru Padma took her from Sankhu to Yanglesho to practice the Yangdak and Vajrakilaya Tantras in his enlightenment meditation retreat. She is known as Shakya Dema or Shakya Devi, perhaps a reference to the Newar shakya caste. During Padmasambhava's meditation here he concealed many treasure texts for future yogis to reveal. The same Tibetan text mentions the visit of the first Tibetan practitioner of dzokchen,

Bairotsana, who fled from Tibet after his teaching was slandered and during his stay in Nepal offered a golden icon to the monastery of Sankhu. If these stories are apocryphal, at least they indicate a tradition of Tibetan Buddhist pilgrimage to Sankhu from the fourteenth to the sixteenth century.

Little information is available about Gum Bahal in the Malla period. Evidence suggests that circa 1350 the image of Ugratara, also known as Mahachina Tara, was brought from Bengal by Buddhist priests escaping the ravages of the Muslim invasion. In 1655 (the year in which Vidyeshvari Bahal was restored), during the reign of King Pratap Malla, the present temple of Vajra Yogini was constructed. Legend indicates that there was conflict between Buddhists and Hindus at Sankhu, but it is difficult to extract historical information from these stories. The late chronicles represent a time when followers of the Hindu champion Shankaracharya, in the alleged process of establishing orthodox Brahmanism in the valley, attempted to usurp the Buddhists at Sankhu but were repulsed. An agreement allowed Hindus and Buddhists equal access to the popular Vajra Yogini and permitted blood sacrifice to her. It is uncertain to which period this account refers, but a guess is the late Malla period, when the town of Sankhu also became predominantly Hindu. The large rock fallen from the compound's lower level, and now seen lying upturned beneath with a chaitya carved into it, is said to have been dislodged by Shankaracharya in his conflict with the Buddhists.

According to other Buddhist legends, the brahmins were defeated in this encounter. Vajra Yogini's necklace of skulls (mundamala) is said to be composed of the heads of Shankaracharya's brahmin followers. The sword that she carries was borrowed from her younger sister, Guhyeshvari, in fulfillment of Shankaracharya's petition after he had been humbled by her for arrogantly upturning the svayambhu chaitya to demonstrate his supreme power. The blood in her skull bowl is the blood of Brahma, collected after she had severed his head at the behest of a reluctant Mahadeva when Brahma had cheated in the contest with Vishnu to discover the height of Mahadeva's lingam of flame.

Anyway, at some undetermined date blood sacrifice at the door of the yogini's temple was initiated, which indicates Hindu authority here. This practice apparently continued until early this century, when the Buddhists again achieved ascendancy. Since then, bloodletting has been relegated to the residence of Bhairava on the stairway, only a token of that sacrifice being permitted as offering to the yogini. A legend relating to a giant frying pan (wok) kept in the bahal establishes Vajra Yogini's erstwhile acceptance of blood and her final rejection of it, but the legend is medieval and cannot apply to this century's development. The legend introduces a king

who appeared to achieve remarkable success in his daily service to the goddess. A rival, wishing to emulate his power, spied on the king and observed him cooking himself in a giant pan and offering himself to the goddess, who consumed him. After each rite of self-sacrifice, the king was magically restored to life. The rival attempted to copy the king, but he curried himself too much for the goddess's liking, for she accepted the rival's sacrifice as a one-time offering, declared herself ultimately satisfied, and foreswore meat thereafter. She then turned over the frying pan, which may still be seen in this condition in the bahal. Since then she has required no blood sacrifice.

The Vajra Yogini

Sankhu Vajra Yogini is the eldest of the Four Sister Yoginis of the valley: Sankhu Khadga Yogini, Guhyeshvari, Phamthing Yogini, and Vidyeshvari. Her principal identification is Ugratara, the wrathful emanation of Tara, the goddess of devotion, and a very terrible protectress. Her images here, however, show her in her fundamental serene aspect. Buddhists and Hindus have their separate Tantras and sadhanas of Ugratara. More specifically she is referred to as Nil Tara or Blue Tara, one of three wrathful forms of Tara. She holds what may be construed as a blue utpala lotus in her left hand, but her principal image is painted red.

By the Tibetans she is accounted as a superior wisdom goddess and a female buddha protectress. She is identified as Ekajati, a particularly terrible protectress, and guardian of the Dzokchen dharma, but she lacks Ekajati's conventional iconography. The Tibetans also accept her as Ugratara. A Tibetan guidebook lauds her: she has the radiance of a dakini emanating from her sky fields of pure awareness, and her image is extraordinarily sublime and gives powerful blessings.

Although she is accounted one of the Four Yoginis, her iconography does not conform to any of the yoginis, or dakinis, of the Chakrashamvara mandala. Naro Khechari or Naro Khachoma (Naropa's dakini), the remaining yogini of the four, is related to Sankhu Vajra Yogini, but since there is no iconography of Naro Khachoma here, this identity could only be made on a secret level by the practitioners of that Tantra. It is notable that in 1991 a painted icon of Naro Khachoma had been pasted onto the back of the Vajra Yogini Temple.

The other names of Sankhu Vajra Yogini are legion. Most commonly she is known as Khadga Yogini, since the sword she holds in her upper right hand is her distinctive emblem.

Torana detail,
Svayambhu chaitya
temple, Sankhu

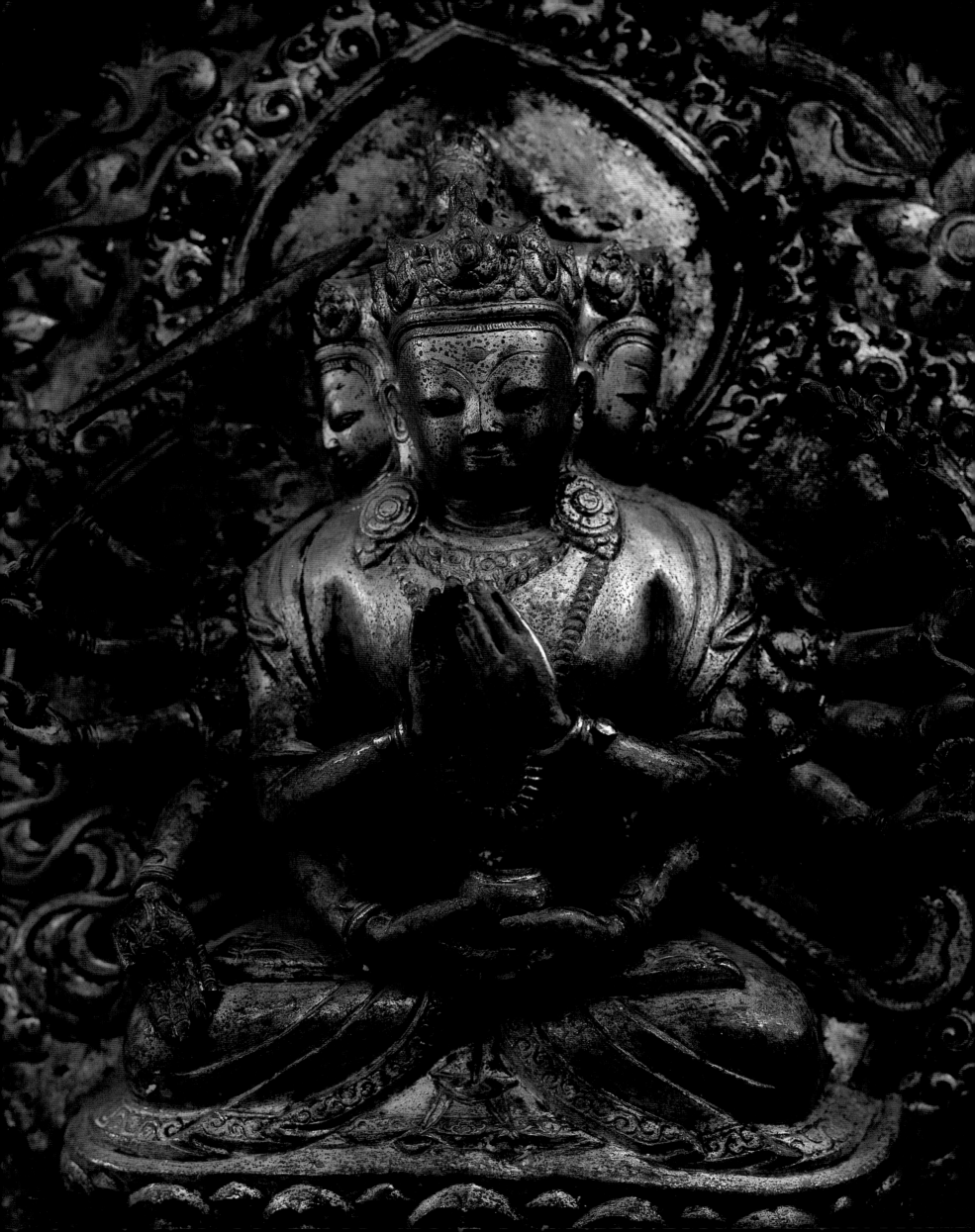

Some call her Mani Yogini, associating her with Manichura, where the Raja Manichura cut off his jeweled hair knot as an offering to the goddess. For some Hindus she is counted among the Dashamahavidya (the ten aspects of Durga), where as Ugratara she is perceived as the personification of spiritual hunger. For the Vaishnavas she is Sankhu Narayani (Vaishnavi or Vishnushakti), one of the Eight Mother Goddesses; for the Shaivas she is Maheshvari. For children she is Nil Sarasvati, confounding Tara with Sarasvati.

Iconographically she is depicted as a serene nubile woman with one face and with either four or eight arms in an aggressive stance standing upon a vetala or human figures. In her four-armed form she holds sword (khadga), lotus (padma), chopper (karpatra), and skull bowl (kapala). In her eight-armed form she also holds arrow, bow, vajra, and elephant goad. Her image within the sanctum is painted red.

Description

Gum Bahal and Vajra Yogini are approached by way of a steep flagstone stairway through a pine forest. Halfway up, beside a water fountain, is the residence of Vajra Yogini's Bhairava consort in the form of a large triangular stone. A canopy erected in 1973 covers this well-worshiped spot, and it is notable that the figure in the center of the canopy mandala is of Mahakala, the Buddhist name of Bhairava. This Bhairava presently receives all blood sacrifice offered to the yogini. Also at this Bhairava Than is a fine image of the gate keeper Ganesha, portrayed with an exceptionally large belly, and a new stone image of Dakshin Kali replacing the broken one lying beside it. Devotees formerly left their shoes in the pati here before proceeding upward. Farther up the stairway is a chaitya on a graduated plinth containing shrines of the Four Buddhas in the four directions, which is the symbol of some Newar families' lineage deity. Beyond this chaitya, on the left, is a vast rock that evidently fell from the lower level of the compound above. A small chaitya originally carved out of the top of this rock now lies upside down underneath it. This is the chaitya that Shankaracharya allegedly overturned. At the top of the stairway, in the midst of a grove of medicinal trees and two tall monkey-tail trees, is the first level of the compound, which contains the two freestanding pagoda temples of the svayambhu chaitya and Vajra Yogini.

The two-roofed svayambhu chaitya pagoda temple has four doors set into well-carved frames in the four directions, each surmounted by a torana. Entry is on the west side, where the door and frame are covered by late copper repoussé work. There the copper torana shows the twelve-armed Maha-Amitabha Buddha on his peacock vehicle flanked by two Sadakshari Avalokiteshvaras. Beneath, on the door frame, is a small cast image of Manjushri Namasamgiti. On the shoulder jambs are Mahakalas and small images of the Five Buddhas. The fine wooden toranas on the other three doors show the buddha consorts of Maha-Amoghasiddhi (north), Akshobhya (east), and Ratnasambhava (south). Thus the iconography of the temple toranas represents elements of the svayambhu vakishvara mandala of Mahamanjushri. The svayambhu chaitya within is the kwapadya of Gum Bahal representing the svayambhu (self-created) Buddha. But this chaitya is a svayambhu chaitya in another sense, for it is a dome-shaped living rock, its form modified by human hand to represent the svayambhu stupa style. The four-foot dome is covered by deteriorating copper sheathing, and its superstructure, reaching into the first floor of the temple, is a replica of Svayambhu's spire. The stone dome of this chaitya may well date to Licchavi times, as legend implies, but certainly the superstructure can be no older than the early Malla period.

In the center of the compound, raised on a high plinth and guarded by a pair of male and female lions, is the large three-roofed pagoda temple of Vajra Yogini, a fine example of seventeenth-century Newar architecture, although the wood carving on the roof is mediocre. The three roofs are of copper, the upper one being gilt with a golden finial (gajura) on top. A gilt copper halampo hangs from the upper roof, and guardian plaques decorate the eaves. The single door to the sanctum is in the south, its jambs and shoulder jambs decorated by exquisite gilt copper repoussé work. The gilt copper torana that surmounts it is of equally fine work and has excellent cast copper figures set into it. The central figure is of serene, one-faced, nubile, eight-armed Ugratara in pratyalidha mudra standing upon kneeling figures. She is flanked by two identical four-armed forms, and Baghini and Singhini, the lion- and tiger-headed yoginis, lie outside them. Above the yoginis are the Meditation Buddhas, Vajradhara, and, at the top, Vajrasattva. On the arched lintel is Yogini in her four-armed form, standing on a vetala, with large Mahakalas at the corners. On the shoulders of the jambs, to left and right, are Chandra and Surya driving their chariots, while beneath them are small Vasundharas and large repoussé Mahakalas. At the base are protective bird-headed yoginis. Within the sanctum is a large four-armed image of Ugratara, flanked by Baghini and Singhini and shaded by large entwined naga toranas. The image, made of some undetermined material, is painted red and covered by ornaments and clothes, so that her iconography is obscured. We know, however, that she carries a sword in her upper right hand.

In the courtyard, in front of Vajra Yogini, are a yogini mandala inscribed in a stone double lotus on an Eight Bodhisattva plinth and a thick pillar supporting a gilt copper lion. To the right is a large pitted rock in a low-walled enclosure, the residence of the Vasuki Nagaraja. In front of the

svayambhu chaitya temple are four simple stone chaitya domes of Licchavi provenance. On the west side of Vajra Yogini is a small shrine that once held an image of Padmapani Avalokiteshvara, but now contains a Sarasvati.

A stairway links the lower and upper levels, and on the right of the stairway is a Newar Vajrayana monk's hermitage. On the upper level is a paved courtyard with a hiti in the middle, surrounded by two-story dharamsalas built in the Rana style. The building on the south side of the courtyard houses the power objects and relics of the bahal. In the ground-floor shrine room are a five-foot-high gilt copper chaitya and a very large (twenty-inch) head of a Buddha, its neck buried in the floor. This head is known as the head of King Vikramajit (or Vrisadeva), father of the patricide Manadeva. Also found in this room is a giant upturned frying pan *(karahi or wok)*. The shrine room of the upper floor contains a gilt copper image of Ugratara with iconography identical to that in the pagoda temple below, again flanked by Baghini and Singhini. To the left is a fine solid bronze image of the Standing Buddha in *visvyakarana mudra*, fifty-two inches high, called the Blacksmith's Queen. On the right side is a solid bronze image of Padmapani, thirty-six inches high.

The Caves of Sankhu Vajra Yogini

Local legend records nine caves in the vicinity of Vajra Yogini. The first, evident behind the yogini temple, is a small square yogi's cave carved out of the rock. Behind the pati on the west side is the Dharma-Pap cave, its two square chambers also carved out of the living rock. Within the inner chamber is a large image of four-armed Ugratara, dating from the early Malla period. The cave obtained its name from the narrow window of this inner chamber, through which devotees may attempt to squeeze; they prove their virtue *(dharma)* if successful or evince their vice *(pap)* if they fail. Avalokiteshvara's mantra, inscribed in large Tibetan script, is visible above the door, and Tibetan mantras are seen on the inner side of the door. Perhaps this cave was the residence of Tibetan yogis in a past era. Another similar cave is located above the Dharma-Pap cave.

Buranilkantha

The village of Buranilkantha lies to the north of Kathmandu on the road to Shivapuri Park. The amazing stone image that lends the village its name lies at its center. Buranilkantha is a massive image of Narayana lying in a small pond on the serpentine coils of a naga. His name means Old Blue Throat (nil=blue; kantha=throat). To the Buddhists he is Buddha Nilkantha, or Nilkantha Lokeshvara, a form of Avalokiteshvara; to the Shaivas he is Buranilkantha Mahadeva; and to the Vaishnavas he is Buranilkantha Narayana and sometimes accounted one of the Four Narayanas of the valley. The Tibetans recognize him as Vishnuraja, a protector of their mandalas. This sculpture is universally perceived by the valley people as a svayambhu image, because no human hand could possibly have fashioned its divine form and features. The basalt from which it was sculpted is found only miles away in the southern hills.

Iconographically, Buranilkantha is Jalashayana—Narayana Supine on the Waters, or Submarine Narayana. He is also known as Sheshashyana Narayana, Narayana Supine on the Naga Shesh, or Anantashayin Narayana—Narayana Supine on Ananta. The image depicts Narayana in his supreme (para) mode, dormant, lying supine in the cosmic ocean at the end of his day, awaiting the moment to emanate the cosmic manifestation of the next eon.

Myth

This is the myth from a Nepali chronicle that describes how Mahadeva received his blue throat:

O Maharaja, in the Satya Yuga the thirty-three crores of gods, devatas, and daityas churned the ocean, and first of all there came out [the horse] Uncharishrava, which Indra took, saying that it was his luck. After the horse came out Lakshmi, whom Vishnu took. Then out came the kalakuta poison, and it began to destroy the world. The thirty-three crores of devatas began to pray to Mahadeva, who alone was able to destroy the power of the poison. Mahadeva, being easily propitiated, appeared and asked what they wanted from him. They replied that the kalakuta poison was destroying the world and themselves, and they sought protection, and implored it with joined hands and tears in their eyes. Mahadeva said that he would instantly destroy its powers; and so saying, he put it into his mouth, but instead of swallowing it he kept it in his throat, which became blue from the effects of the poison, and hence Mahadeva is named Nilkantha. Feeling now very hot he went close to the snowy range of mountains, but the cold there was not sufficient to cool him. So he struck his trishula into the mountain, from which sprung three streams of water, and he lay himself down in it and let the water fall on his head. There [in the Gosain Kunda Lake, in the mountains north of the Kathmandu Valley] lies Sadashiva, who takes away the sins of man, and exempts him from rebirth.[*]

Buranilkantha is the substitute tirtha in the valley for the

[*]Daniel Wright, *History of Nepal* (Calcutta: Ranjan Gupta, 1966), p. 165.

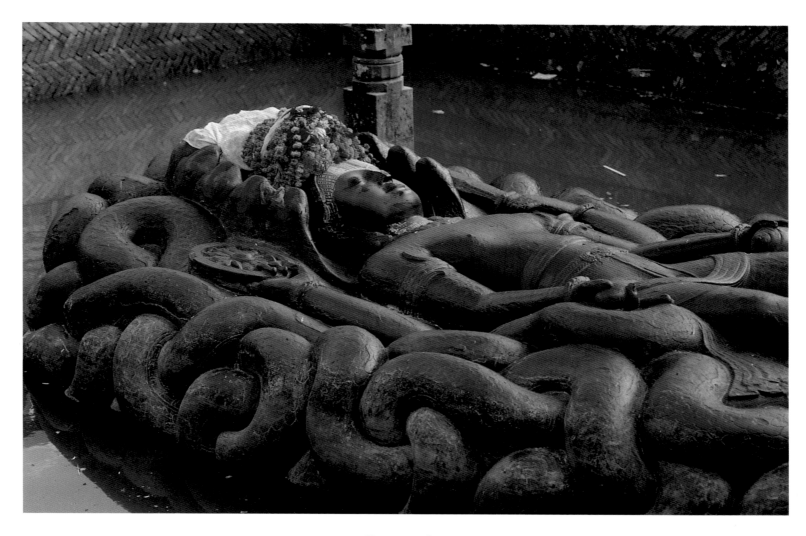

Sleeping Vishnu

Gosain Kunda Sadashiva, and it is widely believed that the water of both the Buranilkantha and Balanilkantha (Balaju) ponds originates at Gosain Kunda.

History and Legend

Buranilkantha is one of three extant monumental images of Jalashayana Narayana established by the Licchavi king Vishnugupta (r. 633–43). The first was taken by Pratap Malla to the Basantapur Palace in the seventeenth century; the second was installed in a pond beneath Nagarjuna Hill now called Balaju; the third image, Buranilkantha, the largest and most magnificent, was installed around 641, in one of the principal centers of Licchavi habitation. It was carved elsewhere and brought by forced labor to the site.

Buranilkantha was apparently covered over and lost for some centuries, perhaps beginning in the chaos of the Transitional period. According to legend, a farmer digging in his fields rediscovered it when his spade hit the toe of the deity. The mark of the spade is now indicated to pilgrims.

By the time of King Pratap Malla (r. 1641–84) the image had been rediscovered (if he was not responsible for its excavation himself), for the king had a dream in which Buranilkantha told him that if he or any of his descendants or succes-

sors visited Nilkantha they would die. From that time, no raja has visited Buranilkantha. Thus the kings of the valley, incarnations of Narayana, may not look upon Buranilkantha lest the reflection of their divine nature overwhelm and destroy them. King Pratap Malla had a canal dug from the pool at Buranilkantha to the pool at the Basantapur Palace, where he installed the image of the older, rediscovered Jalashayana Narayana.

In a recent protective but aesthetically disastrous renovation of the site, the bodhi tree that partially shaded the image was cut down and concrete railings were erected around the pond.

Description

This, the largest stone sculpture in the valley, is in excellent condition, evidence of its centuries underground. The technical mastery of its sculptors was unsurpassed. The impression of the size of the god is reinforced by the strength and massive proportions of the Licchavi workmanship. Yet the face is delicately delineated, and the pronounced Licchavi underlip gives the face particular character. On his forehead he has the sect mark of the south Indian Vadakalai Vaishnavas. In his four arms he holds discus and mace, seed and conch.

On the west side of the pool on the right hand are fine images of a rishi, Varaha, and a Shaiva yogi.

Buranilkantha is cared for by his hereditary brahmin priesthood, only the favored of whom can traverse the image, which is daily cleansed, anointed, perfumed, incensed, fanned, painted, and ornamented. The sweatband is changed as the sun intensifies and sets. Daily his thousand names are chanted. Flowers, garlands, paddy, vermillion, and fruit are his principal offerings.

Patan

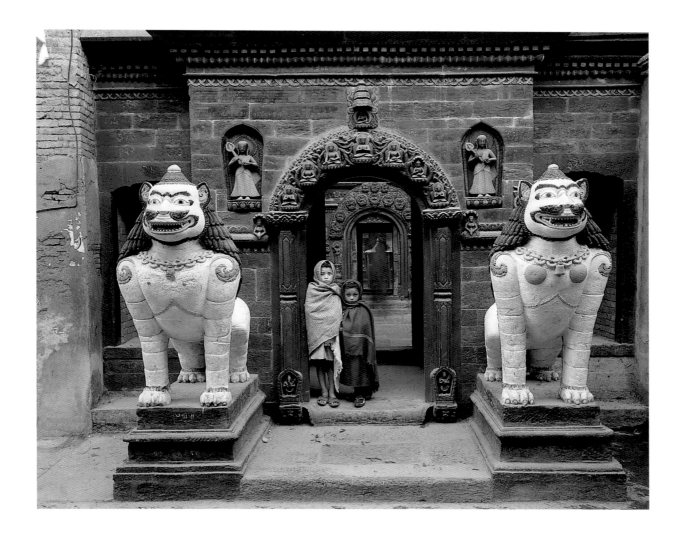

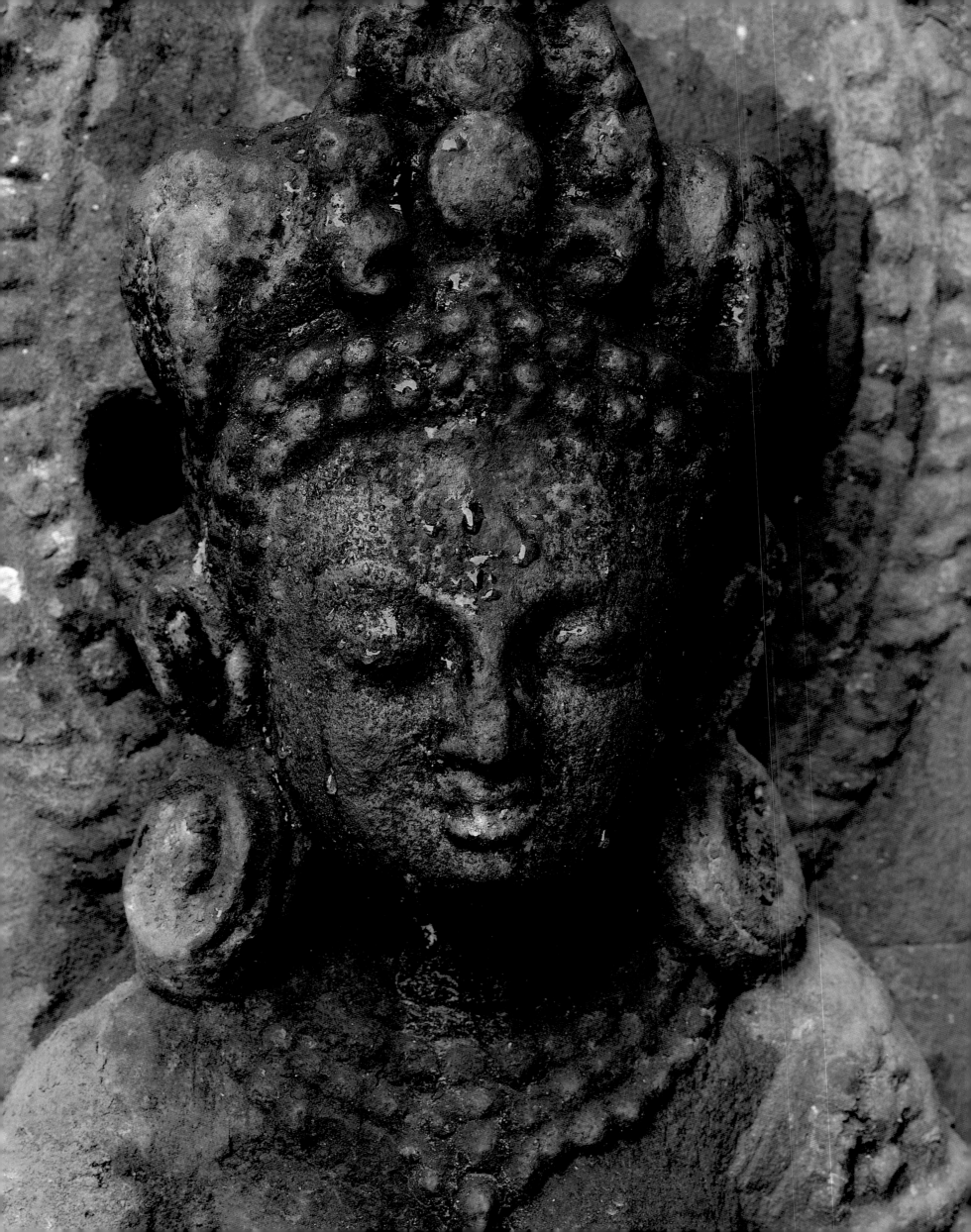

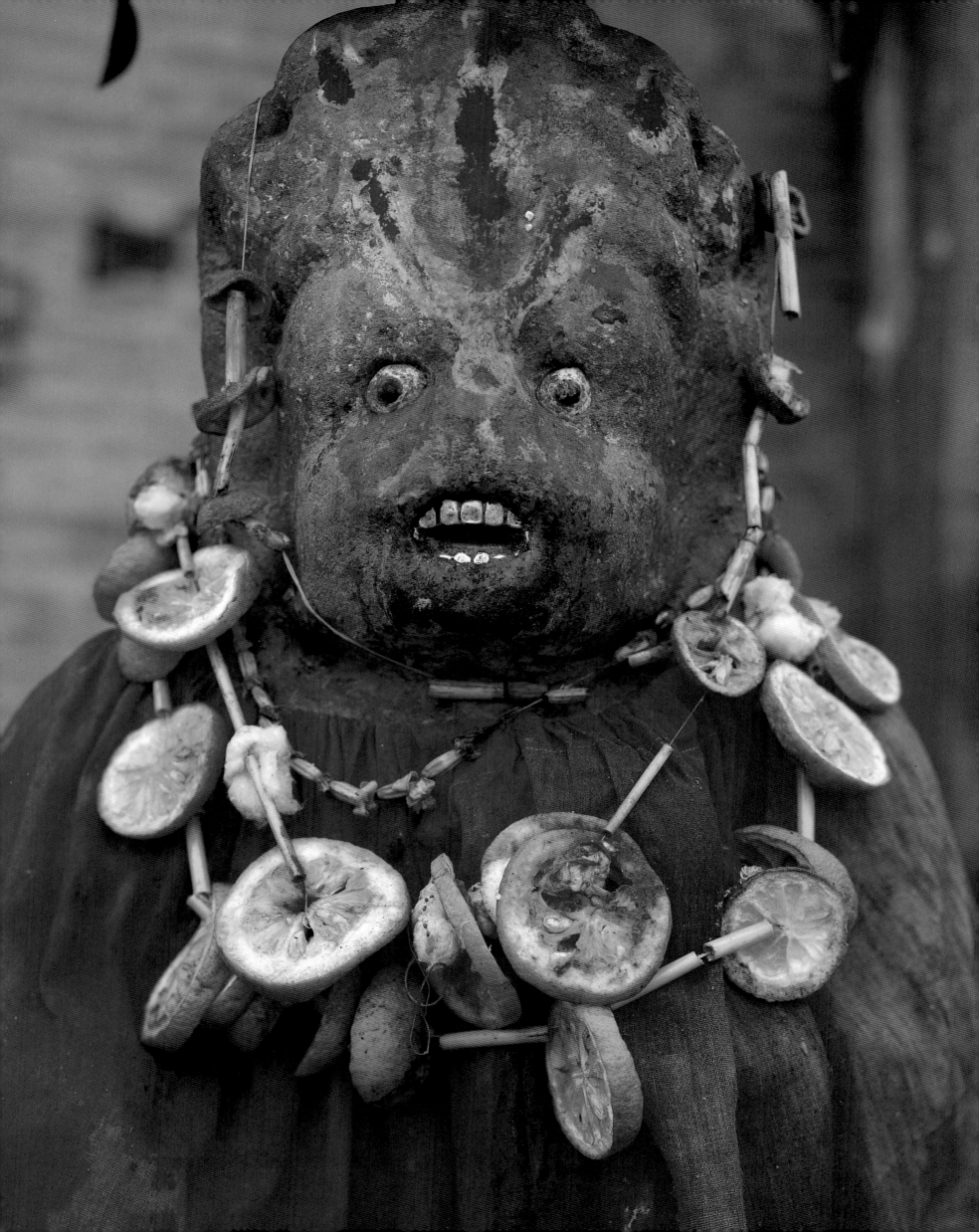

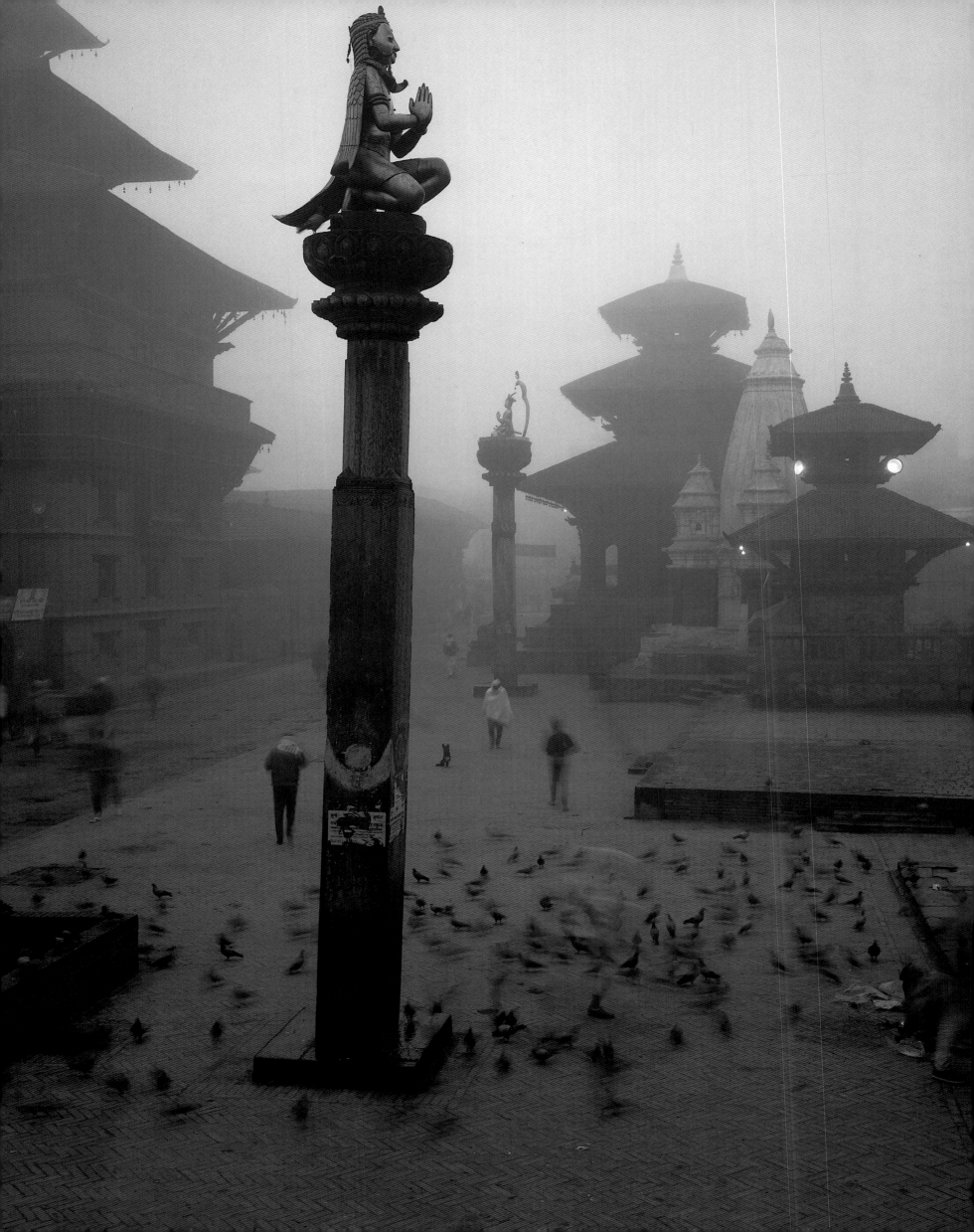

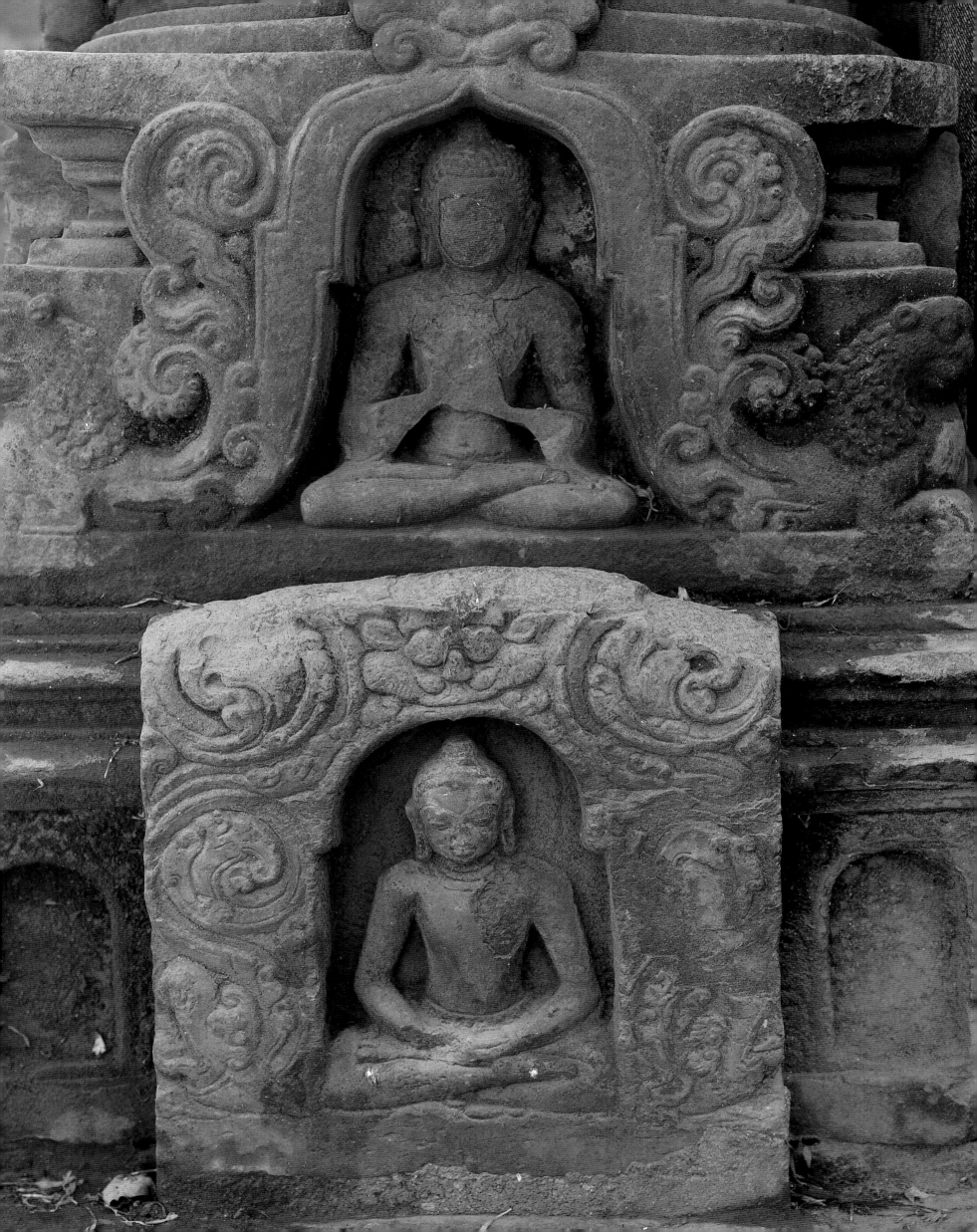

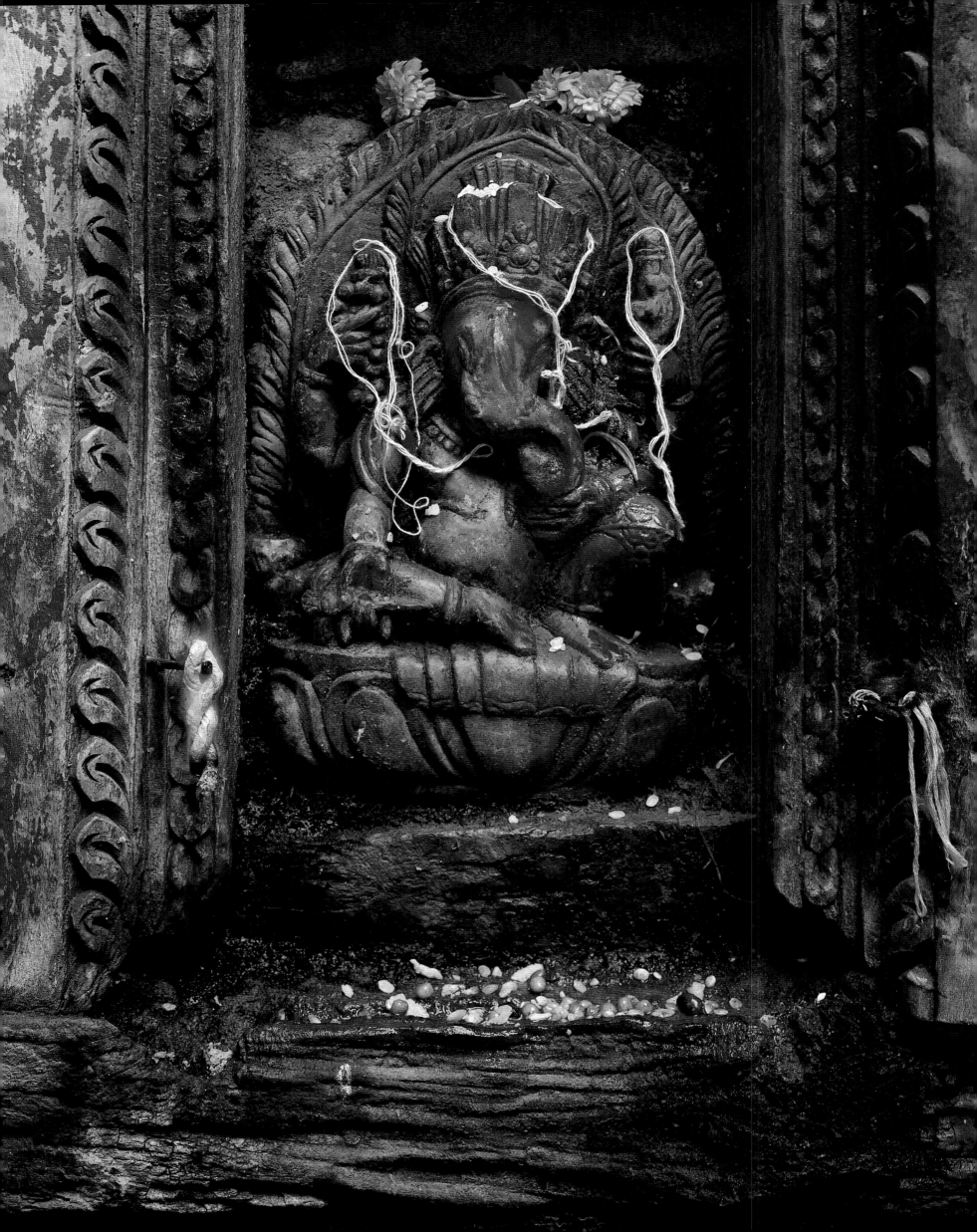

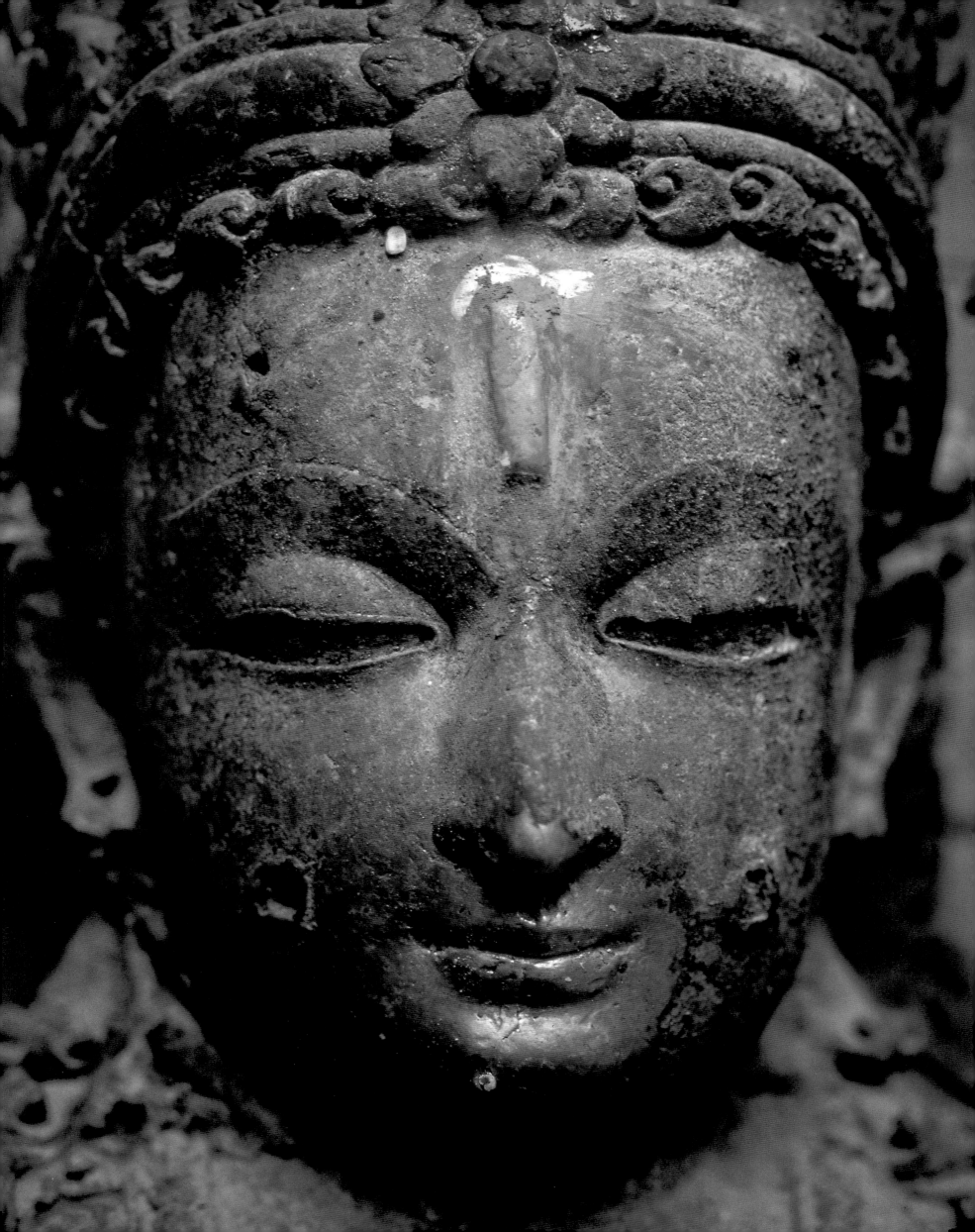

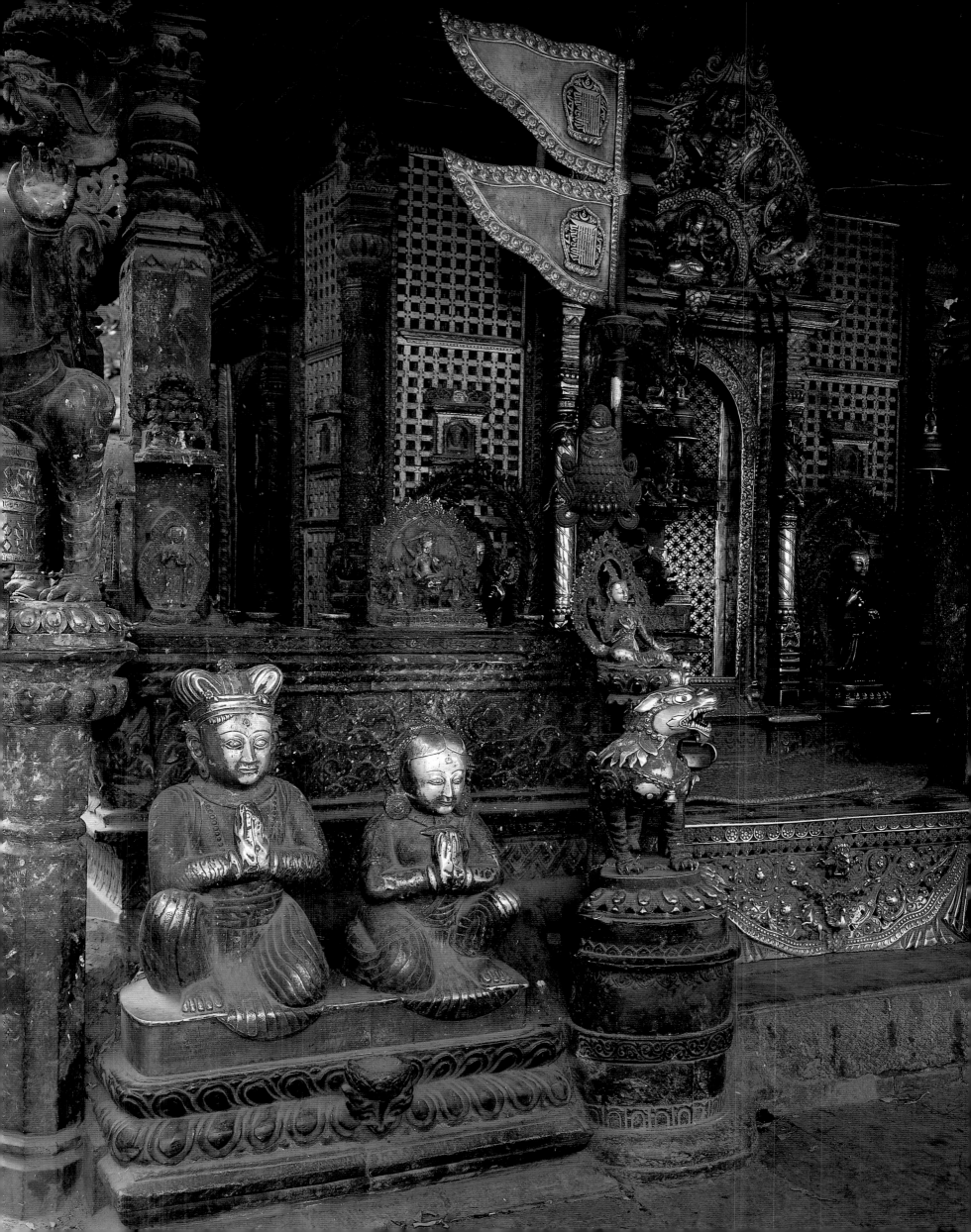

KWA BAHAL

Kwa Bahal is the most significant monastery in Patan by reason of its contemporary religious vitality, its wealth, and its art. It is located on the main north–south artery running through the city, close to the Kwalakhu crossroads. Kwa Bahal is not a residential monastery these days, but rather a center of lay worship consisting of a small temple courtyard crammed with objects of Buddhist worship. Some of these objects are ancient; many are of extraordinary beauty; all are of devotional significance.

Why Kwa Bahal is known commonly as the Golden Temple is immediately apparent to the pilgrim who catches the sun on the gilded copper roofs and shrines. Its formal Sanskrit name, Hiranyavarna Mahavihara, means Golden Great Vihara.

The principal object of worship here is the kwapadya, Shakyamuni Buddha, in the monastery temple. To the Tibetans he is known simply as the Yerang Shakya Thubpa, Patan Shakyamuni Buddha. A svayambhu chatya enshrined in the temple in the middle of the courtyard, a lineage deity, also receives devoted service.

Legend and History

In the legend of the foundation of Kwa Bahal, an old vihara had collapsed from disuse, and the image was buried under it.

Sculpture of Kwa Bahal donors

The Buddha appeared to some farmers, and digging in the vihara ruins, they found an old image. This talking image rejected the residence offered him, and even after the king, Bhaskara Deva, built a new bahal for him, he still rejected it. Finally he told the king that he would live only where mice chased cats. One day the king actually saw a golden mouse chasing a cat; there he built the Golden Bahal, and the image was installed therein. This foundation probably dates from the eleventh century, but rats, considered the pets of the kwapadya, still have the freedom of the shrine.

Many inscriptions in the Golden Temple record offerings made during the Malla period. During this time the bahal expanded to include numerous subsidiary establishments, mostly in the northeastern quadrant of the city. It now has the largest sangha of any bahal in the valley.

Description

A full description of Kwa Bahal is a daunting task. Here only the main features and works of art are described. The entrance to the bahal, the Door of Bhairava, consists of an archway giving access through a passage to the gatehouse. The archway is adorned with a torana showing the seven Manushi Buddhas. The torana over the gatehouse entrance shows Mahavajrasattva at the top flanked by bodhisattvas, and Manjushri Dharmadhatu Vagishvara (in the center) with six Buddhas of his mandala, all with four heads and eight arms. Arhats stand guard below. On the sides, above, are the moon

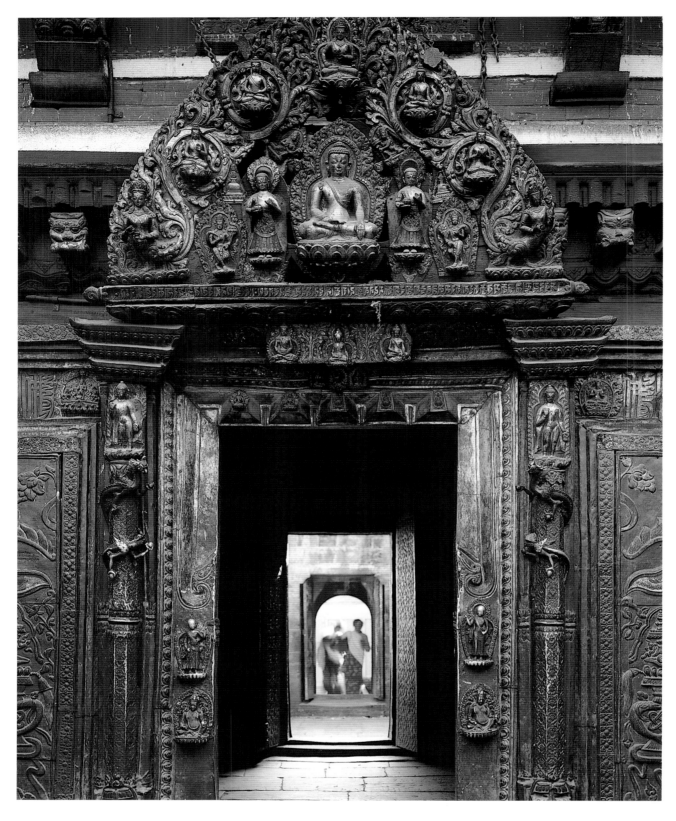

View of entryway and torana at Kwa Bahal

and the sun driving their chariots; Amitabha and Amoghasiddhi in the middle; and below, two standing Manjushris. Inside the gatehouse are two images of Mahakala, a mandala of Guhyeshvari, and an eight-armed Mahamanjushri.

Above the entrance on the courtyard side is a superb gilded copper torana showing Akshobhya in the center, the Five Buddhas around him, and Vajrasattva above. This torana is seventeenth-century work that originally adorned the entrance

to the kwapadya shrine. In front of the entrance, facing the kwapadya temple, are stone statues of devotees riding lions, standing on elephants that are based on turtles. A turtle forms the foundation of the universe, and these animals are revered as pets in the bahal.

Padmapani Bodhisattva

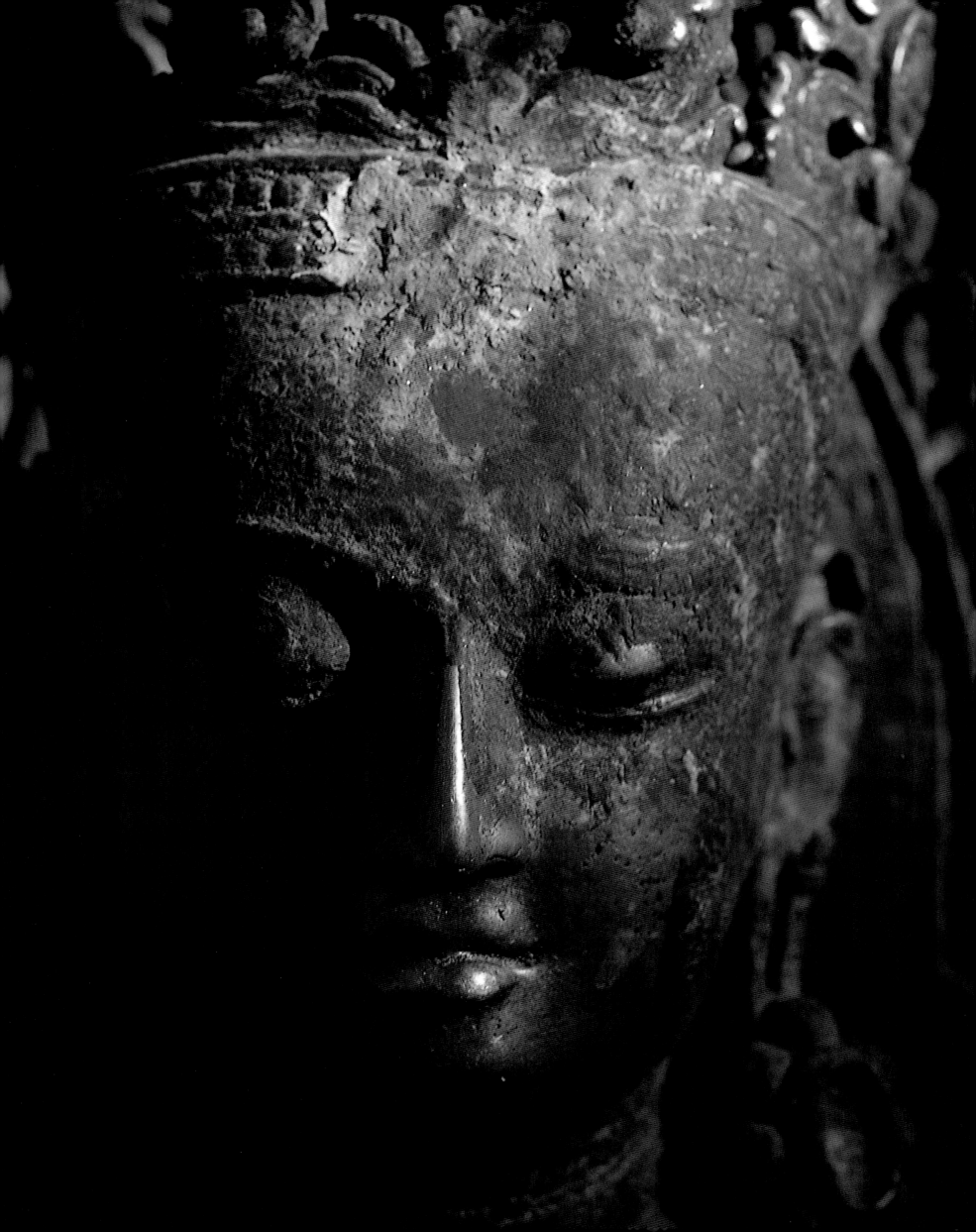

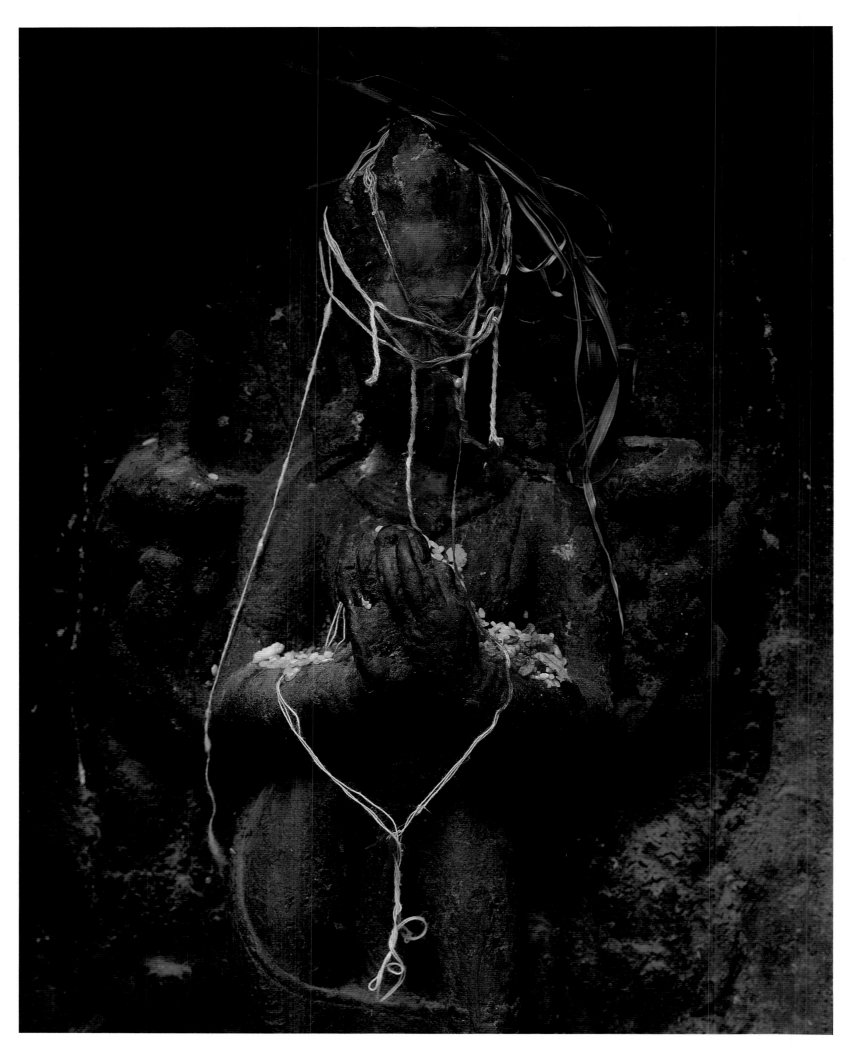

Sculptural figure adorned with pilgrims' sacred threads

The main features of the courtyard are the svayambhu chaitya temple in the middle and the bahal temple behind it on the western side. Walking clockwise around the courtyard on the raised walkway, in the southern corner is the first of four superb, large cast images of the bodhisattvas Padmapani and Manjushri, unique in the valley. This is a standing Manjushri (fourteenth century). On the western side is a shrine to Tara, and in the corner is a shrine to Hanuman. Next to the doorway is a cast Padmapani (fourteenth century) with an elaborate crown.

The bahal temple is a three-roofed pagoda structure, its facade entirely covered by gilt copper repoussé. The entrance is guarded by Simhanada Avalokiteshvara, a cast image of Avalokiteshvara riding a lion that stands upon an elephant. The railed enclosure in front of the temple is forbidden to all but the *dyapala* who services the kwapadya. The doorway is done in gilded copper repoussé and is surmounted by a fine torana worked in silver filigree showing the Five Buddhas, Akshobhya in the center, flanked by the arhats Shariputra and Maudgalyayana, flanked in their turn by attendants. Vajrasattva sits at the top. This fine torana dates only from the beginning of this century. On the lintel are images of the Buddhas of Past, Present, and Future. The Five Buddha motif is repeated in the windows above the door and on the torana over the central window. Again, the row of figures above represent the Five Buddhas flanked by the female bodhisattva Prajnaparamitama and Sadakshari Avalokiteshvara. The roof struts of the lower roof show cast images of the Five Mahabuddhas. Rows of golden chaityas, nine and thirteen respectively, adorn the edges of the middle and upper roofs.

The temple enshrines the kwapadya, Shakyamuni Buddha (Akshobhya), in earth-touching *(bhumisparsha)* mudra and cast in silver. He is arrayed in ornaments. The most important of the other images in the shrine is an image of Vajradhara called Balbhadra.

The exquisite single-roofed temple in the center of the courtyard, covered in gilt copper repoussé, enshrines a small *svayambhu* chaitya in the Licchavi style. This is the lineage deity of the Kwa Bahal sangha. The four superb doorways, covered in gilded copper repoussé, are surmounted by toranas showing the Mahabuddha of the appropriate direction surrounded by the Five Buddhas. Shariputra and Maudgalyayana guard the main door. At the four corners are vicious-looking cast leogryphs, five feet high, guarding the temple. On the

northeast side, underneath a spout for receiving offerings of milk from the chaitya, is the residence of Vasuki Nagaraja. Halampo banners hang down from the roof in the four directions, and the roof itself is crowned by a lotus finial with four nagas supporting a canopy above it.

Behind the chaitya temple is a plinth covered by a dharmadhatu mandala supporting a gilded vajra and protected by a canopy. In the corners furthest from the temple lie the rock residences of protectors to whom the leftovers of feasts are offered.

The northern corner, by the door to the quarters of the dyapala, houses an image of Padmapani (ninth to tenth century), and on the northeastern side is a shrine to Vajrasattva. Behind an image of Padmapani with Amitabha on his crown, in the eastern corner, is a recently installed shrine to Manjushri Namasamgiti.

On the upper floor on the northeastern side, an assembly room in the Tibetan style called the Gumba *(gompa)* focuses Kwa Bahal's strong Tibetan connection. Over the centuries the Newar sangha of the bahal has included many traders to Tibet who lived in Lhasa or Shigatse and who learned the Tibetan methods of worship and on their return practiced them here. These merchants' wealth has lavishly embellished the bahal. The gumba was established in the 1940s after a Tibetan yogi named Kyanchi Lama arrived in the valley, having measured his length on the ground in prostration all the way from his homeland in Kham (eastern Tibet) via Lhasa. He gathered a number of Newar disciples in Patan, and his cult was centered here in Kwa Bahal. The central image on the altar is Amoghapasha Avalokiteshvara. Photos of the renowned Tibetan refugee lamas of the valley hang on the walls. Newar monks of the Tibetan tradition officiate here.

On the southeastern side is the agamche, the secret shrine of Kwa Bahal's Tantric Buddha-deity, Yogambara, and his consort Jnanadakini. Vajra Yogini/Vasudhara is also worshiped here. Only initiates are permitted in this chamber. On the northwestern side is a shrine of Amitabha.

Behind Kwa Bahal is an ancillary courtyard called Ila Nani, and on its far side is a two-floor building housing a second Tantric shrine. On the ground floor is a large image of Chandamaharoshana or Achala, commonly known as Sankata. On the second floor is an image of Chakrashamvara in union with Vajra Yogini.

BUNGADYA
OR
RATO MATSYENDRANATH

Bungadya is the most ancient and most venerated form of Lokeshvara in the valley. Although his home is in the village of Bungamati, four miles to the south of Patan and lying on the ridge between the Bagmati and the Nakhu Khola, he resides for six months of every year in Ta Bahal in Patan and is the patron deity of Patan. Bungamati, still an unspoiled Newar village, is unusual in its dedication to the Buddhist tradition. The village, which is dominated by the great shikhara temple of Bungadya, contains very few Shaiva shrines.

The great glory of Bungadya is revealed during his annual Patan festival, when he is installed in a large chariot and drawn by his devotees through the streets over a period of weeks. The climax of the festival is called the Bhoto Jatra, when the shirt of the deity is exhibited to the people in the presence of the king.

Bungadya or Bungamati Avalokiteshvara is also called Karunamaya Avalokiteshvara, the Bodhisattva of Compassion. His local Newar name is derived from the earlier form Bugama (or Bugma) Lokeshvara. Iconographically he is Padmapani, holding a lotus in his left hand and showing the boon-giving gesture with his right. The Tibetan name Bukham, U-khang, or variations of this form, is a corruption of the early Newar form Bugama Lokeshvara. Popularly, and especially to the Hindus, he is Rato Matsyendranath, the guru of Gorakhnath and the patron siddha of Patan.

Legend and History

There is a general agreement from all sources that Bungadya's great significance as Karunamaya began during the time of King Narendradeva (644–80), when Bandhudatta was the king's wise acharya. The *Svayambhu Purana* (c. fifteenth century) asserts that Karunamaya was brought from outside the valley in order to relieve a twelve-year drought. In the late Malla period the legend of Karunamaya's appearance in the valley had become highly elaborated and was written down. By this time Karunamaya had become identified as Matsyendranath, the guru of Gorakhnath. Many of the essential elements of the legend are of Indian origin, apparently told by Shaivas who incorporated a body of Newar Buddhist lore. The threads of the legend of Matsyendranath as told in the later chronicles are inextricably tangled. This legend conjecturally describes a process by which the most powerful of the buddhas of the valley, Karunamaya, was assimilated by brahmin priests to the Shaiva tradition that dominated the courts of the valley. A contemporary Newar vajracharya tells the story in the following manner:

Narayana, the Lord of Mankind, once perceived that the people of Nepal were in need of the blessings of Karunamaya. To that end he incarnated as the great siddha Gorakhnath. Gorakhnath was born out of cow dung from the seed of Mahadeva. When he matured he was initiated into the prac-

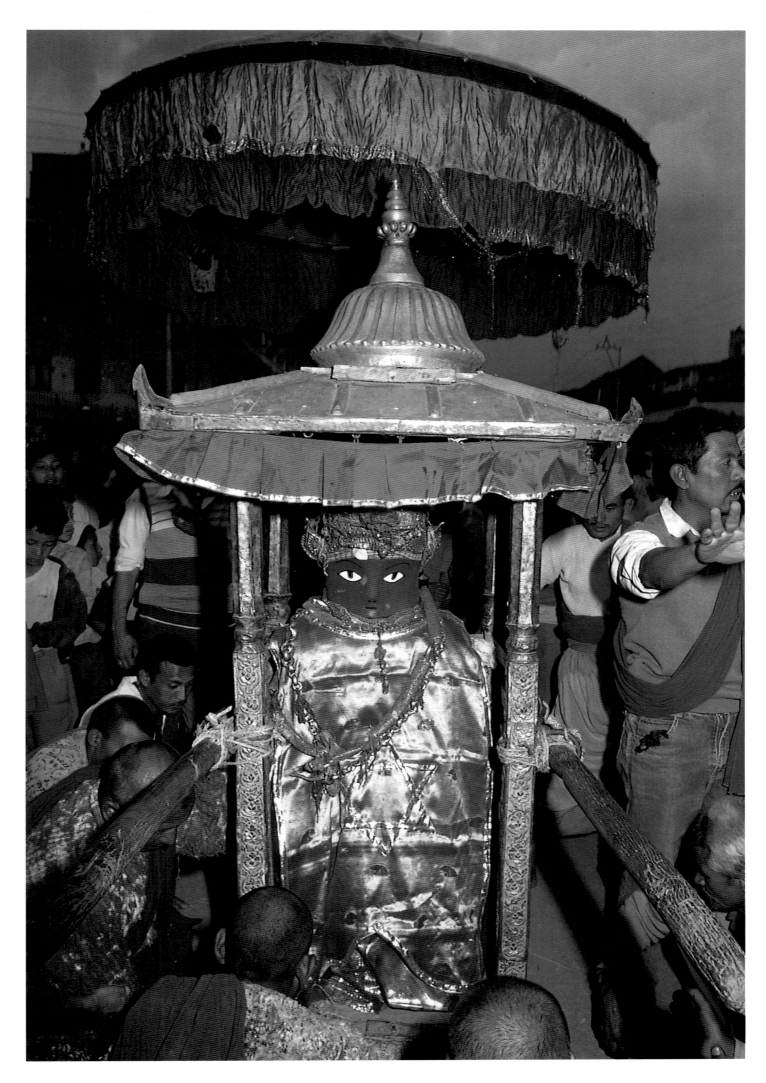

Rato Matsyendranath in procession with priests

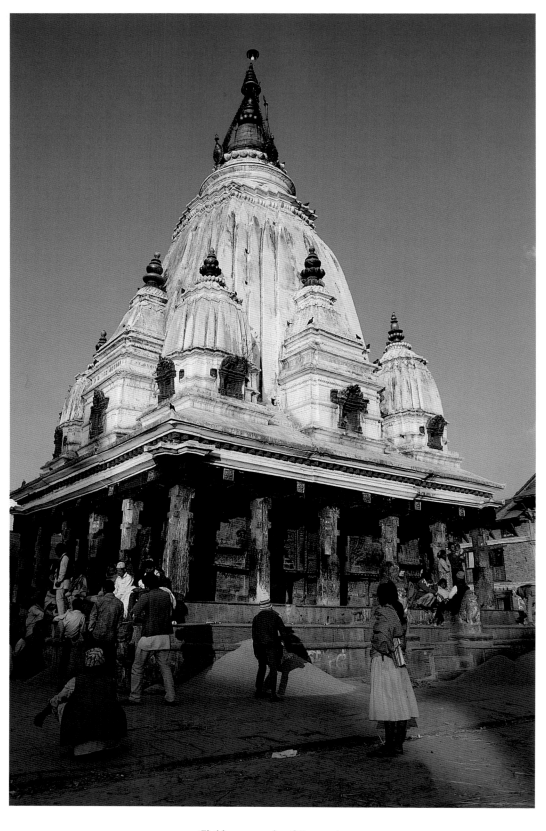

Shikhara temple of Bungadya

tices of the Kanpatha yogis, and later he traveled to Nepal. Upon his arrival a young girl tricked him into losing a bet, and in anger the yogi bound the nine nagas of the valley under his meditation seat, causing a twelve-year drought. The great king Narendradeva was advised by his panditas and astrologers that the only way to end the drought was to bring Goraknnath's guru, Karunamaya, to Nepal, and thus force Gorakhnath to rise from his seat. So Narendradeva, his learned acharya Bandhudatta (a pupil of Shantikara Acharya, from Te Bahal in Kathmandu), and a Patan jyapu set out for Assam, where Karunamaya had been born as the youngest son of the king of Kamuni. The boy's parents strongly objected to Bandhudatta's attempts to lure the boy out of the palace, so the Nepalis left Kamuni for the nearby city and major Tantric power place of Kamarupa.

Finally, Bandhudatta invoked the Four Bhairavas, who wrested the boy's parents' consent and carried the boy on a palanquin to Nepal. As they approached the valley, obstruct-

ing yakshas weighed down the palanquin, making it unliftable, but Bandhudatta's mantra extracted the boy's spirit from his body and transferred it into a bee, which the king captured in a kalasha vase. Arriving at Bungamati, the Bhairavas carrying the kalasha vanished and all the gods descended from their heavens to worship Karunamaya. Gorakhnath also came to worship his guru; rising from his seat, he released the nagas, and again rain fell in the valley. Bungamati was declared the birthplace of Karunamaya, and a temple was built in Patan after an unseemly dispute.

Karunamaya is called Matsyendranath, Lord of the Fish, in non-Newar legends. Matsyendranath was born from a fish who had swallowed the semen of Shiva, which Vishnu had washed from his hand. The leviathan from which Matsyendranath was born had eavesdropped on Shiva's *yoga-jnana* instruction to his consort, Uma, in a haven under the sea.

Very little history can be deduced from the legends concerning the origin of Bungadya except that Karunamaya arrived in Bungamati from India during the reign of the Licchavi king Narendradeva. Almost certainly Bungadya was a local god before he was recognized as Karunamaya, so we can infer that Karunamaya became assimilated to that local god and that his attributes were overwhelmed by those of Avalokiteshvara. It is interesting to note that Narendradeva assumed the throne in 644, which is shortly after the death of the Tibetan king Songtsen Gampo, with whom the Tibetan origin legend of Bungadya is associated.

Historical records mentioning Bungadya during the Transitional period are scarce. A ninth-century record states, however, that a king, Bularjunadeva, made an offering of a crown to Bungadya. A manuscript dated 1079 contains an illustration of a red Avalokiteshvara called Bugma Lokeshvara. In the thirteenth century the Tibetan pilgrim Dharmasvamin, on route to Bodh Gaya, venerated Arya Bu-kham. He wrote, "In Nepal is the sublime Bu-kham Temple in which is an image of Avalokiteshvara, naturally formed in sandalwood, as a five-year-old boy, red in color. This sublime Bu-kham is well known in India, while in Tibet the Sublime Svayambhunath is extolled."*

Until the end of the Malla period, Bungadya was referred to only as Karunamaya or Lokeshvara, but in 1748 a Patan inscription mentions Shri Shri Shri Matsyendranath, and since then, particularly after the Gorkhali conquest, this brahmanic identification has gained currency.

In 1801 Father Giuseppe, a Capuchin missionary, passed through Bungamati and left this impression: "I obtained a sight of the temple, and then passed by the great court which was in front; it is entirely marble, almost blue, but interspersed with large flowers of bronze well disposed, to form the pavement of the great courtyard, the magnificence of which astonished me; and I do not believe there is another to equal it in Europe."†

Description

As the life of the agricultural community of Bungamati revolves around the rites and festivals of Bungadya, so the physical structure of Bungadya's temple dominates the village. The temple stands in a large, irregularly shaped courtyard surrounded by village houses. Although this courtyard may once have been a showpiece of Newar design and order, like the village itself it now gives a derelict impression, wanting for the donations that once gave it a royal appeal.

The courtyard is approached from the north side up a flight of steps with a guardian lion half-buried toward the top. Lions guard the entrance to the gatehouse, which gives access to the courtyard. Immediately facing the gatehouse is the great freestanding shikhara temple of Bungadya. Raised on a double-stepped plinth about four and a half feet high and twenty feet square, six massive stone pillars on each side support equally massive beams, upon which the roof and its mandala of nine shikhara towers is based. The central shikhara reaches thirty feet into the sky. The entire superstructure is constructed of plastered brickwork.

The sanctum within its surrounding colonnade is also built of stone. Its entrance is on the north side, barred doors on the other three sides. A new porch has been recently built in front of the main entrance. Under this porch is a poorly executed repoussé torana, which show Bungadya as Padmapani in the center, flanked by two protecting gods sitting in lalitasana. Padmapani wears a Licchavi-style crown, and his left hand is clenched; the lotus he usually holds is not shown. Above the sanctum door is another torana, whose Buddha representations have been removed and upon which images identical to those of the outer torana have been painted, Padmapani in red. The doors in the other three directions are surmounted by wooden toranas showing forms of Manjushri Namasamgiti in the south and west and another twelve-armed form of Manjushri in the east. To celebrate the twelve-year jatra in 1991, these wooden toranas, the door brackets, and decorative wooden motives surrounding the sanctum were, unfortunately, polychromed.

Within the sanctum the image of Bungadya, Rato Matsyendranath, is of roughly hewn wood, three feet high, a

*See G. N. Roerich, *The Biography of Dharmaswamin* (Patan: JSI, 1959), p. 45.

† See Mary Slusser, *Nepal Mandala* (Princeton, N.J.: Princeton University Press, 1982), p. 373, n. 127.

Pujari (caretaker) of Rato Matsyendranath Temple, Patan

clay-covered standing figure with detachable arms. It is replastered and painted red annually.

In each of the outer faces of the eight small shikhara towers on the roof is a window in which is portrayed a protective deity. Each window, like the central shikhara tower, is surmounted by a gilt pinnacle. Just below the pinnacle of the central shikhara, on the four sides, are four symbols: discus (north), mace (east), lotus (south), and conch (west). These are the symbols of Narayana, an apparent anomaly in this Buddhist context.

In front of the temple is a pit surrounded by oil lamps, the repository of sacred refuse *(chetra pal)*, now containing a broken stone image of a nagaraja, a temple finial, a pillar, and

other oddments. To the north are a dharmadhatu mandala and a firepit. On either side of the entrance are pillars that were once used to display images of King Narendradeva, Bandhudatta, and Lalita Chakra on the first day of each month that Bungadya was resident here. A recent image of Vajrasattva surmounts another pillar.

Further to the west, in a small-domed temple with an ancient wooden doorway, framed in a Newar window at the back, is a mask of Mahakala, also known as Bhairava. This is the Mahakala said to have accompanied Karunamaya from Assam. The image was stolen some years ago, but the thief repented and returned the image after being afflicted by a serious disease. Also to the west of the temple is a row of recent sumeru chaityas, while behind them is an empty plinth used to dress Bungadya as a bride for marriage before his departure for Patan. The larger-domed temple to the west now contains an image of Amitabha, although this is said to have been the original home of Nala Avalokiteshvara. Several other votive chaityas stand in the courtyard, one or two of which may

date from the Transitional period. The larger brick chaitya in the southwest corner, from early Malla times, is of greatest interest.

Hayagriva Bhairava

On the southeast side of the courtyard is a square three-floor Bhairava temple with a rectangular pagoda roof. The shrine room is located in a corner of the first floor. The doorway to this level is surmounted by a repoussé torana that unfortunately has been stripped of its Buddha images except for the Vajradhara at the top—which indicates, indisputably, this Bhairava's place in a Buddha mandala—and a Bhairava on a horse throne at the bottom right. Inside the shrine room, on a raised altar, is an enormous gilded repoussé mask, at least six feet square, with hands showing skull bowl and ankushamudra, representing the deity. A giant copper skull bowl sits on the floor in front of the mask.

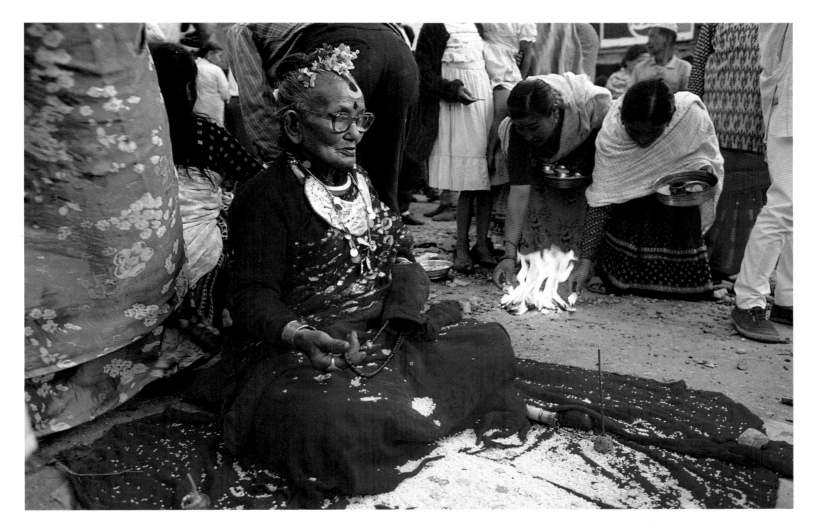

Elderly Kumari and devotees, Rato Matsyendranath Festival, Patan

Chobar Adinath

South of Kathmandu, above the Chobar gorge at the eastern end of the Kirtipur ridge, on a hilltop so high that it protrudes through the winter mists, is Chobar village. In its center, under the brow of the hilltop, its golden finial visible from afar, is the bahal of Chobar Adinath. Adinath is known locally as Anandadi Lokeshvara, Lord of the World "Sea of Bliss." He is the third of the valley's four principal forms of Karunamaya, also known as the Four Sisters. Adinath is androgynous and is identified as both Karunamaya and Mahadeva, and also as Matsyendranath.

Legend and History

Long ago a Tantric master, Suwal Acharya, was meditating by the Bagmati at Jaya Tirtha, just north of the Chobar Gorge at Nakhu Dobhan. Deep in his samadhi, he perceived a jasmine flower floating down the river, and within the flower he discerned the heart essence of Anandadi Lokeshvara. By the power of mantra he caught the flower, put it into a kalasha vase, and took it to Chobar, where the bodhisattva's heart essence was transferred into an image. An annual bathing ceremony was inaugurated at the spot where the bodhisattva was found. Later a chariot festival (Rathjatra) took the image of Anandadi Lokeshvara to Kathmandu—or perhaps to Pashupati in Deopatan, or to Patan. Once during the chariot festival, at a time when Tibetans were raiding the valley, the chariot became stuck in the river and the image was stolen by Tibetan

raiders. Some say that Lokeshvara had transformed himself into a beautiful virgin who had come down from the chariot for a walk and was in that form when the Tibetans abducted him. They took him to Kyirong, where he was bound by mantra, and he has been worshiped there ever since as Phakpa Wati Chenresik. However, Anandadi Lokeshvara again manifested at Chobar, this time to a herdsman called Nanda Guale. Nanda had received the boon of understanding the language of cows after he had informed Karkotaka Nagaraja of his wife's adultery with a common snake, and he overheard a cow telling her calf of the magical property of a certain spot. Nanda found an image of Anandadi Lokeshvara at that place and reinstalled the bodhisattva in the Chobar Temple.

Local legend and the Newar chronicles recount this story with many variations, and the history of Anandadi Lokeshvara remains obscure. It seems probable, however, that the bodhisattva was worshiped at Chobar during the Licchavi period, that the image was indeed stolen by Tibetans, and that thereafter his worship, together with the chariot festival, was discontinued. A palm-leaf land grant of 1588 confirms local belief that worship of the bodhisattva was reestablished at the end of the sixteenth century. The restoration or renovation of the temple in 1642 indicates a flourishing cult at that time.

Another myth relates the Adinath shrine to Jal Vinayaka, the Ganesha temple in the Chobar Gorge. A sadhu sitting in samadhi on an elephant skin on top of the Chobar hill invoked all the gods to participate in a great Ganachakra feast, but he

A statue of the shrew, Ganesha's vehicle, stands as guardian in front of the Jal Vinayaka Temple

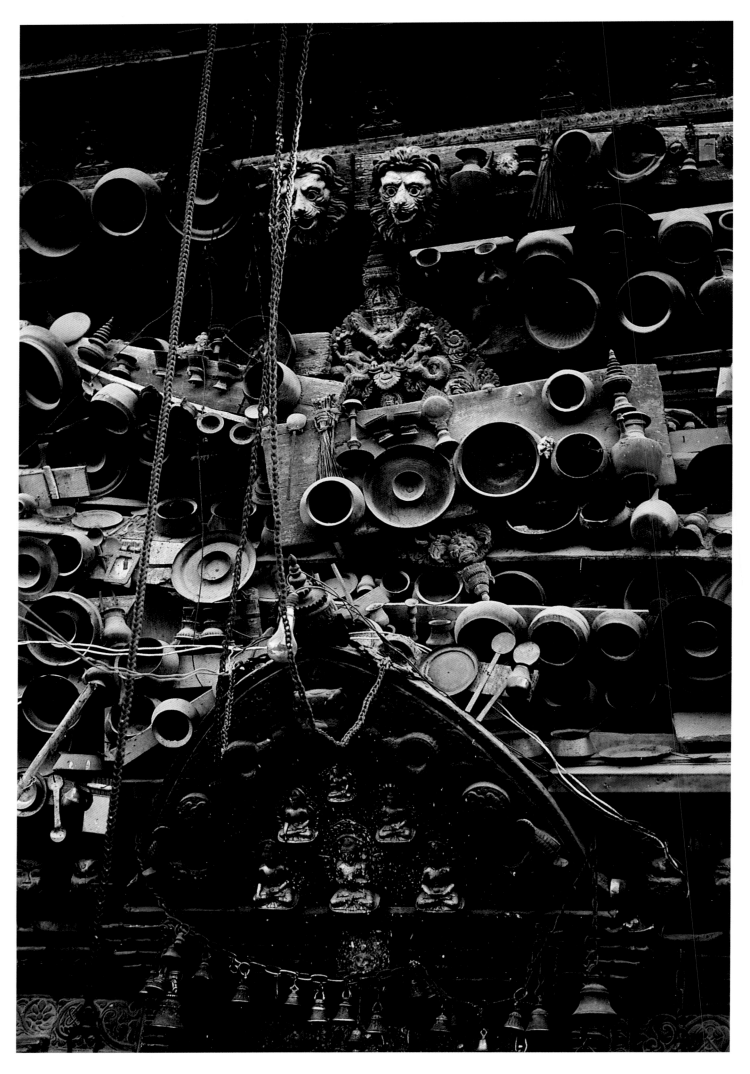

The temple of Anandadi Lokeshvara

neglected to invite Ganesha. Ganesha, as Jal Vinayaka, tunneled up to Adinath and created a disturbance at the feast. The 108 Lokeshvaras appealed to the ten protecting Bhairavas, who ejected Ganesha from the assembly. Each year since then, the bahal has sacrificed a goat to Jal Vinayaka down by the river to allay his jealous wrath. The tunnel that Ganesha dug is believed to open within the sanctum of Gandhebeshvara's temple, although no entrance is visible there. But the Chobar hill is riddled with tunnels and local people confirm that a tunnel joining the two sites still exists.

Description

The freestanding temple of Anandadi Lokeshvara forms part of the buildings surrounding the courtyard of Cho Bahal or Kacchapala Giri Mahavihara. The temple dates from 1642, and the bahal, renovated in the time of King Tribhuvan (r. 1911–55), is still in an excellent state of preservation. The courtyard buildings are used as a primary school and for other nonresidential purposes. In the southeast corner is a bhajan sala containing an image of the Buddha flanked by Rama and Krishna.

The temple of Anandadi Lokeshvara is an imposing three-roofed pagoda structure, its upper roof of gilt copper and the lower two tiled. The finial consists of a gilt pinnacle (gajura) surmounted by a triple canopy. A banner (halampo) hangs down from the upper roof to the lowest, and the Four Guardian Kings are depicted on halampos hanging off the four directions of this roof. On the struts supporting the lowest roof are eight-armed Mahakalas standing above erotic figures. Only here, among the four Lokeshvara temples, is erotica to be found—indicating a Tantric influence.

On the first floor is a large wooden torana covered by pots and pans. These pots and pans and other household utensils, and hundreds like them nailed to planks on the first and second floors of the temple, are its principal identifying feature. Local foreign residents have given it the name Pots and Pans Temple, for this is the most profusely decorated temple in the valley. The pots and pans were offered to Lokeshvara at the death of their owners as a reminder to him to intercede for a better rebirth for them. Some say this offering is made only on behalf of women who had no daughters and therefore no dowry, others that they belonged to women who had no offspring to perform their death rites.

The facade of the ground floor is covered by copper repoussé that imitates brickwork. The old wooden frame of the door is covered by very finely worked gilt copper repoussé. The torana above the door, also of fine gilt copper repoussé, shows the Five Buddhas with Vairochana in the center and Vajrasattva above. Amitabha, as the parent of the image within, is shown on the lintel, with three Buddhas beneath. Midway down the door jambs are the images of two bodhisattvas, while at the bottom of the jambs are two protectors. Chandamaharoshana is the protector depicted on the frame's copper sill cover.

Inside the temple is the image of Anandadi Lokeshvara, or Adinath, the kwapadya of the bahal. It is about three and a half feet high and is adorned with bodhisattva ornaments and robes. The clay face of the bodhisattva is red, with features painted in the crude folk Jugganath style. Above the image suspended from the ceiling is a repoussé mandala of Padmapani.

In front of the temple are an altar for fire puja and a platform used for public display of Anandadi Lokeshvara. In the center of the courtyard is an eighteenth-century shikhara temple dedicated to Gandhabeshvara, a form of Shiva Mahadeva and one of the Eight Heirs to the Bodhisattvas. However, since it is extraordinary to find a shrine to Shiva in a bahal it may be that this shrine predated the bahal foundation as Shaiva devotees identify Gandhabeshvara as Adinath. Inside, where a lingam would be expected, are a ritual helmet and two small unidentified images. The iconography of the deities on the wooden torana above the door is obscure, but local custom identifies the temple as belonging to the Ashtabhairaga, eight wrathful Buddhist protectors.

There is a high Manjushri mandala altar, inscribed with a double lotus, on the west side of the shikhara. In the vestibule of the main bahal entrance at the west are three images of the bahal protector, and in the wall behind a cover are Mahakala and Shaiva niches. Outside the bahal entrance on the north side is the goddess of fertility, Vasudhara, in a caged shrine. Farther to the north is an interesting stupa with a new dome but an old base. Good statues of the Four Buddhas are in four appended shrines, and four Licchavi-type chaityas are at its corners.

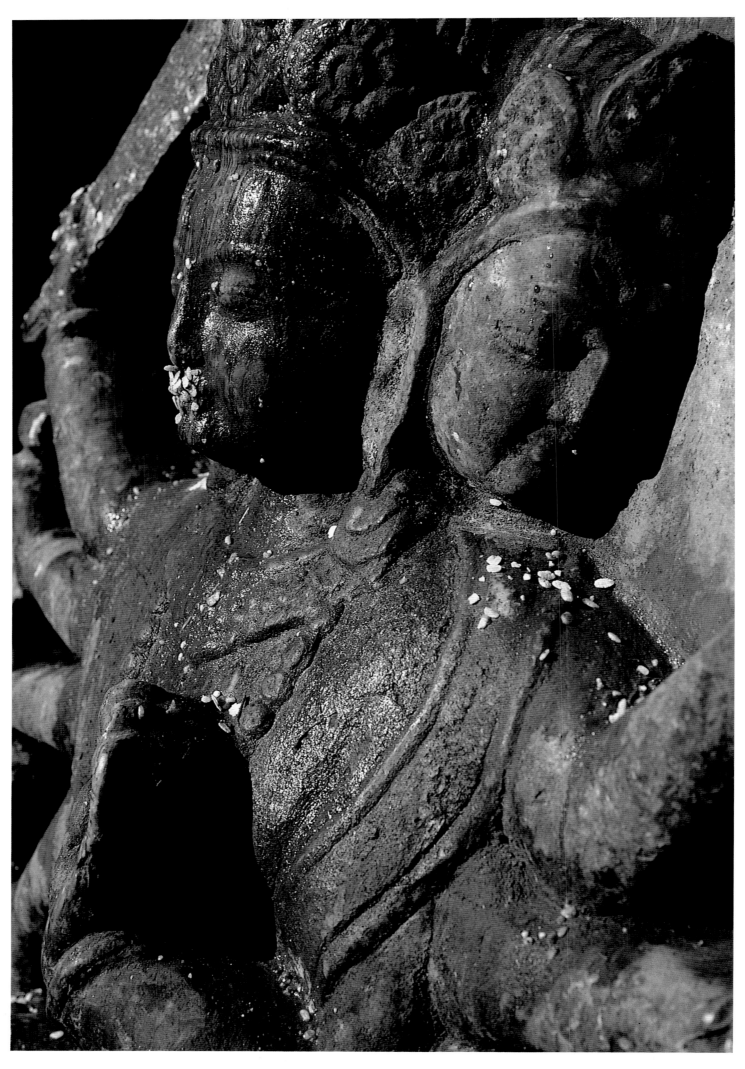

Three-headed stone sculpture from the southeast corner of the Bagh Bhairava courtyard

KIRTIPUR BAGH BHAIRAVA

The great temple of Bagh Bhairava dominates the western end of the Kirtipur ridge. This "Tiger" (Bagh) Bhairava protects the ancient Newar town of Kirtipur that lies around it, but it is also worshiped by the people of Kathmandu and Patan. In his preeminent status he is known as Ajudya, the Grandfather God. Although the Bagh Bhairava Temple overshadows the large temple compound, within its environs are a multitude of highly significant icons.

A familiar local legend describes the origin of this unique "Tiger" Bhairava: Long ago, the shepherd Gothala passed the time while tending his sheep by creating the image of a tiger out of burrs. To complete the image, he left his sheep to search for a red poinsettia leaf in the forest to represent the beast's tongue. Upon his return he found his flock missing and the tiger's mouth full of blood. The omens indicated Bhairava's possession of the image, which was thereafter venerated as Bhairava himself.

The large rectangular temple, enclosed on its ground floor, is a three-roofed pagoda, the lower two roofs tiled and the upper roof of gilt copper. It is surmounted by eighteen gilt pinnacles—an exceptionally large number. The upper part of the ground floor walls are decorated with faded murals depicting scenes from the Mahabharata. The struts of the lower roof are carved with some remarkable erotica. On the third level, weapons dating from the Gorkhali conquest are attached to the wall. The helmet in the center is believed to have belonged to the general Kalupande, the conqueror of Kirtipur. The people

of Kirtipur took the brunt of Prithvi Narayan Shah's invasion during the Dasain festival of 1768, and for their pains they had their noses sliced off, an act that has not escaped the long memory of the people of Kirtipur.

In front of this east-facing temple, to the left of the entrance, is a rock for blood sacrifice to the deity. It is enhaloed by wood and stone toranas depicting the Mother Goddesses, Bhairava's consorts. Above the main door is a wooden torana showing Bhairava in his ten-armed aspect standing on a lotus and a vetala. The window to the left of the door is opened to allow the first rays of the sun to shine on the image of Bagh Bhairava. Within the shrine, to the left is the clay image of Bagh Bhairava himself, its face represented by a silver stylized wrathful repoussé mask two feet in diameter, its tongueless mouth hanging open. It is garlanded with snake-necklaces and crowned by a leaf-shaped diadem. A canopy of seven umbrellas shades it. Vajracharyas are Bagh Bhairava's priests, and the clay used to remodel the image of the deity is gathered from seven points around the Mhaipi Devi shrine.

Within the compound, the most important structure is the small two-roofed pagoda temple just within the main eastern gate. Open on three sides, this temple houses three of the oldest stone images in the valley. The first is a three-foot-high abraded statue identified as either Shiva Mahadeva or the shepherd Gothala, whose tiger model became possessed by Bhairava. His arms are said to have been lost in war. This image can conceivably be dated to the pre-Licchavi period. Next to Gothala is an

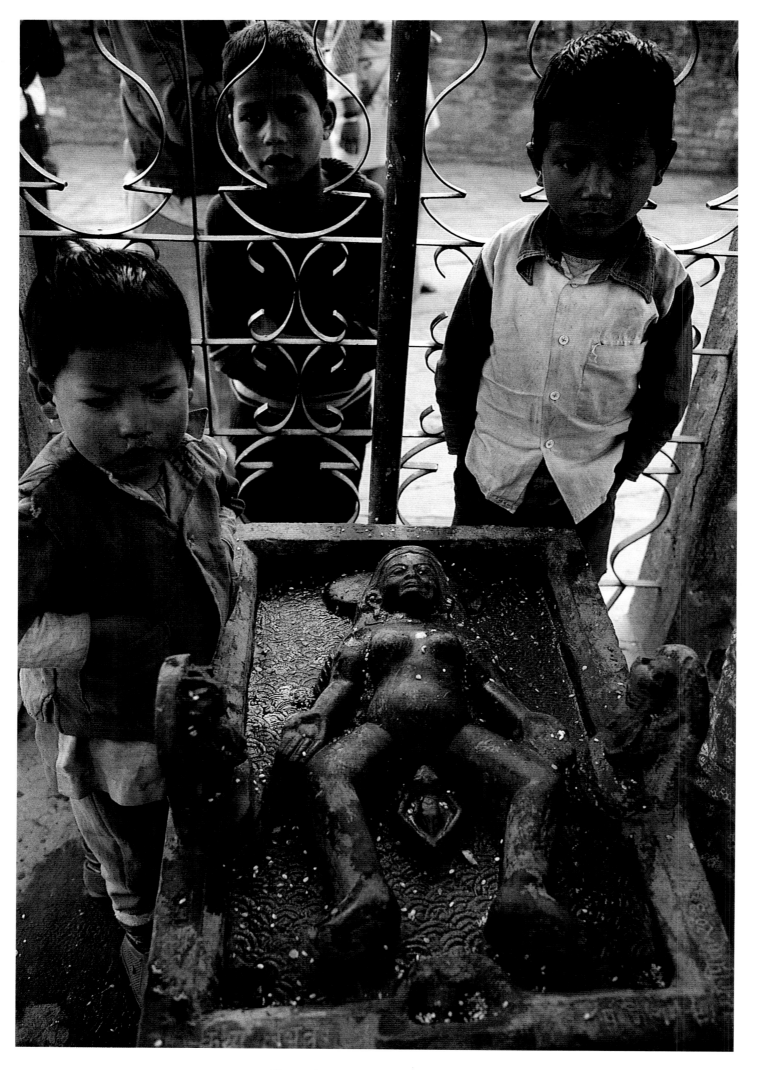

Shrine of Dhartimatta, the Earth Mother

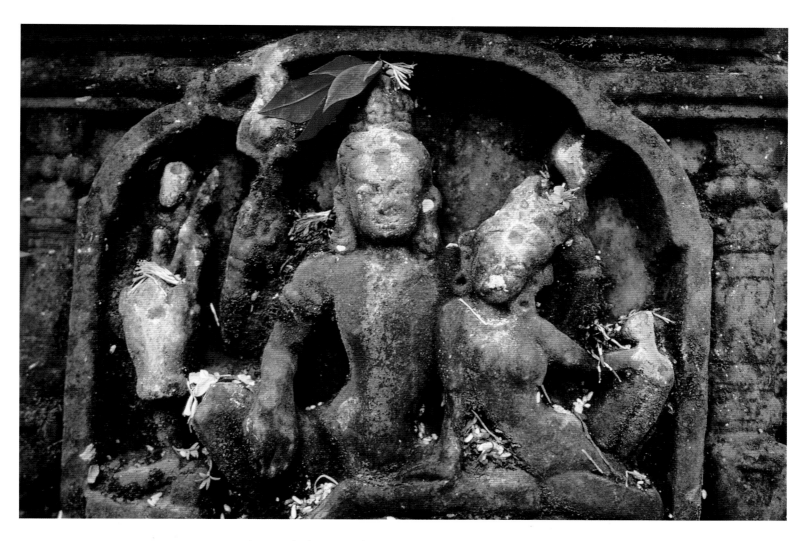

Uma-Maheshvara on the Pharping Road to Shesh Narayana

image of Vishnu, and next to him are small statues of Shiva and Parvati, also possibly from pre-Licchavi times. Still counting clockwise, there are five images of the Mother Goddesses, identified locally as Vaishnavi, Varahi, Kalimai, Parvati, and Lakshmi. These powerful, heavily defined images represent the earliest forms of the mother goddesses in the valley and may be dated to the pre-Licchavi period. Finally, the image of Ganesha, self-manifested out of a natural boulder, is the remover of obstacles to worship of Bhairava.

In the nortwest area of the compound is the shrine of Dhartimatta, the Earth Mother, lying supine with parted thighs and flanked by Brahma and Narayana. She is worshiped by women to relieve problems arising during pregnancy and to expedite birth. Farther to the east is a large statue of Vishvakarma, the god of artisans, in ten-armed aspect and sitting in lotus posture. On the south side is a shikhara on a plinth decorated with reliefs of Narayana's emanations. In the upper floor of the building to the south is the dyache of Indrayani, in which the Eight Mother Goddesses are present as small brass images.

PHARPING VAJRA YOGINI

The village of Pharping is located above the Bagmati River just before it enters the deep gorge that cuts through the Shivalik Mountains on its way to the Indian plains. The village is ancient; in medieval times it was far more important than it is today. The south-facing hillside behind the village is of vast significance for Buddhists, particularly Tibetan Buddhists. It is the location of the Yanglesho Cave in which Guru Rinpoche Padmasambhava attained his ultimate enlightenment. A further cause of the sanctity of this hillside is the bahal residence of the Vajra Yogini of Pharping.

This Vajra Yogini, we are told by Tibetan sources, is the embodiment of pure awareness (*jnana, yeshe*) and is a talking yogini—an oracle who whispers replies to the questions of her devotees. She is the image of the heart vision of the mahasiddha Phamthingpa and others. She is also known as Indra Yogini, She Who Defeats All Opposition, and Indra Kechari; as Uddhapada Yogini, Foot-in-the-Sky Yogini; as Phamthing Yogini, the Yogini of Phamthingpa; and in Hindu Tantra as Nil (Blue) Tara. Call her what you will, she has her right foot planted firmly upon Maheshvara, while her left foot is raised high in the sky, pulled up by her left arm, which presents a skull bowl to her lips. In her right hand she holds a hooked knife slightly away from her side. A khatvanga rests on her shoulder. Here she is red, but according to Tibetan tradition, and to the formal mandala, she is white.

Phamthingpa, whose secret dakini this was and who had the image made in the eleventh century, was renowned as one of the great teachers of his day. He studied in India under the mahasiddha Naropa for nine years, receiving the transmission of the Chakrashamvara and Hevajra Tantras, among others. His name is almost certainly a derivation of an original form of the name Pharping, which is probably derived from Shesh Narayana's epithet Phannathingu. He is better known by his personal name Vagishvarakirti, and his remains are said to be preserved at Lo-chia-t'un in Kan-su province in China, where he died on his return from Wut'ai-shan, the five-peaked mountain paradise of Manjushri. He had two brothers, also practicing tantrikas: Kalachakrapada, who also studied with Naropa, and the youngest of the three, Thangchungpa.

There are no records of the origins of Phampi Bahal, the bahal in which the shrine of Vajra Yogini is located. A Tibetan tradition associates an original image of the yogini with Phamthingpa (eleventh century) and records a restoration and reconsecration of the image during the late Malla period. The present bahal is of brick and evidently dates from the Rana period. Today there is no local sangha connected to the bahal, and a vajracharya priest from Patan performs the rites. The bahal is also called Dharmadhatu Mahavihara.

Description

The two-story, three-sided bahal encloses a courtyard with a high-plinthed chaitya in its center. The south side has been designed to resemble a three-roofed pagoda, but essentially a

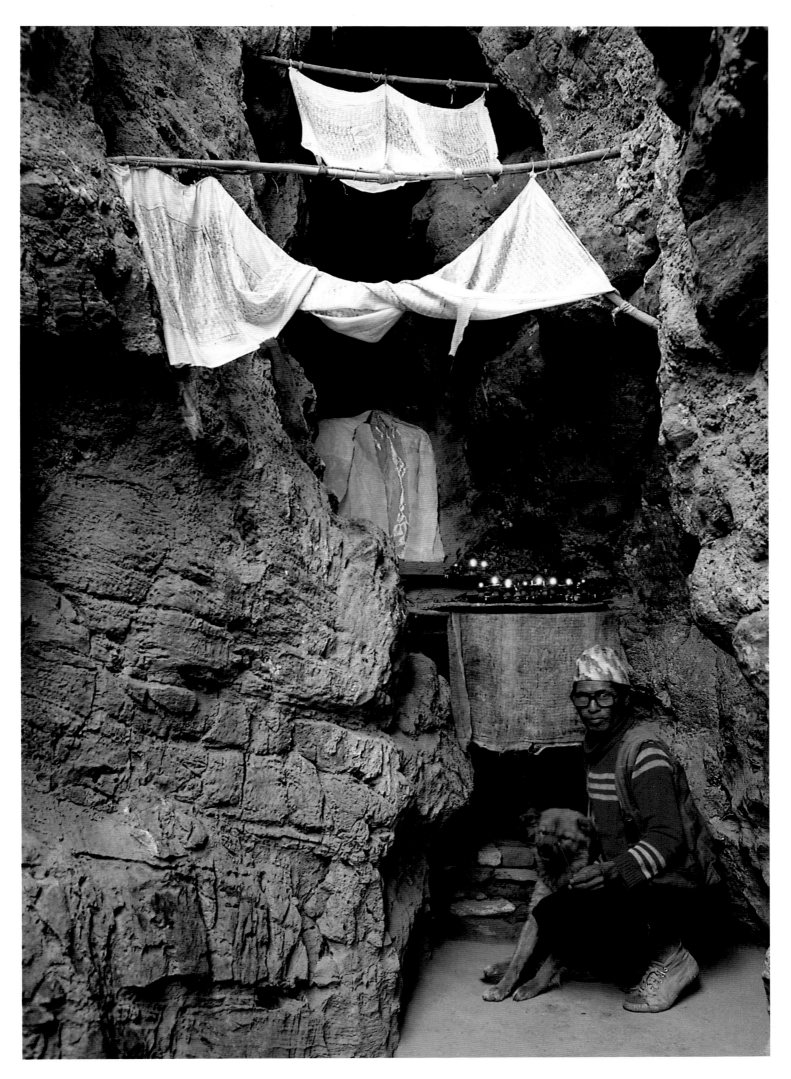

Shrine of Guru Rimpoche, near Asura Cave, Pharping

two-roofed cupola caps the northern bahal wing above the Vajra Yogini shrine. On the ground floor, guarded by six rampant lions, is an open shrine displaying images of Akshobhya, the Buddha of the bahal, flanked by Prajnaparamitama and Padmapani Lokeshvara, representations of Buddha, Dharma, and Sangha. A copper torana depicting Vajrasattva surmounts the doorway. Between the floors are painted reliefs of the Eight Auspicious Emblems.

On the first floor is the shrine of Vajra Yogini, surrounded by a passage for circumambulation. Its doors and jambs are decorated in silver repoussé. Above the door is a gilt torana depicting Uddhapada Yogini flanked by Baghini and Singhini, protectresses of all Tantric shrines and particularly those of the yoginis. A mandala with the triangle of the yogini in its center hangs from the ceiling. Inside the shrine is a thirty-inch bronze image of Uddhapada Yogini, covered in silver and copper repoussé ornaments and wearing an elaborate crown. Baghini and Singhini flank her. On the side of the shrine is a glass case containing wooden images of Manjushri and Tara. In the northeast corner of the upper floor is another shrine room. A wooden torana above its door displays a good representation of the yogini, which contains images identical in form to the main shrine but standing in a palanquin. The gilt copper cast image, probably from the late Malla period, shows fine facial features and delicate hands and feet. Within her aura of flame is a border of vajras. During the Gunla festival this image in its khat is taken around the village.

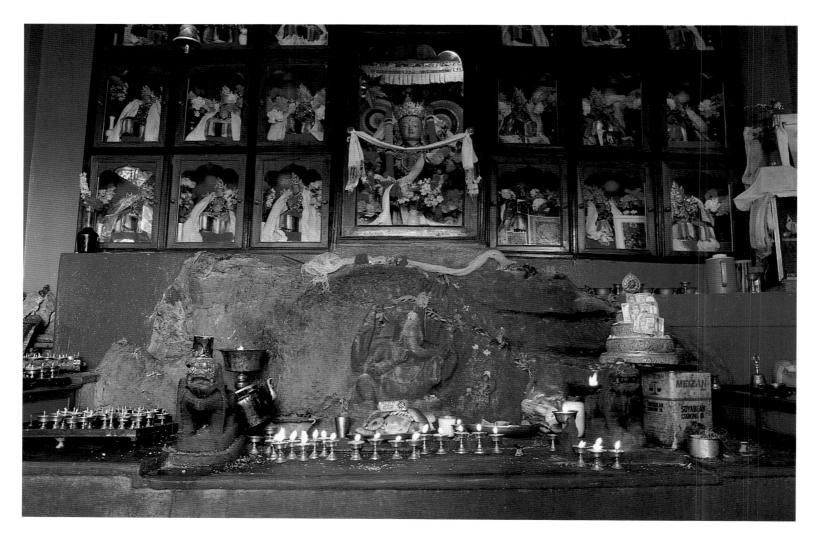

Shrine of self-manifested Tara and Ganesh, Pharping

SHESH NARAYANA

Shesh Narayana is Narayana's principal power place in Pharping. Above two pools of pristine spring water shaded by tall trees, it lies under a high limestone cliff on the road approaching the village. Shesh Narayana is one of the four main power places of Narayana in the valley (with Changu Narayana, Vishankhu, and Ichangu).

Shesh Narayana—Sekh Narayana Than to the Newars—celebrates Vishnu in his dormant, unmanifest form in which he is confounded with Ananta, the cosmic serpent and origin of the cosmos. The large, evocative natural serpentine limestone forms that decorate the cliff face above the temple must have been the original inspiration for the identification of the place with Shesh Narayana and the cosmic serpent Ananta. The Newar Buddhists recall the purpose of the Great Guru Padmasambhava's sojourn at this place as the subjection of the nagas to bring them within the purview of the Vajrayana mandala. The cave of the Great Guru is located beside the temple, and the Shesh Narayana power place forms the most ancient and essential part of the Buddhist complex at Pharping.

Myth and History

The naga Shesh is "the remainder" of the cosmic ocean after Narayana (Vishnu) has created the universe. He is confounded with Narayana himself—thus Shesh Narayana. Upon the dissolution of the universe Narayana becomes the naga Ananta, "the endless," upon which he reclines at the end of his "day," a cosmic cycle. He remains in this dormant form throughout the cosmic night, until he again creates the universe for another cycle of cosmic daytime. As the remainder of the cosmic waters after the creation, the naga Shesh is elevated to symbolize all life force, or the cosmic concept of the element water, preeminent as the potential source of life.

An eighteenth-century Tibetan guidebook relates this Newar Buddhist tradition:

> When the Great Master Padmasambhava or Padmakara was sitting at this place in samadhi, through the naga's magical devices a plethora of venomous snakes appeared, hanging down from above. Disturbed by this temptation, the Guru, with a fixed gaze, struck the naga on the crown of his head with his magical vajra dagger [vajrakila], turning the menacing serpents into stone. Even today on the crag [overhanging the temple] many serpentine shapes are to be seen struggling downward. From the trace of the kila on the crown of the head of the central snake, water emerges at certain auspicious moments.

The same Tibetan guidebook mentions a golden image of Shesh in a well-guarded temple forbidden to non-Hindus. Within living memory the central image in the temple has vanished, to be replaced by the Shridhara image. This indicates a serious and unusual lapse on the part of the Vaishnava brahmin pujaris and temple protectors, who, as a Changu Narayana, can usually be relied upon to maintain an officious and exclusive presence.

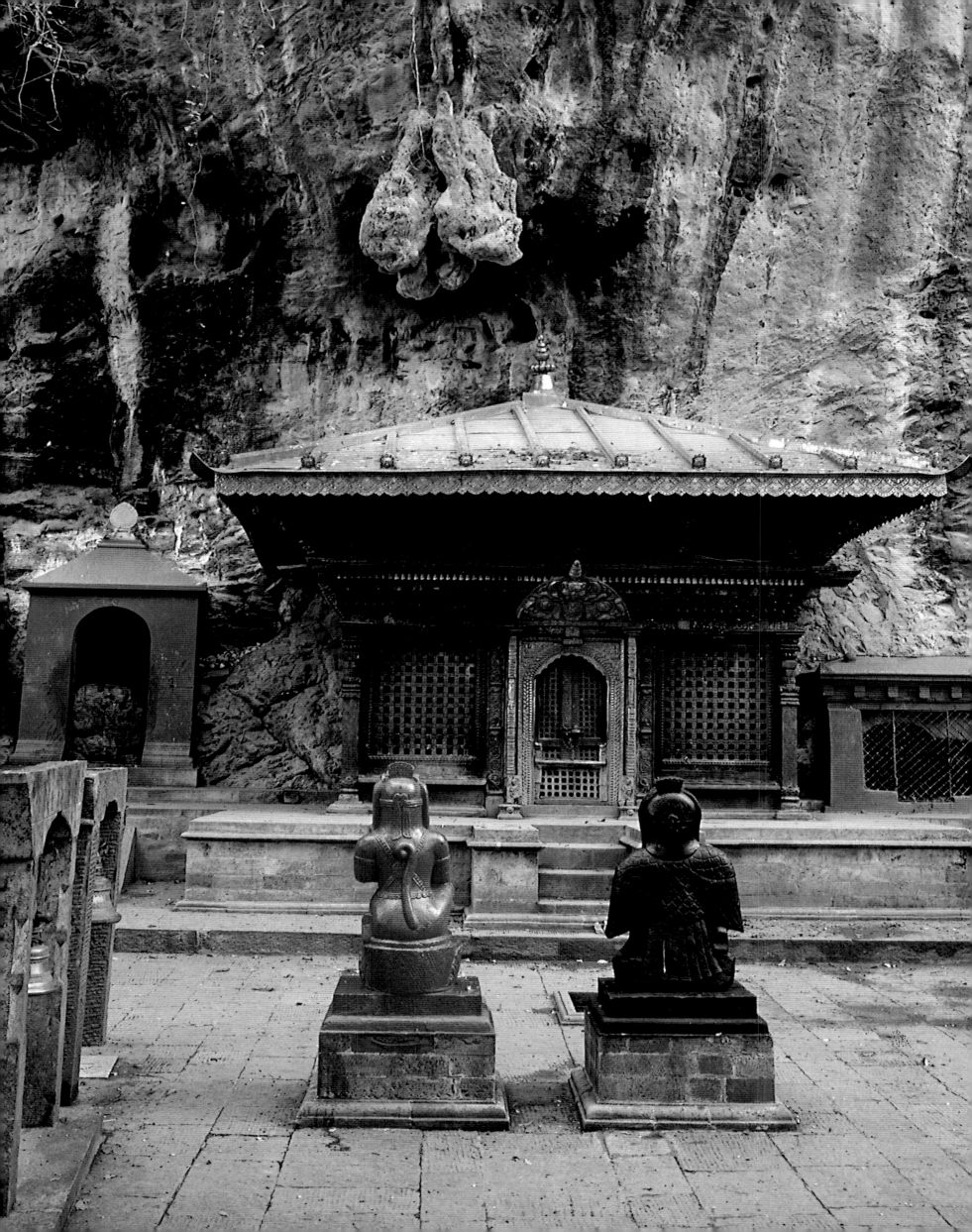

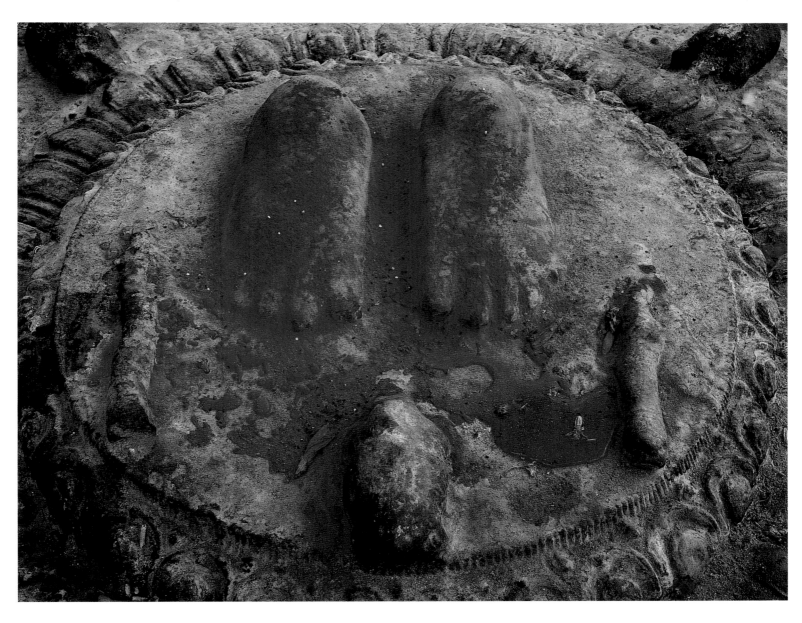

Relief of Vishnu's divine feet

Description

There are two pools of spring water by the Pharping road, both full of carp, sacred to Narayana. In the upper pool stands an early stone image of a devi, probably Lakshmi, holding a lotus. Nearby is some early Malla relief stonework. This is the only evidence here of the antiquity of the site. Beside the upper pool and between the two pools is a shikhara temple enshrining a chaturmukha lingam. There are three other chaturmukha lingams in the vicinity, and an image of Shiva Yogeshvara. Another temple, dedicated to Krishna, contains good late images of him and his wives and attendants. Above the waterspout between the upper and lower pools is a relief of Uma-Maheshvara. In the pool are images of Surya, the sun-god, riding his twelve-horse chariot.

Cliff-face residence of Shesh Narayana

Steps lead the pilgrim upward to the Shesh Narayana Temple built against the cliff face. The temple is a small single-roofed wooden structure, its three sides consisting of latticed woodwork. The erotica sculpted on the roof struts is unusual on a Vaishnava temple. The recent copper torana over the door depicts Narayana in his usual Shridhara form, holding discus, mace, lotus, and conch. Within, in the center, is a new stone image of Shridhara Narayana. To the left of this image is a naturally formed, eroded stone in which the coil of a serpent may be discerned. The top of this stone is painted bright orange-red; this is the abode of Shesh Narayana. A floral aura decorates it.

Outside to the right of the temple is a row of caged stone reliefs. The first depicts Vishnu's avatar, Vishnu Vikranta, Striding Vishnu, in a relief from the thirteenth century. This is the latest and perhaps the least impressive of the four extant Newar attempts to portray the incarnation of the dwarf Vishnu transformed into his cosmic emanation encompassing the universe in three strides to reclaim it from a demonic

interloper. It lacks the dynamic movement and plasticity of the Changu Narayana (see page 115) and Tilganga reliefs and is rendered in a symbolic or cartoon style. Still, all the elements of the drama are present.

Next to Vishnu Vikranta is a relief of Vishnu's avatar Balarama. Then, in a row, are three Buddhist subjects: Green Tara, Guru Rinpoche Padmasambhava, and a bodhisattva sitting in lalitasana, holding a lotus surmounted by a vajra in his right hand and showing the mudra of protection with his left. To the right of these reliefs is the Yanglesho Cave of Guru Rinpoche.

To the left of the temple is an enshrined limestone rock, pitted and eroded, which on auspicious occasions lets forth a stream of "milk." This milk is the blessing of Shesh Narayana and is effective in curing naga-related diseases and snakebite.

In front of the temple, the monkey god Hanuman and Narayana's mount, Garuda pay homage to their master. At the top of the stairway are two Vishnu Paduka votive offerings—reliefs of Vishnu's divine feet—surrounded by his symbols: discus, mace, conch, and lotus. In contrast to Buddha's feet, which are depicted in a negative impression, Vishnu's feet are always represented in relief.

BHAKTAPUR

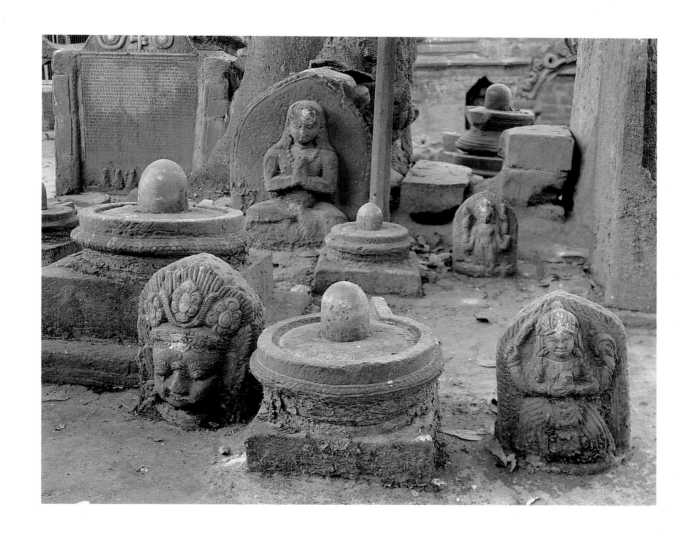

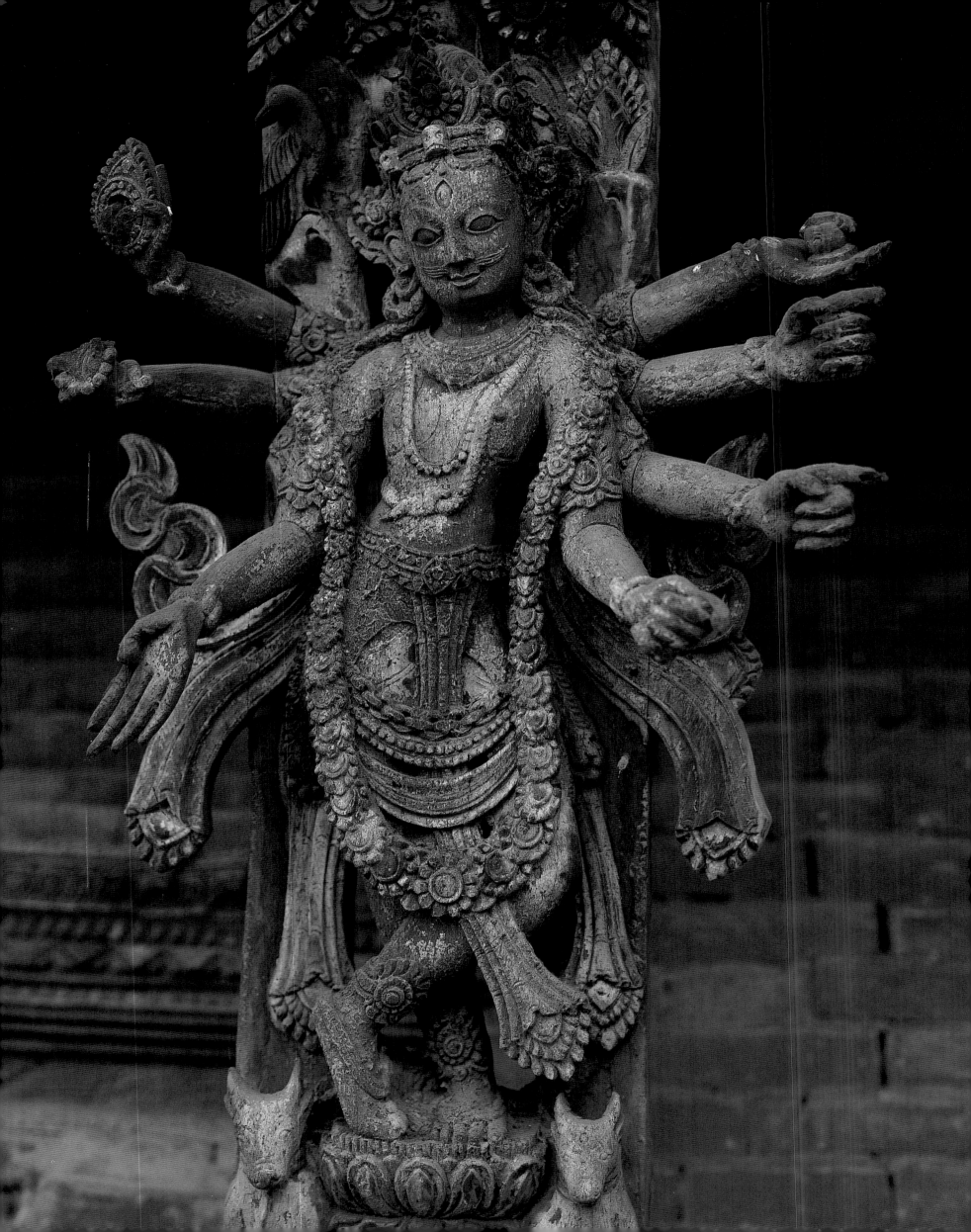

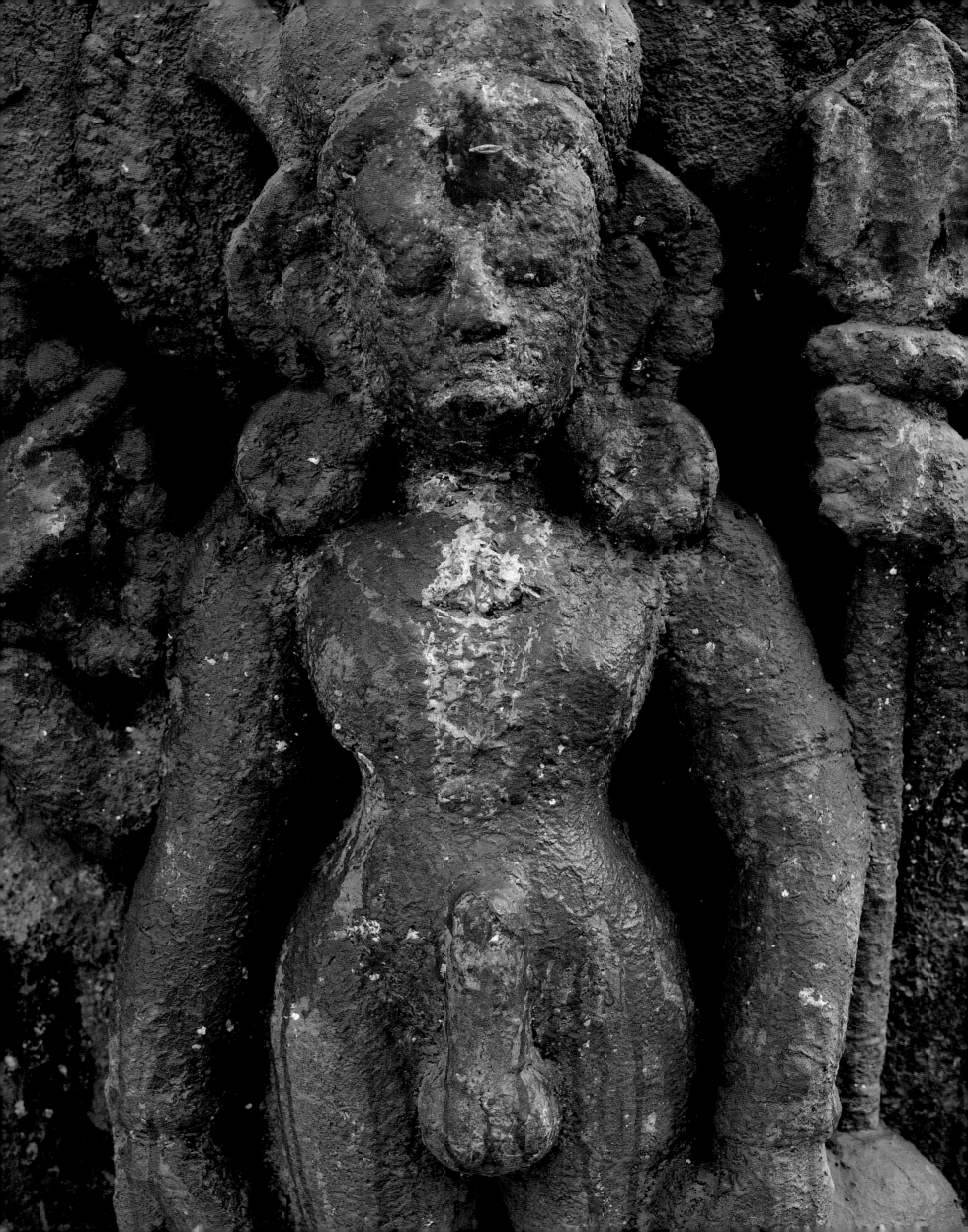

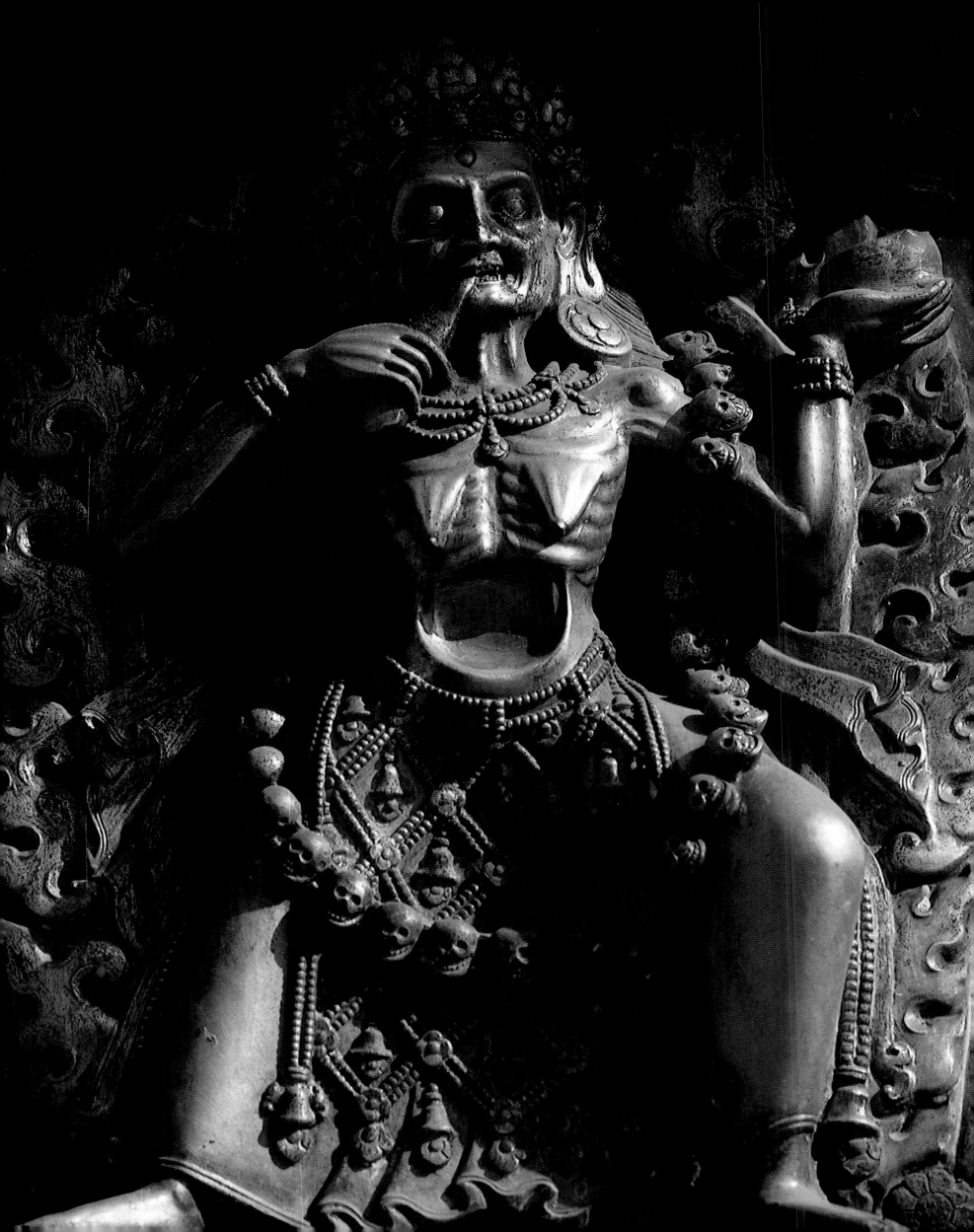

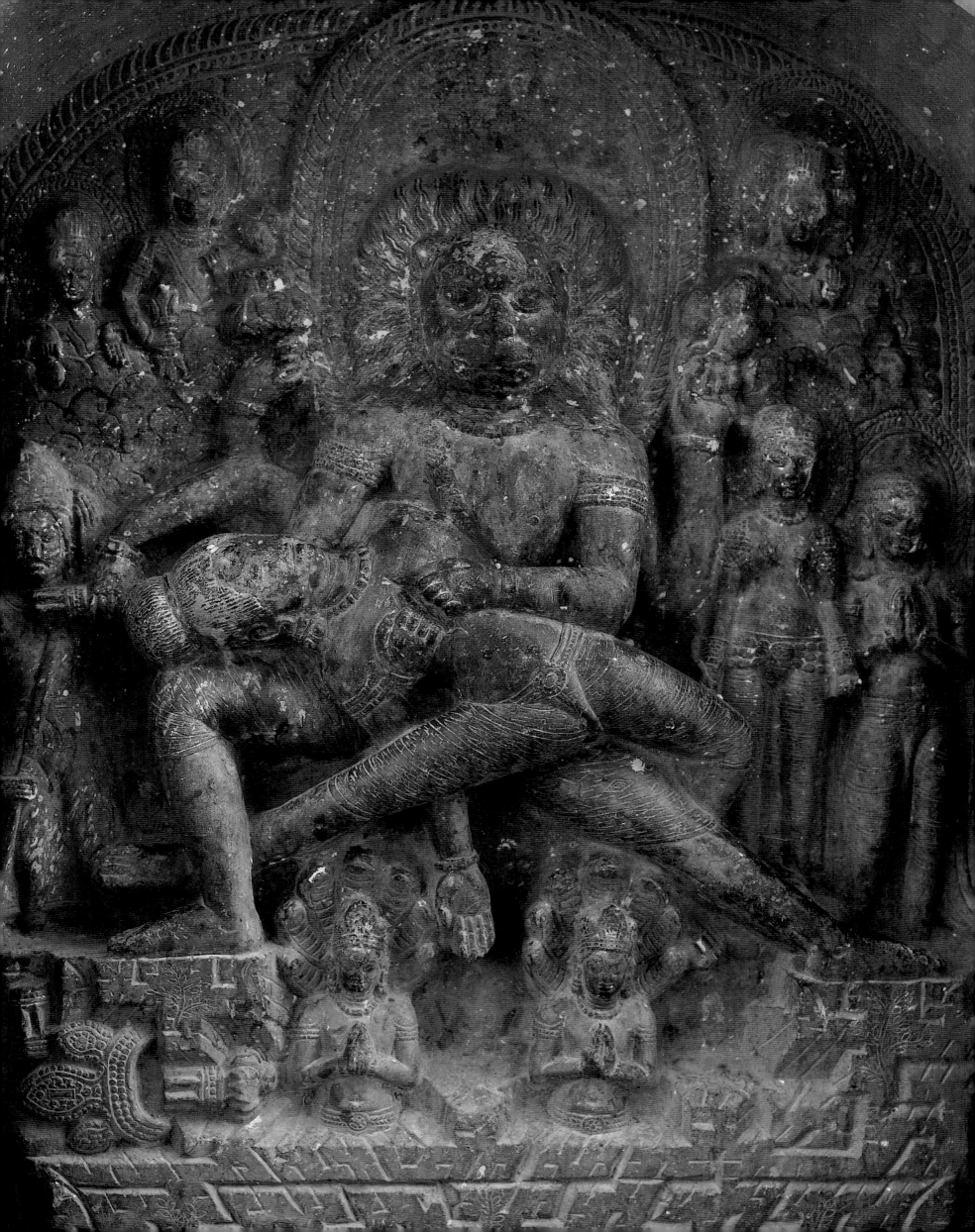

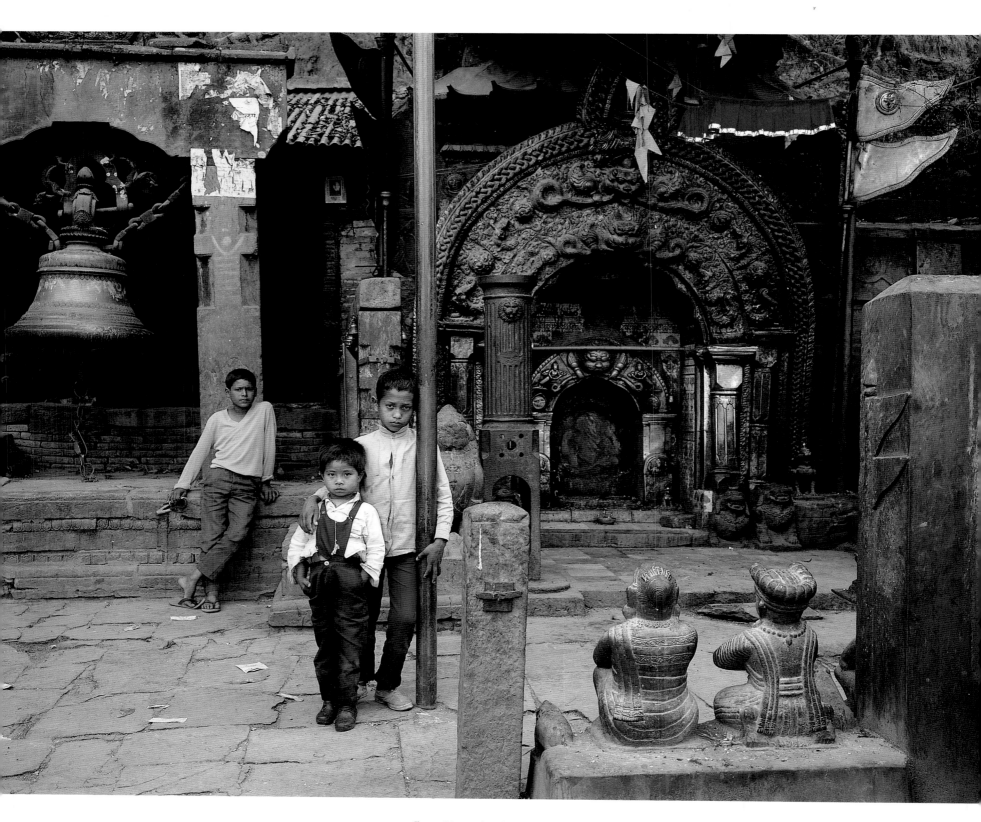

Surje Vinayaka shrine

106

SURJE VINAYAKA

The remover of Bhaktapur's obstacles is Ganesha, known here by the epithet Surje Vinayaka, the Sun Guardian. His residence lies on a forested slope south of Bhaktapur. A hundred feet up the hillside, ancient trees shade the power place in summer, whereas Ganesha's glade is damp and mossy during the monsoon. The temple faces east, and the image of Ganesha catches the first rays of the rising sun. Surje Vinayaka is widely known for his cure of the deaf and mute as well as the halt and lame. Newlyweds come here for his blessing of a happy marriage and many children.

When the gods still walked the earth and rishis inhabited the jungles and caves, one particular sage had a dearly beloved son. One day calamity struck, and he found his son seemingly dead without any cause. The sage, unwilling to accept his loss without interceding with the gods, repaired to Pashupati, where he fasted before requesting Mahadeva for an account. The great god surmised that the death had been caused by his son Ganesha, who was notorious for apparently gratuitous aggression. He advised his petitioner to discover the spot where the sun's first morning rays hit the valley floor and to raise there a shrine to Ganesha and invoke him to beseech the boon of his son's life. As Mahadeva advised, the sage built a shrine at the designated spot and invoked Ganesha, who answered his summons and fulfilled his boon. Thus, at this place where the sun's first rays illuminate the valley, Ganesha came to be called Surje Vinayaka.

Inside the gateway that gives onto the flight of giant steps leading up to the shrine is the rock residence of a Nagaraja with a relief of the serpent behind it, and a shrine and image of Kumara, Ganesha's brother, riding his peacock. At the top of the steps are images of a rishi and of a devi locally identified as Parvati. Within the compound, built against the hillside, is the high shikhara temple in which the large, ill-formed svayambhu stone image of Ganesha peers out of the open sanctum. The shikhara is decorated with a fine repoussé image of Ganesha, and the top has a flourish of four gilded nagas hanging from the pinnacle. Three huge gilt copper toranas arch over the shrine, the uppermost composed of nine intertwined nagas and the lower two showing Kirtimukha with nagas in his mouth and unusual griffin-like figures at the lower ends. In front of the shrine is a large brass canopy with a repoussé image of Ganesha at its center.

In front of the shrine, a chuchunda, Ganesha's shrew-rat vehicle (without sweetmeat), surmounts a lotus pillar. Below are stone portraits of two pairs of royal Bhaktapur patrons and oil lamps also decorated with images of devotees. To the right of the shrine is an image of Bhairava, and behind it a giant bell. To the left is a bhajan pati. In the southwest corner of the compound is a cluster of several lingams, Nandis, and small images of Durga and Ganesha. On two sides of the compound are dharamsalas—pilgrim shelters and space for sadhus.

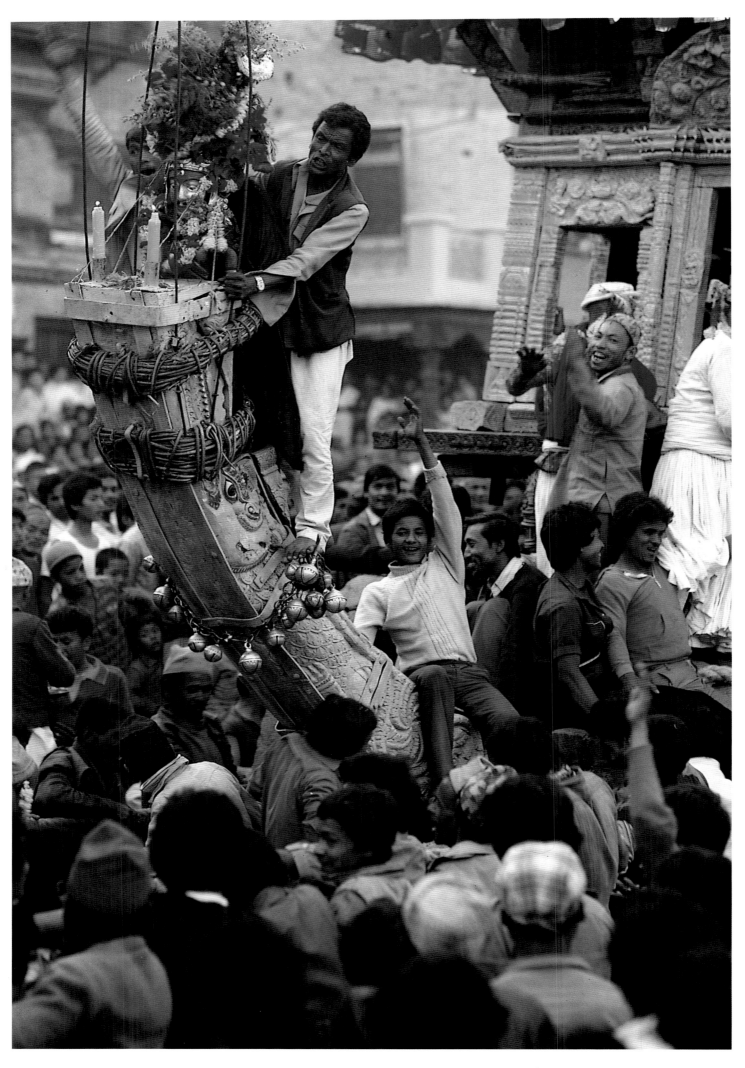

The chariot of Akasha Bhairava, Bisket Jatra

Akasha Bhairava

The Bhaktapur Bhairava is Akasha Bhairava, or Sky Bhairava, whose residence is the magnificent rectangular Kashi Vishvanath or Pantali Temple in Taumarhi Square, a ritual center of the city. In Bhaktapur, Akasha Bhairava is known only by his Newari name, Bhailadya. Akasha Bhairava is the consort of Mahakali, and as one of the two central figures in the Nine Durga dance cycle, part of Bhaktapur's greatest festival, Bisket Jatra, he may be considered the principal deity of Bhaktapur. In the popular mind the many-chambered Bhairava Temple is the subject of rumors about the darkest of Tantric practices.

Legend and History

The legend of Bhaktapur Akasha Bhairava distinguishes him as a separate entity from Kathmandu Akasha Bhairava. Long ago, Kashi Bhairavanath, the great Bhairava of Banaras, came to the valley to witness the Bhadrakali Jatra. A tantrika recognized him in the crowd and attempted to put him in a trance and immobilize him. Bhairava attempted to escape the tantrika's spell by sinking into the ground. When only his head was still visible, Bhadrakali recognized him as her husband and ordered his head to be cut off so that at least it would remain with her in Bhaktapur. Bhairava's head was enshrined in the Taumahri Temple, and his body escaped back to Banaras, where an important headless Bhairava still

remains. Bhaktapur's jatras celebrate that meeting of Bhairava and Bhadrakali. Like the origin legend of the Kathmandu Akasha Bhairava, this story explains why Bhairava is represented only by his head. It also explains why the temple is called Kashi Vishvanath, Shiva's principal shrine in the subcontinent.

The founder of the temple was King Jaggat Jotti Malla (r. 1637-43), but it is generally attributed to Bhupatindra Malla (r. 1696-1722), who, it is said, was advised to build the Nyatapola Temple to house a mother goddess to balance and control the incorrigible behavior of Bhairava. Bhupatindra certainly added the upper floors, finishing the work in 1708. The temple was demolished in the 1934 earthquake, and the original parts were reassembled thereafter.

Description

The Kashi Vishvanath Temple is a large, rectangular, three-roofed pagoda temple, with two and a half floors under its lower roof. The upper roof is of sheet metal topped by seven gilded pinnacles. The fifty-six struts supporting the roofs are ornamented by carvings of the Mother Goddesses and the Nine Durgas. The front doorway and windows are covered with finely worked gilt copper. The good gilt copper repoussé torana over the doorway once showed an eight-armed

Kala Bhairava, Kashi Vishvanath Temple

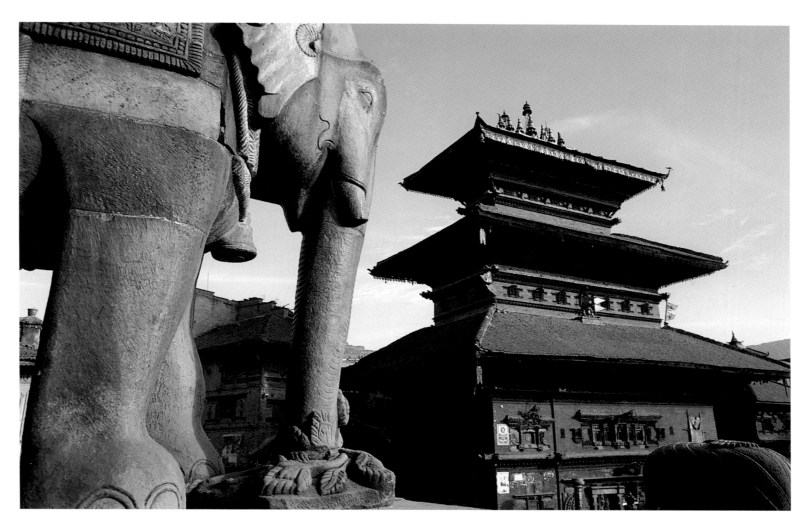

Nyatapola Temple and elephant guardian

Bhairava standing on a vetala flanked by Ganesha and Kumara. Beneath it was a copper repoussé mask of a serene and noble Bhairava. These images have been stolen. To the right of the front entrance, now closed, is a niche housing a small brass image of a four-armed Bhairava, holding sword and shield, skull bowl and ankusha mudra. He stands upon a vetala, which is sometimes identified as Kala Bhairava, since "even the Lord of Death trembles before him." The first floor, which houses the Akasha Bhairava shrine, is lit by a line of fine wooden windows. Within the first-floor chamber is the large head-and-shoulder mask of Bhairava.

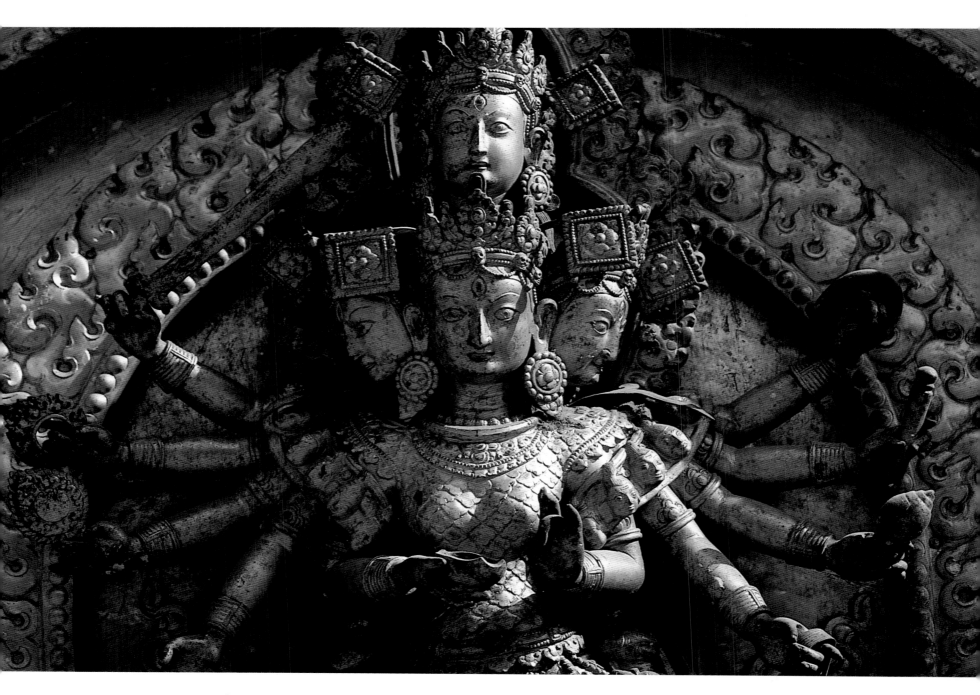

The repoussé image of Taleju, Bhavani on the Golden Gate (1753), Durbar Square, Bhaktapur

TALEJU

The goddess Taleju, the lineage deity of the Malla kings, was and still is a royal goddess. Her temples are located in the palace complexes in Kathmandu, Bhaktapur, and Patan. She is a Tantric goddess par excellence, and although in her secret form she is not iconic, to the public she is represented as Bhagavati, or Durga, and as Maheshasuramardini. Taleju is not represented here as a principal focus of worship of Bhagavati, first because as a royal goddess she is exclusive to royal brahmins (rajopadhyayas), and second because originally she was an interloper into the valley, and the Malla dynasty that gave her such great significance has now passed into history.

Legend and History

Taleju is not an indigenous Kathmandu Valley goddess but was brought to the valley in early Malla times. Her original residence in the Kathmandu Valley was certainly Bhaktapur. Legend relates that King Harisinghadeva brought her from his kingdom in Simraongarh, in Mithila, after he had been defeated by the Bengali Muslim Turks. Actually, Taleju is known to have been worshiped in Bhaktapur before King Harishinghadeva's successful conquest of the city, but in the minds of the people the glorification of the goddess is associated with him nevertheless.

In legends of Taleju's origin the goddess is identified as a yantra, a geometric representation. This yantra was once worshiped by Indra, the king of the gods, but it was stolen by Ravana, the demon king of Sri Lanka, during his attack on heaven. When Ravana was defeated by Rama, the victor took it to his capital of Ayodhya. Before Rama died, however, the goddess appeared to him in a dream and instructed him to throw the yantra into the river because no one else was capable of worshipping it. For millennia no one could take possession of the goddess, until in a dream she appeared to an ancestor of Harisinghadeva and told him where she could be found. Thereafter she remained in Simraongarh until that city was conquered by the Muslims, and she came to Bhaktapur still in the form of a yantra.

With the overthrow of the Malla kings by the Gorkhali Shahs, the significance of Taleju has declined. Nevertheless, as the goddess most involved in the city's political life for several centuries, she still plays an important part in the religious life of the city. Her priests, the rajopadhyaya brahmins, are considered the supreme Tantric gurus of the city. She is the central deity in the Mohani (Dasain) celebrations.

Description

The Taleju Temple is located in Mul Chowk behind the royal palace. The entrance to the succession of courtyards that give access to Mul Chowk is from Durbar Square through the golden gate. Mul Chowk is forbidden to non-Hindus, and the sanctum is forbidden to all but initiates.

The secret of the form of the goddess remains privy to initiates. Outsiders assume that the principal object of worship inside the sanctum in the inner court, the metal kalasha vase, is the goddess herself.

Also within the Taleju Temple are the residences of Maheshvari, Guhyeshvari, and Dui Maiju, a pitha goddess. Maneshvari, the Licchavi lineage goddess, is also represented in the inner courtyard.

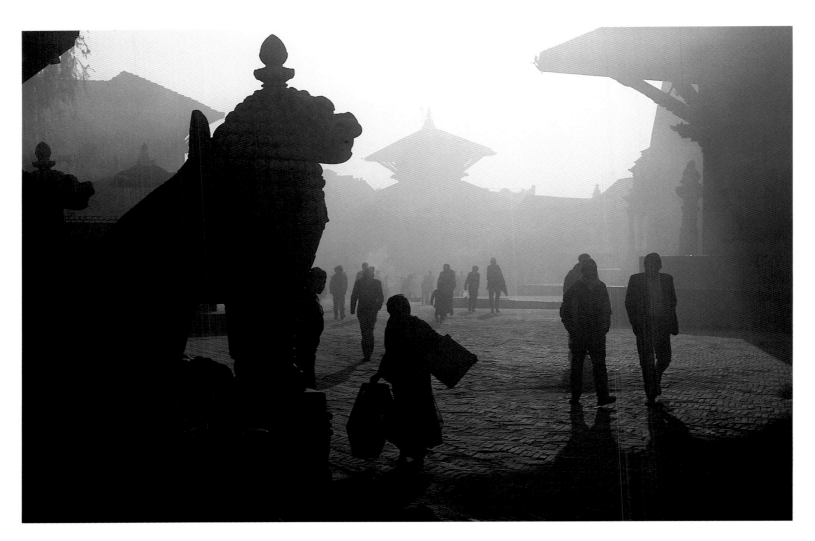

Durbar Square, Bhaktapur

CHANGU NARAYANA

In the early mornings of the cold season, only a few hilltops protrude from the mist-wrapped Kathmandu Valley. Punctuating a serpentine ridge in the east of the valley, the hilltop of Changu Narayana catches the full burst of the rising sun, gilding the pagoda pinnacle and then illuminating the large temple sanctuary in its wide spacious courtyard. This regal complex, surrounded by the small village of Changu, is Vishnu's principal residence in the valley. It is also one of the valley's oldest shrines, dating at least to the fifth century, and within the courtyard are some of the great masterpieces of Newar stone sculpture. The physical prominence, the size and majesty of the temple, and the art of wood, copper repoussé, and stone sculpture that adorns the complex provide a felicitous environment for the Benign, the Glorious, the Lord of Men at Changu.

Vishnu's name at Changu is Changu Narayana. Changu means "Hill of the Palanquin" in Newari; the Sanskrit equivalents are Doladri, Dolagiri, and Dolashikhara. In Sanskrit, therefore, Changu Narayana is known as Dolashikhara Svamin, Lord of the Hill of the Palanquin. At some unascertained period he also gained the name Champak Narayana, *champak* being the name of a shrub with white or yellow flowers.

Myth and Legend

In the days when the earth was inhabited by both humans and gods, and when gods were visible for all to see, Vishnu committed the cardinal sin of killing a brahmin. The brahmin was evil and the world was better rid of him, but nevertheless the crime of brahminicide must be expiated. So Vishnu wandered the world seeking absolution. He found it on the hill of Changu, then called Doladri, where the ascetic rishi Sudarshana beheaded the anonymous wanderer. His crime expiated, Vishnu asked that he might remain there and receive worship as the Lord of Men at Changu, Changu Narayana.

At Changu Narayana the image of Vishnu in the inner shrine depicts the god riding his mount, Garuda. According to the myth of their first encounter, the mother of Garuda, the old sun god, had been enslaved by a co-wife, mother of the nagas, the water spirits. The nagas promised to free her if Garuda would bring them the elixir of the gods' eternal life. Garuda succeeded in obtaining this elixir, but when he returned with it to the nagas, he was accosted by Vishnu, who conferred eternal life upon him for his constancy and virtue in abstaining from taking the elixir for himself. He also gave him the sole prerogative of being seated in a superior position. Garuda became Vishnu's mount and henceforth served the god in everything, but first he continued on his way and delivered the elixir to the nagas. Indra, however, deprived them of it, thereby generating the eternal quarrel between Garuda and the nagas.

From Newar Buddhist sources the story of Changu's origin gives Garuda, Vishnu's mount, a primary role and explains Vishnu's subservient role to Avalokiteshvara. Garuda, the winged sky god, servant of the sun, is in eternal conflict with the serpentine naga demigods of water

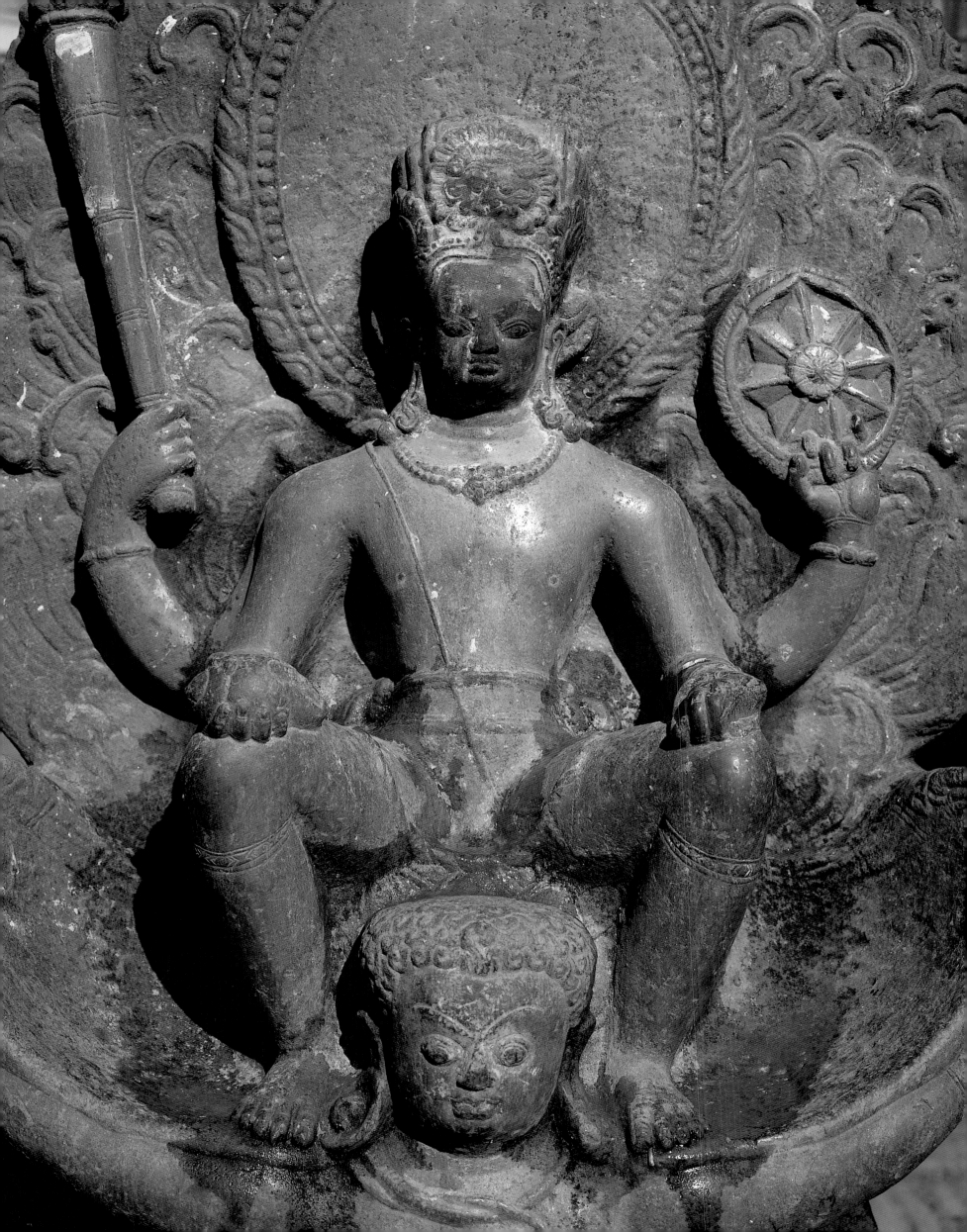

and earth. The earth may be fruitful only when there is harmony between Garuda and the nagas, since both possess the power of withholding rain and parching the earth. In one titanic battle between these universal powers, when Garuda was about to vanquish Takshaka, one of the kings of the valley nagas, Avalokiteshvara, the Bodhisattva of Compassion, interrupted the fight and insisted that the two enemies reconcile. As a sign of harmony between these irreconciliables, he draped the naga around Garuda's neck. Vishnu then mounted Garuda and as a sign of Avalokiteshvara's superior wisdom took the bodhisattva upon his shoulders. A griffin carried all three to Doladri. The griffin can be seen in various representations at Changu. Representations of Avalokiteshvara riding Vishnu and Garuda and the griffin (called Hari-Hari-Harivahanodbhava-Lokeshvara) are rare in the valley, and none are extant at Changu, but the representation of Vishnu mounted upon Garuda, known as Garudasan Narayana, remains as the main object of worship in the inner shrine at Changu. Various depictions are also found in the courtyard and throughout the valley. Changu Narayana, like all forms of Vishnu, is conceived and worshiped as Avalokiteshvara by the Newar Buddhists.

History

The original shrine of Changu Narayana was built by kings of the Licchavi dynasty, a group of conquerors from the south. The chronicles tell of Haridatta, a near-legendary Licchavi king, probably of the third century but perhaps the first, who established four seats of Narayana in the valley: Changu Narayana, Ichangu Narayana, Shesh Narayana in Pharping, and Hamsagriha. The location of Hamsagriha was lost during the Transitional period and replaced in the quartet of Narayanas variously by Vishankhu Narayana, Macche Narayana, or Buranilkantha. Certainly Changu Narayana has always sustained a position of supremacy among these four foundations.

The status of Changu Narayana was reinforced and secured forever by the greatest of the Licchavi kings, Manadeva. In 464 C.E. this warrior king declared his triumphs on an inscribed pillar that stands on the western side of the temple. It is said that the magnificent Garuda kneeling before the western doors once adorned the pillar and that the Garuda's face is a portrait of Manadeva. The close association of the Licchavi kings with Changu Narayana is further proved by the other great king of

Licchavi times, Amshuvarman. The stone image of Garudasan Vishnu in the inner shrine is sheathed in gilt copper; Amshuvarman replaced the old, worn sheath in the year 607 and at the same time offered a large donation of cash.

The Muslim vandals of Shamsuddin Ilyas evidently failed to penetrate to the far east of the valley in their fourteenth-century raid. Changu Narayana was thereby spared their depredations, and its wealth, particularly its Licchavi stone sculpture, was retained intact for later generations. Where the Muslims failed, however, the elements and human fallibility have succeeded in reducing the temple itself to ruins many times over the centuries. Inscriptions and chronicles have recorded only a few such calamities. The most notable restoration, and for us the most significant, was patronized by Riddhilakshmi, the queen mother of Bupalendra Malla of Kathmandu, whose regency spanned the last decade of the seventeenth century. After more than a thousand years of worship, the inner image's head had broken off during daily puja, and Riddhilakshmi, in the name of her son Bupalendra, offered a new gilt copper sheath for the head. She was also responsible for the splendid torana over the western doors. Further, after having the temple fully restored, she offered Changu Narayana her own weight in gold and precious stones, and to the brahmin pujaris she gave an elephant, 108 horses, cows, buffalos, goats, and sheep. Finally, she had fine gilt copper images of herself and her son installed in a shrine in front of the western doors. Less than twenty years after Riddhilakshmi's restoration, however, the temple was gutted by fire, and the temple we see today is substantially the result of the succeeding restoration, which was consecrated in 1710.

A legendary treasury is associated with Changu Narayana. Its location is uncertain, but it is said to contain an accumulated wealth of gold, jewelry, and sculpture in copper and stone that must be unequaled by any other religious foundation of the valley, besides providing an artistic record rivaled only by the stone sculpture in the Changu Narayana courtyard.

Finally, to place Changu Narayana within a broader framework but in a hypothetical context, it is probable that while the Licchavi people were still ensconced in their Indian homeland, the Changu hill was a place of mother goddess worship, and that the shrine now dedicated to Chinnamasta predated by centuries the arrival of the brahmins with their benign savior, Changu Narayana. Certainly, some of the images within this shrine are as old as the Vaishnava foundation of Haridatta in the fourth century, and the stones must have a still older history of worship. Thus the cult of the mother goddess, which has survived to sustain its local importance through the centuries to become the primary focus of worship of many of the local people today, should be considered the older and more resilient object of worship.

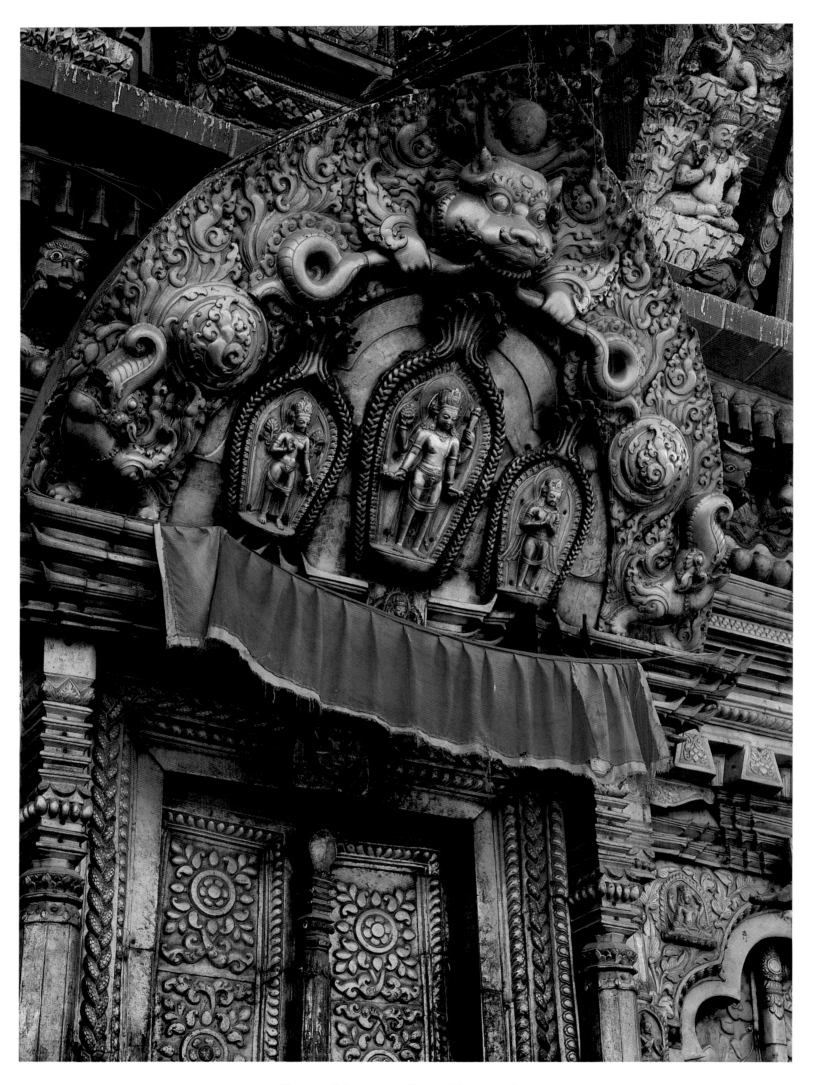

Torana and doorway to Changu Narayana shrine

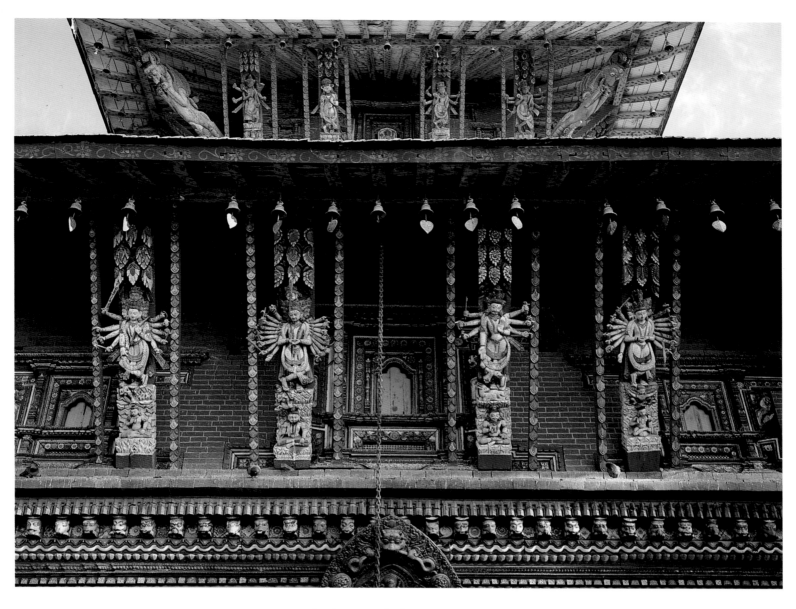

Temple struts of Changu Narayana

Description

In a wide courtyard surrounded by two-story pilgrim shelters and residences, the benign and glorious Changu Narayana, is enshrined in the largest of the Kathmandu Valley's pagoda temples. At thirty-two feet square, larger than the temples at either Gokarna or Panauti, this Newar-style jewel of temple architecture stands on a single high plinth. Steps on its four sides are flanked by pairs of lions, griffins, Garudas, and elephants. Pairs of guardian gods flank the doors. On the north side a spout drains the consecrated oblation from the inner shrine into a tank for distribution as prasada.

The two-story brick pagoda has central and flanking doors on each side. The great western doors present a large expanse of gilt copper work: the entwined nagas on the inner door jambs, the kalasha vases of fertility on the outer door jambs, the torana canopy of Shridhara and his consorts under the large Garuda and makara above the central doors, and the brackets on each side of the outer doors are all remarkable

evidence of mastery of this art form in the seventeenth century. The central northern door's torana represents Narayana's avatar Krishna (the flanking figures now missing), the eastern door has Shridhara with consorts, and the southern door has a very good depiction of Garudasana Narayana.

The upper roof, in need of regilding, is surmounted by a fine gilt gajura. The large lower roof is supported by excellent seventeenth-century wooden struts, six large carved beams on each side. These strut carvings represent the avatars of Narayana, together with Bhairava protectors and others. An element of humor is included in the corner griffin struts, where small monkeys can be seen clinging to the beasts' phalluses.

Within the shrine, to which entrance is strictly forbidden to prohibited castes and where even a glance from without is deflected, is the original stone image of Narayana riding his mount Garuda, covered by a gilt copper sheath from the seventh century. Many images of stone are also lodged within.

In front of the western doors, outside the plinth, is Manadeva's fifth-century pillar inscribed with a record of his

triumphs, standing upon a naga, the spirit of the cosmic ocean, and with Narayana's war-discus atop. A pillar on the other side, mortised into the turtle that supports the *axis mundi*, is crowned by Narayana's other most common symbol—his conch. The stump of Manadeva's broken pillar is immediately in front of the steps, next to the magnificent Manadeva Garuda in half-kneeling posture that once adorned the pillar. Behind the pillar stump in a latticed cage on a high plinth are the gilt copper statues of Queen Mother Riddilakshmi and her son, beneficent patrons during the seventeenth century. Behind the Manadeva Garuda is the Licchavi king Shivadeva's stone inscription.

The Stone Sculpture of Changu Narayana

Because of the quirk of fortune that kept the invading Muslim vandals of the fourteenth century from penetrating to Changu, and because of the wealth of stone sculpture from all ages preserved here, Changu Narayana is a living museum for the art historian. Several stone sculptures in particular merit close examination. All of them are forms of Narayana or of his mount Garuda.

The Licchavi image of Changu Narayana in the inner shrine is inaccessible. The Garudasana Narayana in the courtyard is said to be a copy of it, although executed in the ninth or tenth century in the Transitional period. This large image portrays a divinely distant yet benevolent Narayana, evoking a heroic period of the valley's history. He carries with ease his symbols of majesty and power—the discus and mace as weapons, and his conch and jewel—while composed in solemn meditation as he contemplates the good order and benign continuity of his creation and beings' happiness. To show his constant availability everywhere, he flies through the sky on the back of a serene Garuda's outstretched wings, the bird's intricately depicted tail feathers forming the back of his throne. There may be no other sculpture in the valley that expresses godhood in such an image of magnificent power. A later, early Malla portrayal of the same subject (c. thirteenth century), now let into the plinth where the tree grows, shows the typical softening of the notion of godhood and a more user-friendly deity. Garuda's widespread wings appear to show protection to the smiling, short-limbed figure of Narayana.

The earliest sculpture at Changu Narayana is the devotional Garuda that probably once adorned the Manadeva pillar. He is called the Manadeva Garuda, since his face, with its protuberant lower lip, almond eyes, and aquiline nose, is said to be a portrait of the great Licchavi king. This attribution is probably apocryphal but is nevertheless suitable, since the great warrior king's name evokes the strength and simplicity that this massive yet delicate Garuda displays in abundance—the

warrior at prayer. Like all such devotional Garudas, the figure is human, his bird half indicated only by the winglike cape depicted in a far more stylized manner than the figure itself. The naturalistically depicted snake adorning his neck is Takshaka Nagaraja, which Avalokiteshvara wrapped around him as a sign of reconciliation after their mortal combat. The crack in the statue's head may have been caused by its fall from the pillar. If the Manadeva Garuda is indeed as old as the pillar, it is datable to the fifth century, but it has also been attributed to the sixth or seventh centuries.

In his capacity as savior, the benign presence of Narayana incarnates to deliver both human beings and gods from the demonic power of ignorance. One of the most successively executed avatar forms in the valley is Vamana, the dwarf avatar, who is shown not as a dwarf, however, but as Vishnu Vikranta, Striding Vishnu, also known as Trivikrama Vishnu, Vishnu of Three Strides. This form is also known locally as Bahun Avatar, *bahun* in Newari meaning both brahmin and the number fifty-two, for the fifty-two-inch-high dwarf. Vishnu was incarnated as a brahmin dwarf to counter the threat to universal order of the tyrant demon Bali. At his great horse sacrifice Bali was induced to offer the dwarf the boon of possessing whatever he could encompass in three steps. Vamana, the dwarf, then returned to his cosmic form, striding around the universe in two strides. With a third stride he brought Bali to hell. This difficult theme is represented in the Changu courtyard in a dramatic ninth-century relief, perhaps the most impressive of its type in the subcontinent. Eight-armed Narayana dominates the relief in world-encompassing stride. Lakshmi, his wife, and Garuda attend on his right, and a naga couple supports his right foot while Rahu holds his left foot. Below are Bali and his wife pouring an oblation of water to the dwarf, symbolizing their offering to him, while other demons attend him. The horse indicates the occasion of sacrifice. This magnificent relief is dated to the ninth century.

At the start of the ancient Indian Armageddon at Kurukshetra, Arjuna the charioteer lost heart at the prospect of wreaking death and destruction upon his own people. He sought comfort and strength from Lord Krishna, his driver and Vishnu's avatar, who proceeded to encourage him with a vision of his ultimate, all-encompassing nature. This vision is known as Vishvarupa, Vishnu's cosmic form. In Changu's courtyard is a relief sculpture of this theme that shows late Licchavi art (ninth century) at its most magnificent. The work deserves head-down devotion and minute examination of its extraordinary detail and plastic vitality. At the bottom Shesh Narayana lies upon Ananta, the Cosmic Serpent, symbolizing creation in its unmanifest formlessness. Ananta and the nagarajas holding Narayana's feet indicate the netherworld; the terrestrial world is indicated by Prithvi, the earth goddess, between his feet and the elephants that

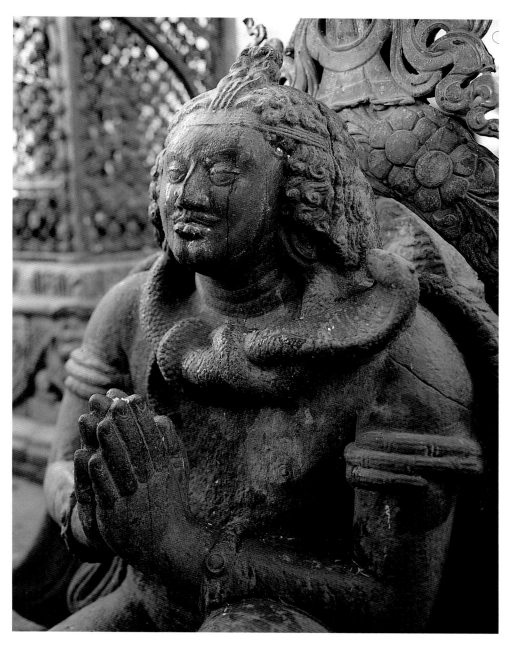

Manadeva Garuda, 6th century

indicate the four cardinal directions; and the gods and sages indicate the heavens above. The god's attendants on his right are Balaram and his consort, a sensuous and nubile Lakshmi. On his left are Garuda and Shri Devi, his second consort. All of this is dominated by the ten-headed, ten-armed Vishvarupa himself, who stands, passive and benign, triumphant and transcendent, above and beyond his creation.

To celebrate more recent valley sculpture and a Tantric concept of Narayana, the finely executed Vaikuntha in the Changu courtyard of the late Malla period is beyond compare. It shows a fourteen-armed, seven-headed Narayana with Lakshmi on his knee, sitting in lotus posture upon a throne mounted on the back of a six-armed Garuda. Vaikuntha is Narayana's paradise, and the Tantric conception of this ideal mind state includes Lakshmi as the god's energy source *(shakti)*, the multiple possibilities of emanation indicated by his lion and boar faces, reminiscent of two of his avatars, and his hier-

archical being indicated by the upper heads. The sculpture is done in gray, black-striated stone, which has lent itself to exquisite detailed carving and also a fullness and majesty unusual in Malla work.

There are other stone images of interest at Changu Narayana. An early Malla stone relief of the Narasimha, Man-Lion, an avatar of Narayana, depicts him tearing the heart out of a father who had persecuted his devotee son. A fine Transitional period Shridhara flanked by Lakshmi and a standing Garuda shows an unusual plasticity for this often highly rigid subject. There is a Padmapani Avalokiteshvara from the Transitional period in a niche under the tree, the only Buddhist image in the compound. In the Chinnamasta Temple are small but exquisite figures from Licchavi times of the mother goddesses in the form of Haritis. Outside the compound, in the garden on the east side, are a fine four-faced Narayana and also a chaturmukha lingam, both from the early Malla period.

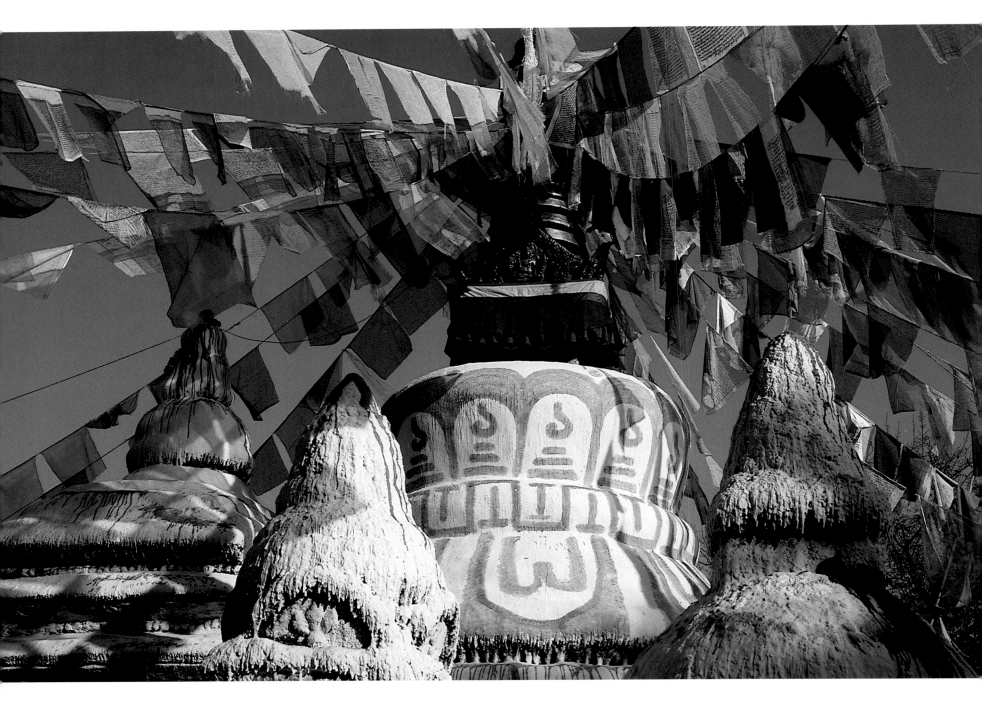

Stupa of Namo Buddha

Namo Buddha

Namo Buddha is located to the east of the Kathmandu Valley, at the southern end of a ridge protruding into the neighboring valley of the Rosi Khola, southeast of the Newar town of Dhulikhel and northeast of Panauti. It is reached by a three-hour walk, or half an hour by motor on the jeep road, from either of these towns. Approached from the Dhulikhel side, the stupa of Namo Buddha lies on a north-facing flank of the ridge in thick jungle, while the Tibetan lama Trangu Rinpoche's Karma Kagyu retreat center lies on top of the ridge.

Namo Buddha celebrates the Buddha Shakyamuni's sacrifice of his body to a starving tigress in a previous life. A Tibetan reported that in the seventeenth century, out of fear of the tiger, the people of this area would not utter the real name of the stupa, "Tiger Body Gift" (in Tibetan, Takmo Lujin), but instead would invoke the name of the Buddha, saying "Namo Buddhaya!" "Hail to the Buddha!" Since to speak the Buddha's name is to be free from fear, both Hindus and Buddhists fell into this convention, and thus the place became known as Namo Buddhaya, or more commonly Namo Buddha, or simply Namura.

The stupa shrine of Namo Buddha is attended by Newar Buddhist initiates from Nhu Bahal, in Panauti, and from Sangu, the village at the base of the Namo Buddha ridge. Although the legend of Namo Buddha is widely known by Newars, the stupa is rarely visited by them. On the other hand, Namo Buddha is one of the three principal places of pilgrimage south of the Himalayas for Tibetan Buddhists, and the Bhotias worship here in large numbers during the pilgrimage season.

The history of Namo Buddha is obscure, but its origins must go back at least to early Malla times. It was probably during the late Malla period that the stupa took on its Tibetan bell-shaped form. There is no evident explanation why the image of Shankara Narayana should be found in the principal shrine of the stupa, but certainly this would indicate that Shaivamargis, probably Vaishnavas, were in charge of the stupa at one time. The Tibetan association with the stupa is demonstrated by an early twentieth-century restoration under the auspices of the Tibetan lama Tokden Shakya Shri, whose sons and disciples managed the restoration of all three major valley stupas between 1917 and 1920. Only the principal stupa at Namo Buddha was restored, its surroundings remaining untouched.

The Legend

The legend of Namo Buddha, or Takmo Lujin, is found in the Vyaghri Jataka. It is also related in the Mahayana sutra entitled Suvarnaprabhasottama Sutra. The Tibetans are aware that locations in India are also associated with this legend.

There are many variations on the popular theme of the legend of the bodhisattva on the path of learning who sacrifices his body to a starving tigress. A Tibetan source relates the essence of the story as follows. The bodhisattva, having

practiced the six perfections, including the perfection of generosity, and seeing a tigress ravaged by hunger and about to devour a small boy whom she had been stalking, was moved to such pity that he sacrificed his body to her.

A more lengthy Newar version describes the bodhisattva as a prince in his prime, called Mahasattva, Great Heart, son of a king of Panauti. Full of valor, skilled in the martial arts and in sport and athletics, one day he went hunting with his brothers in the forest. There they encountered a tigress with young cubs, the mother emaciated through lack of food and unable to feed her offspring. The bodhisattva prince was moved to the bottom of his heart by the sight, but continued on with his brothers, knowing that they would inhibit his intention to offer his flesh to the tigress and save not only her life but also the lives of the cubs. Returning later on with a knife, he cut strips of flesh from his body and offered them to her until the tigress's hunger was sated. He fell over and died, to be found later by his friends. His hair and bones were enshrined in the stupa of Namo Buddha.

Further, it is said that when Shakyamuni Buddha himself visited the valley on pilgrimage, after delivering his sermon at Gopuccha Parbat on Manjushri Hill, he came to this place. Here he taught the Jataka story of his previous incarnation; upon concluding, he clapped his hands, and the reliquary stupa of the bodhisattva, which hitherto had lain underground, miraculously appeared.

Description

The Namo Buddha stupa compound is approached through a new concrete gateway. It is surrounded by a couple of old Newar houses and several new structures. The stupa itself, about twenty-five feet high, is festooned in prayer flags and covered by thick layers of whitewash. It stands on a base plinth, two feet six inches high, and a high threefold stepped plinth. On the highest plinth is a lotus course, a broad flange, a pronounced lip, and the bell-shaped dome narrowing slightly from top to bottom in Tibetan style. The harmika box is shallow, its cornice adorned with a textile apron. Toranas show the Four Meditation Buddhas facing appropriately in the four directions, all in gilt copper. The spire consists of thirteen disks.

Built into the high, stepped plinth on the east side and reaching to the height of the harmika is a large shrine that once was the residence of Akshobhya and that is now found on the lower step to the right of the shrine. Above the shrine entrance is a torana showing a unique four-armed image of

Buddha offering his flesh to feed a tigress and her cubs

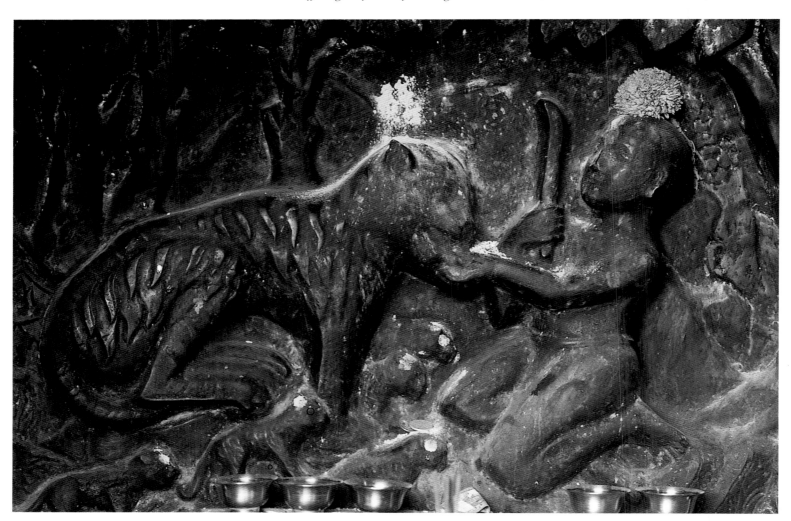

Prayer flags and votive butter lamps at Namo Buddha Stupa

Shankara Narayana, the upper hands holding discus and trident, the lower encircling Lakshmi and Uma, who sit on his right and left knees respectively, to touch their breasts. A similar rough stone image is found within the eastern niche of the stupa that this greater shrine encompasses. This niche is surrounded by a good stone torana, partially covered in copper repoussé, showing a vajra beneath. On either side of this shrine are stone images: on the right Sadakshari Lokeshvara; on the left, Sahasrabhuja Lokeshvara.

In the niche on the south side of the stupa is a broken Buddha with his right hand raised and his left hand at his heart, while Ratnasambhava stands on the southwest corner; on the west side, in an elongated niche, are three Buddha images difficult to identify, perhaps Vajrasattva on the left; in the northern niche is Amoghasiddhi. On the corners of the base plinth are four chaityas, perhaps of Licchavi provenance but obscured by whitewash. On the northern side, beyond the plinth, are two large chaityas; on the southern side four more large chaityas; on the eastern side a new square shrine room, two nineteenth-century Newar shikharakuta chaityas, a

dharmadhatu offering mandala upon an octagonal Eight Bodhisattva plinth, and a further chaitya with a Newar plinth, a large flange, a double lotus, and a dome showing the Five Buddhas in relief. This last chaitya is covered with Tibetan mantra graffiti.

On top of the ridge above the stupa is a complex of new buildings: a monastery retreat center built by Trangu Rinpoche, a Karma Kagyu lama based in Boudha. The center of this complex is the Newar relief, about three feet long and two feet six inches high, depicting the legend of Namo Buddha. It lies in a new concrete structure under a mayal tree and shows the tigress with five cubs accepting the flesh of the bodhisattva, which he has cut from his thigh with the large knife that he wields. His clothes and Gorkhali crown are perched in one of the trees in the forest where the action takes place. The relief is surrounded by Newari script that relates the story. On the top of the ridge above the mayal tree is a chaitya called Taladola with a shrine to Amitabha to the west. Below the mayal tree is a large concrete statue of Shakyamuni standing on a plinth. Under the plinth is a hole identified as the original tiger's lair.

Glossary of Sanskrit and Newari Terms

Acharya. A Tantric master

Agamache. (Newari) The secret Tantric shrine room

Agamdya. (Newari) The secret Tantric deity

Amrita. Ambrosia

Ankushamudra. Gesture of aggression

Asana. A seat or posture

Asura. A demonic, jealous god

Avatar. An incarnation of Vishnu

Bahal. (Newari) A Newar Buddhist monastery (Sanskrit *vihara*)

Bahi. (Newari) A raised, single-story Newar monastery structure

Bhajan sala or **pati.** A room or shelter for ritual chanting

Chaitya. A small **stupa**

Chaturmukha. Four-faced (**lingam**, **stupa**, or shrine)

Dakini. A female buddha or **yogini**

Damaru. A **tantrika**'s small two-faced drum; monkey drum

Dankini. A servant of Devi

Dharamsala. A rest house for pilgrims

Dharma. The Buddhist teaching

Dhuni. A sacred hearth

Dyache. (Newari) A townhouse of the goddess

Dyapala. (Newari) A temple caretaker

Gajura. A finial or temple pinnacle

Gompa. A Tibetan monastery

Halampo. (Newari) A copper banner hanging over a temple roof

Harmika. The cube surmounting a **stupa** dome

Hiti. (Newari) A sunken bathing place fed by a spring

Jalahari. The plinth of a **lingam** serving as a drain

Jatra. Festival

Kalasha. A sacred vase representing Devi

Kapala. A **tantrika**'s human skull bowl

Khatvanga. A symbolically ornamented Buddhist trident

Kunda. A bathing pond

Kwapadya. (Newari) The public Buddha deity of a **bahal**

Lalitasana. The posture of royal ease, one leg drawn up, the other pendant

Lingam. A stylized phallus representing Shiva Mahadeva

Manushi. Relating to an incarnate buddha

Mudra. Hand gesture

Naga. A water spirit (serpent); demigod

Padma. Lotus

Pati. (Newari) A small pilgrim shelter open on three sides

Pitha. An open residence of **shaiva** gods

Prasada. A material blessing from a deity or guru

Rakshasa. A demon

Sadhana. A **tantrika**'s spiritual practice

Sangha. The Buddhist community

Shaiva. A devotee of Shiva Mahadeva

Shakti. Spiritual energy; a female consort

Shikhara. The tower of a stone temple

Shraddha. Ceremonies for the dead

Siddha. A Tantric adept

Stupa. A monument representing the Buddha

Svayambhu. Spontaneously existent, self-manifest

Tantrika. A Tantric adept

Tirtha. A residence of **nagas** usually at a river confluence

Torana. A half-moon-shaped tympanum, usually of wood, surmounting temple doors; an arch, usually of stone, covering a deity's rock residence

Trishula. A trident, the token of Shiva

Ushnisha. The protuberance on the head of a Buddha

Vaishnava. Relating to Vishnu Narayana

Vajra. Diamond adamantine thunderbolt scepter

Varadamudra. The gesture of giving in Buddhist iconography

Vetala. An animated corpse; a gruesome fiend

Yantra. A sacred geometrical diagram

Yogini. A female Tantric adept

Yoni. The female sexual organ; the plinth of a **lingam**

ABOUT THE PORTFOLIOS OF PHOTOGRAPHS

Kathmandu

Patan

Bhaktapur

Overleaves

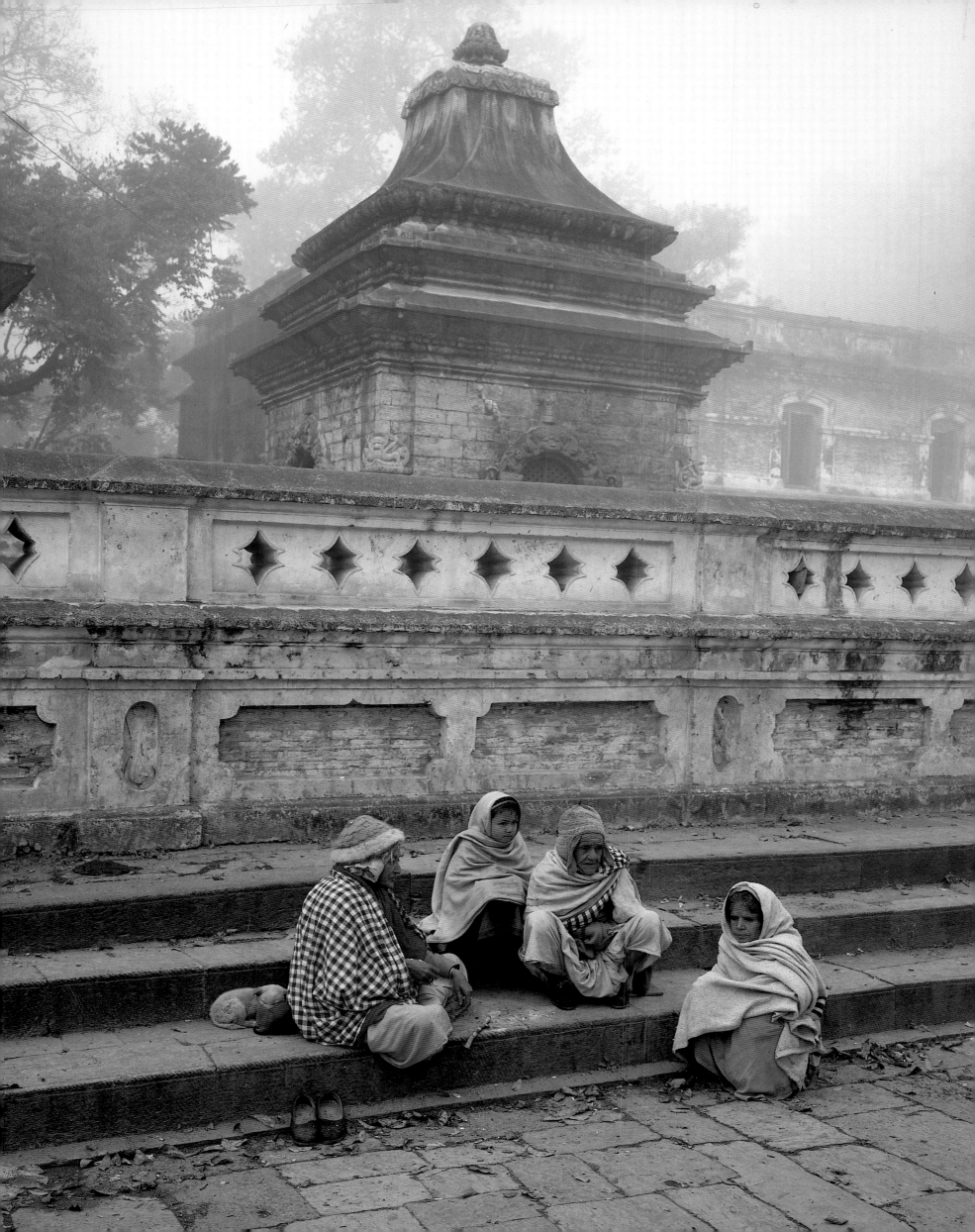

ACKNOWLEDGMENTS

My thanks to the National Endowment for the Arts, the Fulbright Foundation, the United States Education Foundation (Nepal staff) and 1988–90 directors Anne Lewis, Pamela Poon, and Dr. Penny Walker; 1989 USIS director William Dawson; and Ambassador Leon Weil.

I thank Hugh Swift for introducing me to Keith Dowman in December of 1989. Mukunda Raj Aryal of the Centre for Oriental Studies at Tribhuvan University and Niels Gutschow exposed me to many of the vital power places described here. Mary Slusser's wonderful book *Nepal Mandala: A Cultural Study of the Kathmandu Vallley* (Princeton University Press, 1982) was an invaluable key to discovering the visual mysteries of the Kathmandu Valley. Bijaya Raj Dongol, Dhana Maharchan, and Ananta Jyoti Sharma were very helpful assistants with the location view camera photography. My thanks to all the people of Bhaktapur, Boudhanath, Changu Narayana, Dakshina Kali, Kathmandu, Kwa Bahal, Patan, Pashupatinath, Svayambhunath, and the other locations in the Kathmandu Valley.

I would like to thank Brad Bealmear and Walter Nelson in the USA who introduced me to the transcendent qualities of large format color transparencies. In Nepal I would like to thank our extended family of Pam Ross and Charles Gay, Manohari Upadhyaya, and Surjya Maharjan. Appreciation and love to my wife, Laura, for her encouragement all along the way.

KEVIN BUBRISKI

I am indebted to the generosity of His Majesty's Government for my extended residence in the Kingdom of Nepal, during which time my research on the power places was undertaken. In particular I owe gratitude to Professor Prem Khatri, the Director of the Centre for Nepali and Asian Studies at Tribhuvan University, for the facilities extended to me during the last two years of my research, and to Dr. Dron Rajaure, Nirmal M. Tuladhar, and Professor Trilokchandra Majupuria for their kind assistance. To the innumerable anonymous people of the Kathmandu Valley who provided local information at the power places and inimitable good humor and hospitality I am forever grateful. My gratitude also goes to William Forbes for sharing his research, to Steve Leclerc for his companionship in pilgrimage, and to my wife, Meryl, for her constant support.

KEITH DOWMAN